A Revolution in Wood

The Bresler Collection

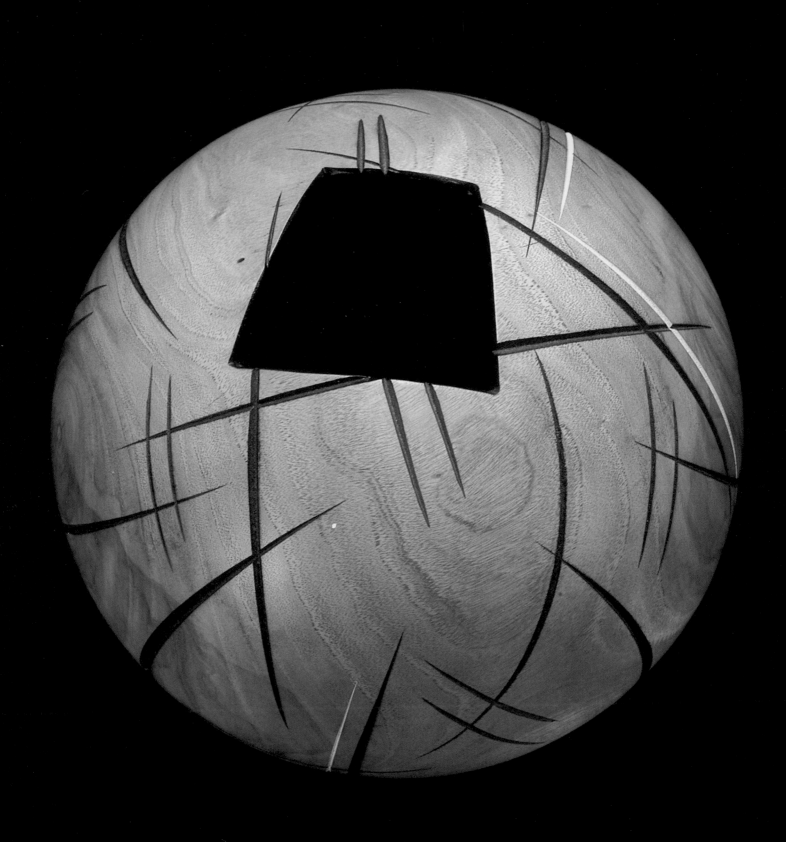

A Revolution in Wood

The Bresler Collection

Nicholas R. Bell

Renwick Gallery of the
Smithsonian American Art Museum
Washington, D.C.

A Revolution in Wood:
The Bresler Collection

Chief of Publications: Theresa J. Slowik
Senior Editor: Susan L. Efird
Designer: Robert B. Killian

Published in conjunction with the exhibition
of the same name, on view at the
Smithsonian American Art Museum's
Renwick Gallery, Washington, D.C.
September 24, 2010–January 30, 2011.

Distribution by:
Random House, Inc.
1745 Broadway
New York, NY 10019

Library of Congress
Cataloging-in-Publication Data

Smithsonian American Art Museum.
 A revolution in wood : the Bresler collection /
Nicholas R. Bell.
 p. cm.
Includes bibliographical references and index.
 ISBN 978-0-9790678-7-7 (cloth cover : alk.
paper)
 1. Art woodwork—United States—Exhibitions.
 2. Bresler, Fleur—Art collections—Exhibitions.
 3. Bresler, Charles—Art collections—Exhibitions.
 4. Art woodwork—Washington (D.C.)—
Exhibitions. 5. Smithsonian American Art
Museum—Exhibitions.
I. Bell, Nicholas R. II. Renwick Gallery. III. Title.
IV. Title: Bresler
collection.
 NK9612.S65 2010
 745.510973'074753—dc22

 2010018693

The Smithsonian American Art Museum is
home to one of the largest collections of
American art in the world. Its holdings—more
than 41,000 works—tell the story of America
through the visual arts and represent the most
inclusive collection of American art in any
museum today. It is the nation's first federal art
collection, predating the 1846 founding of the
Smithsonian Institution. The museum celebrates
the exceptional creativity of the nation's artists
whose insights into history, society, and the
individual reveal the essence of the American
experience.

 Smithsonian American Art Museum

For more information or a catalogue of
publications, write:

Office of Publications
Smithsonian American Art Museum
MRC 970, PO Box 37012
Washington, D.C. 20013-7012.

Visit the museum's Web site at
AmericanArt.si.edu.

Mixed Sources
Product group from well-managed
forests, controlled sources and
recycled wood or fiber
www.fsc.org Cert no. SW-COC-001734
© 1996 Forest Stewardship Council

Front cover: Derek A. Bencomo, *Hana Valley,
First View* (detail), from the "Peaks and Valleys
Series," see pages 44–45

Back cover: Michael Lee, *Armored Crab*
(underside), see page 83

Frontispiece to book: Christian Burchard, *Dance,*
from the "Old Earth Series," see page 47

Donors' page: J. Paul Fennell, *Mesquite Basket,
from the* "Lattice Series," see page 57

Frontispiece and detail to Foreword: Michelle
Holzapfel, *Table Bracelet: Promenade Suite* (two
details), see pages 66–67

Frontispiece to *A Revolution in Wood:* photo-
graph of the Breslers' living room, see page 18

Frontispiece to A *Conversation with Fleur Bresler:*
Lincoln Seitzman, *Petrified Sewing Basket,* see
pages 104–105

Frontispiece to *The Bresler Collection:* Bruce
Mitchell, *Canyon Oasis #4,* see page 90

Frontispiece to *Wood Art at the Renwick Gallery:*
Rude Osolnik, *Five Candlesticks,* see page 94

Frontispiece to the Bibliography: Hugh E.
McKay, *Morata,* see page 89

Image for Index: Robert Cutler,
Lidded Jar (detail of lid), see page 52

Contents

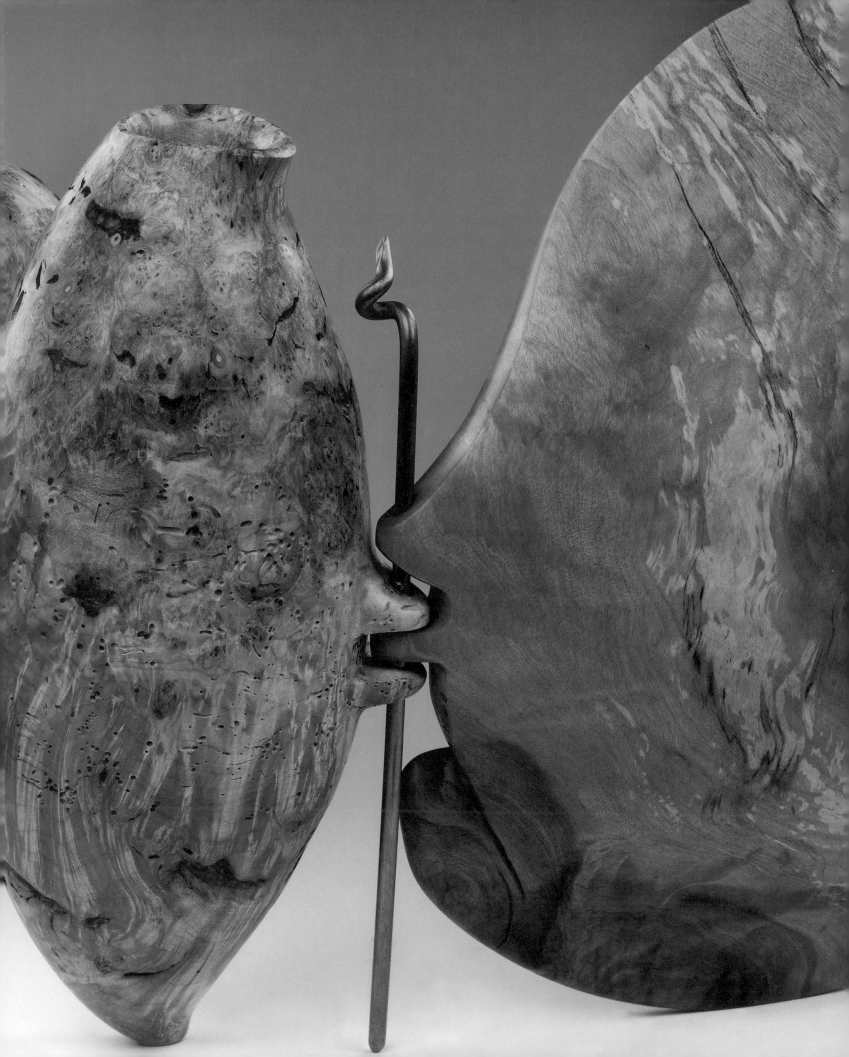

Foreword

One of the most rewarding aspects of the craft arts is watching how creative minds and hands respond to the inherent qualities of materials. Artists define themselves by how they respect the natural properties of clay or wood or glass, or sometimes push those materials beyond what they normally "want" to do. Sometimes the distinction is not so clear! Dale Chihuly's fantastical blown sea-forms express the eagerness of molten glass to flow and capture transparent color, while Howard Ben Tre's cast benches remind us that glass is a substantial structural material too. Which is the more "natural" treatment, and how is each artist's career shaped by the direction he pursues?

In the same way, collectors who pursue their passion over a long time tend to define themselves by their choices. It seems significant that Fleur Bresler chose to collect artworks made from wood, a material that corresponds to something essential about her character. Wood, like fiber, is organic and alive before it becomes an artist's material. Even after being harvested, it retains what Ansel Adams called the "luminous insistence of growing things." The former life of the tree is recorded in its anatomy, so each piece of wood is unique. With metal or glass, you can replicate a formula to ensure standardization, but each piece of wood is different from every other.

Fleur Bresler revels in those differences. She has profound insight into each artist's creativity in approaching the wood. She is the kind of collector artists most love, for she deeply values their interplay of invention and technique. She understands the depth of passion that artists can embed in a simple turned bowl.

Of the five craft media, wood most neatly balances inherent material limitations with a vast potentiality for creative intervention. Experienced artists working with more malleable materials like glass or metal may tease out extraordinary new shapes without risking disaster, but wood artists must always be aware that the object may crack or splinter if they force their will onto the material. Wood artists must cultivate a special deep sensitivity to the strength or vulnerability of the specific piece of wood chosen, respecting its

individual grain and growth patterns. As William Blake said, "I can look at the knot in a piece of wood until it frightens me."

Wood also conveys a cozy friendliness. A poor conductor of heat and cold, wood always feels comfortable to the touch. In fact, wood invites touching. Fleur Bresler introduces a "viewer" to her collection by offering the objects to be held, so they are experienced in a deeper way. Weight and balance and surface texture become strong ingredients of the artwork as experienced, as much as form and color. The life of the wood returns, enriched by the artist's intervention.

The qualities that Fleur Bresler values in a wood artwork are, not coincidentally, those qualities that we value in her. She has an unusually vibrant and warm presence. She is sensitive to our vulnerabilities but always seeks out our strengths. She is comfortable and reassuring, and friendships with Fleur deepen as they are held and cherished. The only thing Fleur Bresler values more than art is education, and in her inspired way, art becomes an educational experience, encouraging wisdom and insight. She understands that each of us is a unique material too, and, as Mies van der Rohe said, "Each material is only what we make it."

We are deeply grateful to Fleur Bresler for sharing her insights and collections with the Renwick Gallery of the Smithsonian American Art Museum, formally as a docent, and informally as well. And we are grateful to her husband, Charles Bresler, who joins her in this magnificent gift to the Smithsonian. For decades, Charles has been the very best partner in collecting and in life—supportive, collaborative, always encouraging. It's typically generous of the Breslers that they use their gift to honor their great friend Kenneth R. Trapp, curator-in-charge of the Renwick Gallery from 1995–2003. We are honored to preserve and protect their treasures for the future, and we love sharing them with audiences now and for generations to come. Through the Breslers' gift, the wood lives again, for each of us.

Elizabeth Broun
The Margaret and Terry Stent Director
Smithsonian American Art Museum

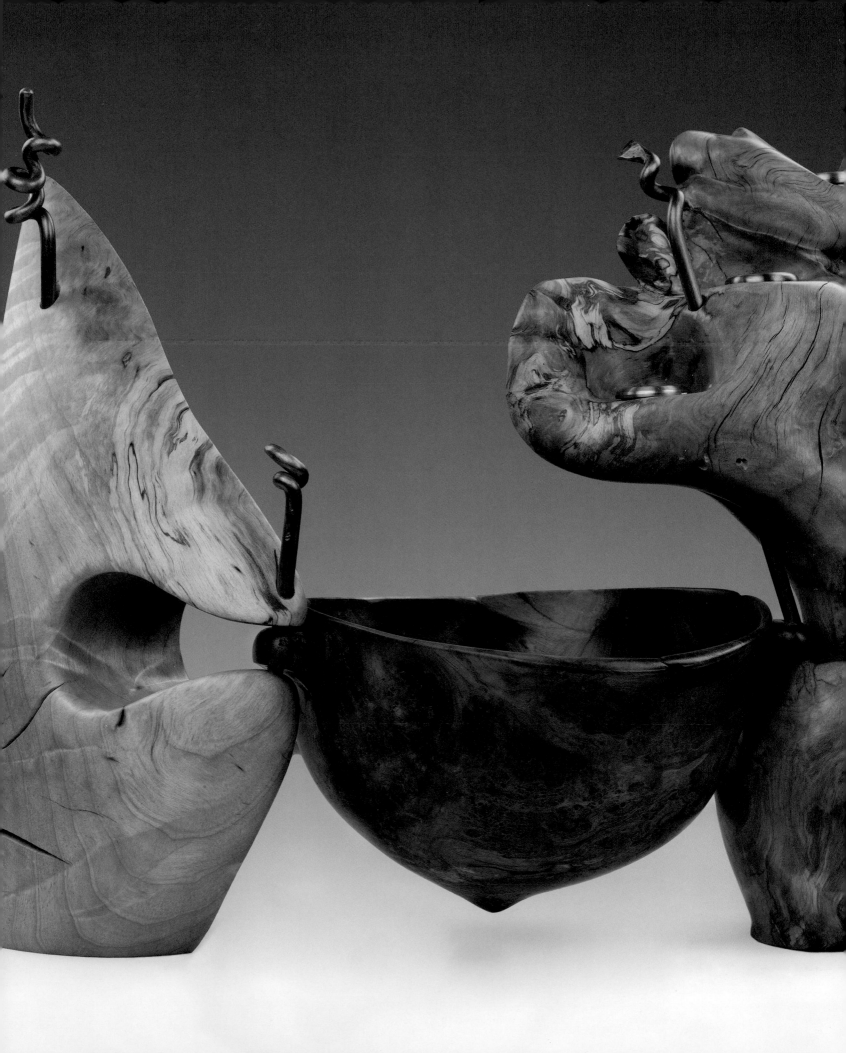

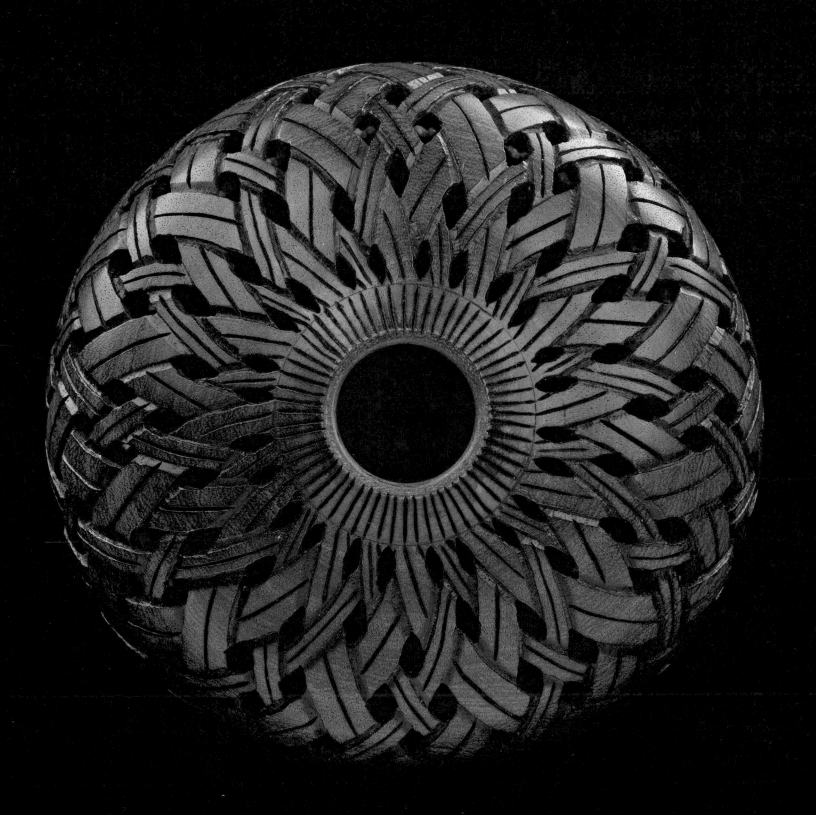

A Revolution in Wood: The Bresler Collection is organized and circulated by the Renwick Gallery of the Smithsonian American Art Museum.

The Windgate Charitable Foundation generously supported the publication.

The James Renwick Alliance contributed generously to the film, exhibition, and public programs.

The Collectors of Wood Art provided funding for the exhibition.

Acknowledgments

The character of a museum derives from its collection, but its soul is born from the individuals whose efforts bring objects to life as a mirror of our cultural values. Fleur Bresler's visit to the Renwick Gallery to view Edward Jacobson's exhibition in 1986 was momentous for many reasons—the foundation of her collection, the eventual extension of our own, and the introduction to the Renwick of an individual of extraordinary talent and passion. This catalogue is dedicated to her in gratitude for the boundless spirit that has shaped the future of the Renwick, of wood art, and of craft at large, for the better. Special appreciation is also due to Charles Bresler for his unwavering support of Fleur's collecting and his equal share in the generosity of their gifts to the Renwick.

This collection, this exhibition, and this catalogue would not exist without the support of former Renwick curator-in-charge Kenneth R. Trapp. It was through Ken's friendship with Fleur that the idea for the gift took hold, and through his curatorial vision that it took shape. His guidance has been invaluable, as have his views on the place of wood art in contemporary craft. Ken would like to thank Brenda Behrens, Derek Bencomo, Christian Burchard, Galen Carpenter, Nicholas Crevecoeur, Michelle Holzapfel, Robyn Horn, Donald Freeman Mahan, and Howard Risatti for their support during the early stages of this project.

It is with great pleasure that I thank the Windgate Charitable Foundation for providing a generous grant covering the full cost of publication. Exhibitions offer important insights into our collective identity and how we understand our culture through artistic production; without supporting publications, however, their survival over time is bound to human memory, and ultimately ephemeral. Admirers of wood art everywhere are indebted to the foundation for preserving this collection in print.

The Collectors of Wood Art provided generous support for the exhibition and public programs. Phil Brown was indispensable in spearheading the organization of turning demonstrations at the Renwick. We are indebted to the volunteers from the Capital Area Woodturners, the Montgomery County Woodturners, and the Chesapeake Woodturners for staffing the lathe in the gallery and for sharing their passion and skill with an eager public.

The patience and guidance of many individuals has been critical to the success of this project. Albert and Tina LeCoff greeted my queries with enthusiasm and contributed many hours out of their busy schedules at the Wood Turning Center to speak with me about all things wood. During the 2009 American Association of Woodturners Symposium in Albuquerque, I met with Frank Cummings, David Ellsworth, Mike Hosaluk, Binh Pho, Terry Martin, Kevin Wallace, and others to discuss their work and trends in the field. Martha Connell, Lloyd Herman, Michelle Holzapfel, Mark Lindquist, and Norm Sartorius also contributed important insights. At Winterthur, Emily Guthrie, Julia Hofer, Charles F. Hummel, Brock W. Jobe, and Susan Newton warmly answered my inquiries on early American wood turning. No history of the technique would be complete without that museum's resources or the collective knowledge of its staff. Martin Huberman produced the introductory video including interviews with Fleur, David Ellsworth, and Mark Sfirri.

It is important to note that the Breslers neither requested nor expected an exhibition or publication as a result of their gift. The Smithsonian American Art Museum's director, Elizabeth Broun; deputy director, Rachel Allen; and Renwick chief, Robyn Kennedy, all championed this first medium-based show at the gallery in several years.

The complex tasks of mounting the exhibition and of publishing the catalogue were made less so by the talented staff at the American Art Museum and Renwick Gallery. Exhibition designer David Gleeson tackled his mission with the fervor of someone genuinely passionate about the craft. This book owes its grace to Susan Efird's rigorous editing, to Gene Young's and Bruce Miller's excellent photography, and to Robert Killian's exquisite design, all under the careful guidance of Theresa Slowik. Ross Randall provided crucial development support. Fern Bleckner ran frequent interference between departments, while Rebecca Robinson provided administrative support. Interns Jordan Klein and Rita O'Hara conducted initial research on the collection, and Alberta-Smithsonian intern April Matisz compiled the bulk of the bibliography, working from the Renwick's extensive artist files. It would not have been possible to publish the museum's entire collection without the institutional memory and extraordinary research capabilities that Marguerite Hergesheimer provided. She maintains the artist files and contacted each artist or artist's estate to ensure that the information was accurately recorded—a process lasting more than a year. Her input was invaluable to this first comprehensive publication of wood art at the Renwick.

Nicholas R. Bell
Curator
Renwick Gallery of the
Smithsonian American Art Museum

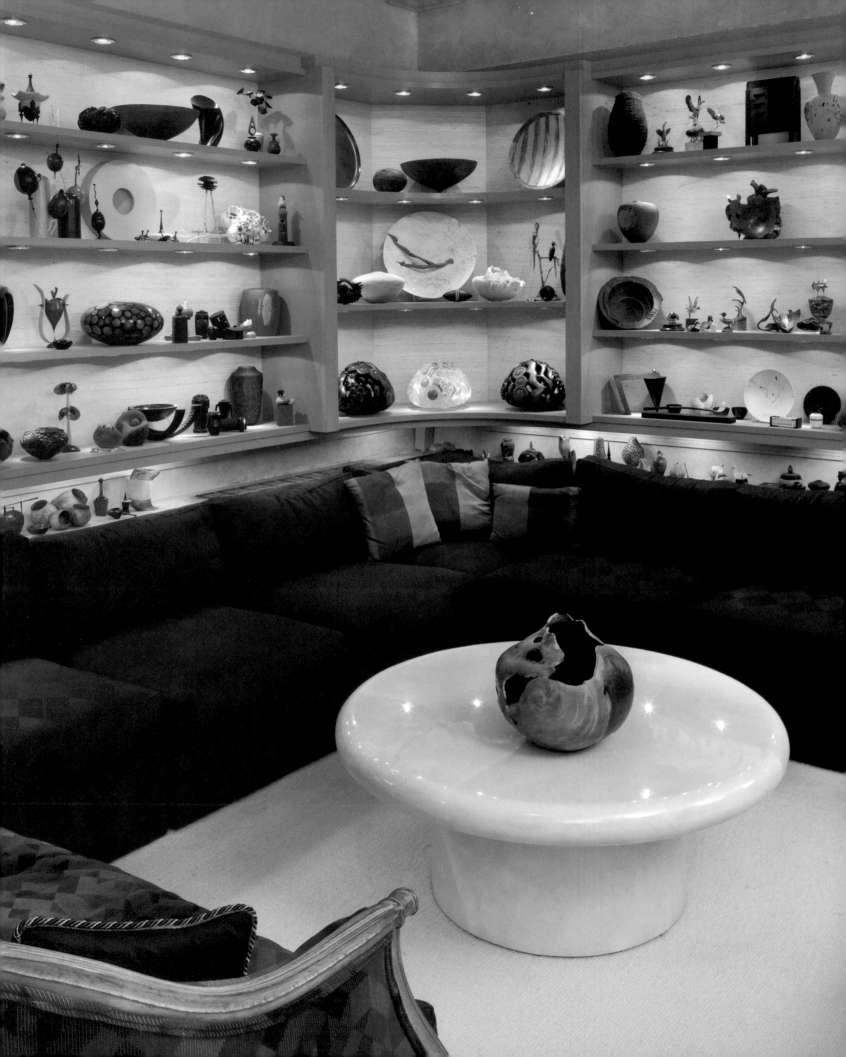

A Revolution in Wood

THE COLLECTION

A Revolution in Wood celebrates sixty-six turned- and carved-wood objects given to the Renwick Gallery by Fleur and Charles Bresler in honor of former Curator-in-Charge Kenneth R. Trapp. The gift is one of the most significant in the Renwick's history and one of the largest of wood art to any American museum. The broad scope of the collection demonstrates the Breslers' unwavering support of the fledgling craft for more than twenty years, as well as Fleur's efforts as an educator, benefactor, and overall champion of the medium. The extraordinary generosity of this donation complements the Renwick's existing holdings in the field and establishes at the gallery one of the preeminent public collections of wood art in the United States.

Fittingly, the Bresler collection has its roots in a chance encounter at the Renwick Gallery. In 1986 Fleur wandered into the groundbreaking exhibition *The Art of Turned-Wood Bowls*, organized from the collection of Edward Jacobson (fig. 1). While several exhibitions of lathe art had been mounted in previous years, the collection's elegant presentation and publication, as well as the selection of a venue with a broad audience of craft enthusiasts, served as an introduction to many future collectors of turned wood.[1] "I was smitten," says Fleur. "I had never seen wood in that color. I had never seen all the different patterns. And if the guard hadn't been there, I probably would have taken the tops off the cases and picked the pieces up."[2]

That first visceral reaction quickly gave way to a burgeoning curiosity about the material and its shapers. Before long, Fleur had purchased her first turned works and was attending an increasing number of events to learn about the field. In 1991 she traveled to Philadelphia to view the Wood Turning Center's *International Lathe-Turned Objects: Challenge IV* exhibition. There she first heard Dr. Irving Lipton—perhaps this country's greatest private collector of wood art—speak about collecting practice. He suggested that "if you found a turner whose pieces you liked, you should buy at least two pieces, and they should be very different pieces. And you should follow the artist's career, even if he made something or went through a phase you didn't like, so that you would

1 The Edward Jacobson collection installed at the Renwick Gallery in 1986.

2 Michelle Holzapfel, *Untitled*, 1986. Cherry burl, 9 ⁵/₈ x 11 ¾ in. diam. Gift of Fleur and Charles Bresler, 2003.60.19

3 From left to right: Connie Mississippi, David Wahl, Rude Osolnik, Fleur Bresler, and Nick Cooke at the Arrowmont School of Arts and Crafts, Gatlinburg, Tennessee, 1994.

4 Michael Peterson, *Mesa*, from the "Landscape Series," 1993. Locust and india ink, 5 x 9⅞ in. diam. Gift of Fleur and Charles Bresler, 2003.60.45

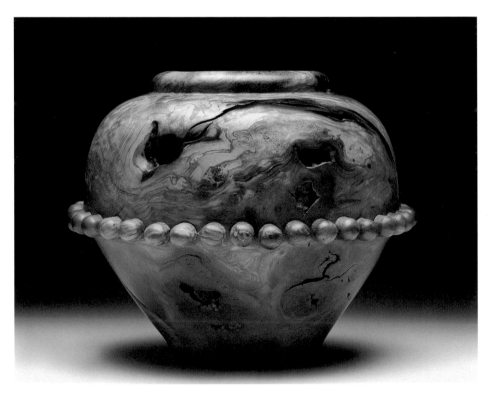

have a record of his evolution in wood turning."[3] As Fleur began to define herself as a collector, this advice emerged as her core philosophy. At craft shows hosted by the Smithsonian Institution, the American Craft Council, and other organizations, Fleur put Lipton's advice to use, collecting multiple works by

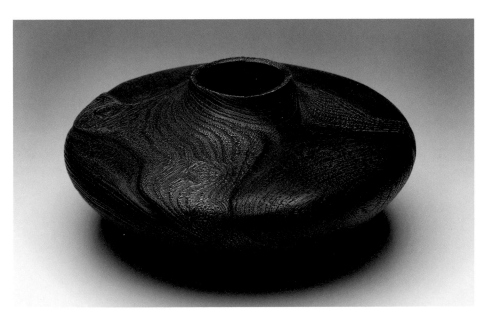

such artists as Michelle Holzapfel, Bud Latven, and Barry Macdonald (fig. 2).

The depth and complexity of her collection advanced significantly following the 1994 conference *Woodturning: A Tribute to the Osolniks* at the Arrowmont School of Arts and Crafts in Tennessee (fig. 3). For Fleur it was an opportunity to make contact with a different community of turners—those less likely to exhibit in juried craft shows. The collection—and the Breslers' network of friends—flourished with the addition of works by David Ellsworth, Todd Hoyer, Bonnie Klein, Michael Peterson, Del Stubbs, and many others (fig. 4). The Bresler home in Rockville, Maryland,

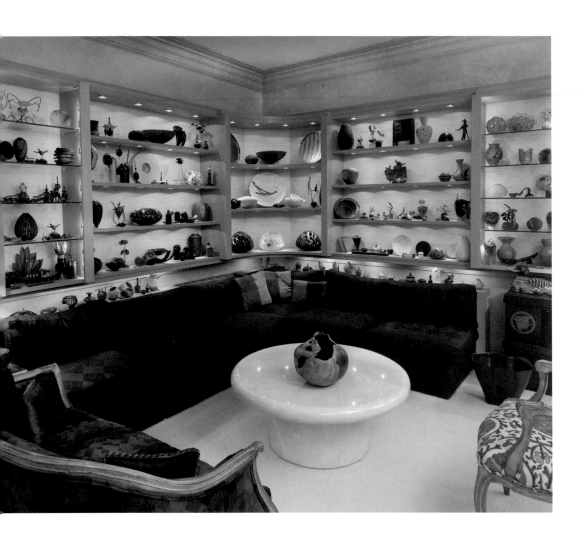

became something of a guest house for turners visiting the Washington metropolitan area. The collection installed there, now numbering in the hundreds of objects, still serves as the field's greatest conversation starter, as artists from across the country—and the globe—pore over each other's work in the shelf-lined rooms (fig. 5).

Fleur's infectious enthusiasm for craft led her to join the Renwick as a docent in 1997. It was in this capacity that she befriended Kenneth R. Trapp, then curator-in-charge at the gallery, and invited him to compose a gift from her collection. From the outset, Trapp was given free rein to consider any and every object for acquisition (so long as it had not been promised to a family member)—a rare degree of latitude from someone parting with favorite things. Because the Renwick's collection of turned

5 The living room of Fleur and Charles Bresler, Rockville, Maryland.

wood already included a strong representation of certain makers, such as James Prestini, Mark Lindquist, and Bob Stocksdale, the Bresler gift was structured to complement the existing collection by incorporating objects from several prominent but underrepresented artists. The inclusion of multiple works by Ron Fleming, Michelle Holzapfel, Todd Hoyer, and Norm Sartorius demonstrates this effort, as well as the fruits of Fleur's adherence to Lipton's collecting philosophy. Other makers, such as Frank Cummings, David Ellsworth, and William Hunter, saw their representation in the collection strengthened by the addition of new work. Trapp also introduced many turners into the Renwick collection for the first time, such as Brenda Behrens, Jon Sauer, and Mark Sfirri. More than fifty pieces in the Bresler collection were made during the 1990s and reflect the movement's shift away from the lathe toward carving and also embellishing with nonwood materials.

Ultimately, this varied approach broadens considerably the scope of the Renwick's collection of wood art, illustrates the evolution of its aesthetic, and adds depth to the histories of individual artists—a critical tool for understanding the evolution of the movement in America. To place the Bresler gift in the appropriate context, the Renwick's entire collection of wood-based art (excluding furniture) is included in the catalogue (see pages 114–138).

THE MOVEMENT
Roots

The lathe has been described as the first machine tool and can be dated as far back as the Bronze Age.[4] Variants of the technology—strap, bow, treadle, great wheel, and pole-powered models—developed independently in several European and Asiatic cultures.

A turner operated the pole lathe by pumping a treadle while standing (fig. 6). A strap or rope connected the treadle to a pole mounted over his head and was wrapped around the shaft at his waist, securing the wood to be

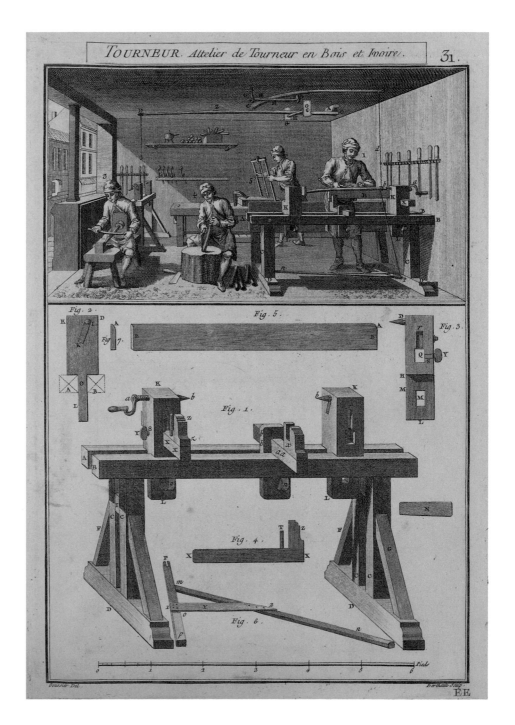

6 "The Wood-Turning Workshop," illustration from père M. Hulot's *L'art du tourneur mécanicien.* Paris: Chez M. Roubo, Me. Menuisier, 1775. Courtesy of Winterthur Library: Printed Book and Periodical Collection. Pole lathes of similar design were simple to build and were used in America into the nineteenth century.

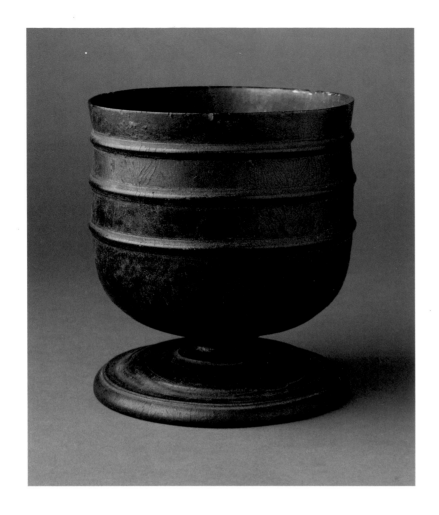

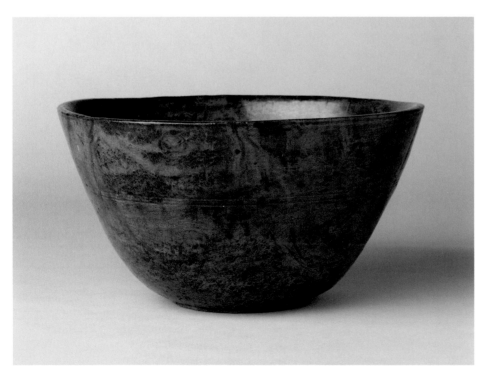

worked. As he depressed the treadle, the strap pulled the pole downward, and the shaft rotated toward him, allowing him to shape the wood with a hand-held tool. When he raised his foot, the pole sprang back to its original position, pulling the shaft in the opposite direction. This reciprocal process was popular in medieval and early modern Europe as a method for turning bowls, spindles, and minor architectural elements. Continuous rotation, and hence more efficient and accurate work, was made possible following the sixteenth-century adaptation of the great-wheel lathe for wood turning. Powered by an assistant cranking a large wheel attached by strap or rope to the stock, this design proved more sophisticated and labor intensive than the pole lathe, ensuring that the latter remained in wide use into the nineteenth century.[5] It was primarily in this capacity that wood turning arrived in the New World (fig. 7).

The first European settlers to the eastern shore of what would become the United States were confronted by a wilderness both abundant in raw materials and lacking in any infrastructure with which to exploit them. The ability to locally manufacture even basic wares developed over the course of decades, not years. Many of the goods used by early Americans were imported, including ceramics from China and textiles from France and England. Perhaps the most notable exception was furniture. A furniture maker could begin work quickly with a few tools and an education in the "art and mystery" of the craft, in a

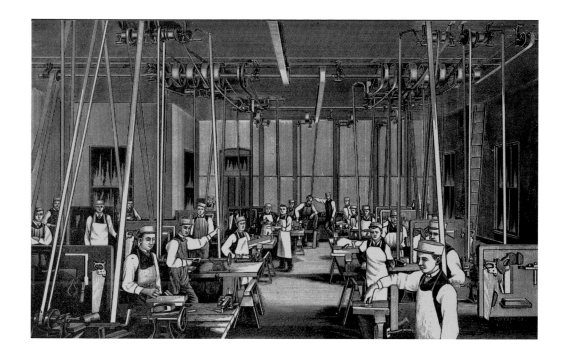

land originally populated by more trees than people. Early colonial cabinet making and turning made full use of domestic stock, with oak, maple, walnut, and cherry serving as common primary woods. Depending on availability by region, white and yellow pine, tulip poplar, chestnut, beech, and various fruitwoods could be pressed into service as secondary woods (fig. 8).[6]

Gradually, mahogany took over as the most desirable primary wood, with ebony and satinwood serving as popular accent woods, as the evolution of trade, taste, and wealth made exotic hardwoods increasingly available. As the craft matured, so did the division of labor, and turning grew into its own as a specialized position in the artisanal community.

The fate of professional wood turning in the nineteenth century mirrored the long decline of many trades in America. The Industrial Revolution and the advent of an economy powered by steam, then electricity, rendered antiquary a system training young men to pump a treadle or crank a wheel. Instead, tasks were increasingly specialized, and the manufacture of objects splintered between machines and a marginalized work force. Ironically, advances in technology propelled both the number of things one might own and the speed with which one forgot how to make them. Recognition of this dramatic loss of skilled knowledge led at the end of the nineteenth century to the birth of the manual training movement.[7] Its philosophy advocated teaching basic industrial skills, such as drafting, forging, and wood turning, alongside traditional academic subjects. The goal was not to produce a highly skilled work force, but to lay a foundation upon which further training could be pursued if desired, as well as to reintroduce the satisfaction of crafting an object from start to finish. Wood-turning projects in these settings tended toward domestic objects—kitchen implements, vessels, and spindles—that emphasized the medium's practicality and the immediate gratification of making something useful.

The movement's popularity led initially to the establishment of several private manual training schools and eventually to the adoption of a similar curriculum in public schools across the country (fig. 9). It was the precursor of the modern-day shop class. The lathe became a standard tool in schools nationwide for the same reason it remains popular today: finished items can be produced quickly with only basic knowledge of the craft.

7 *Wassail Bowl,* 1685–1715, England or New Jersey. Lignum vitae. Courtesy of Winterthur Museum. Other surviving examples suggest that this vessel for seasonal spiced punch was originally fitted with a turned lid decorated with finials. It has been attributed to the Luyster farm outside Middletown, although it was likely made in England. It demonstrates the quality of turned-wood vessels used by colonial Americans.

8 Felix Dominy (1800–1868), *Bowl,* 1820–35, East Hampton, New York. Applewood burl. Courtesy of Winterthur Museum. Turning burls was uncommon but not unknown in preindustrial American woodworking. Dominy likely turned the bowl on an arbor-and-cross attachment mounted on a great-wheel lathe.

9 "The Woodworking Shop," illustration from C. M. Woodward's *The Manual Training School: Comprising a Full Statement of its Aims, Methods, and Results.* Boston: D.C. Heath, 1887. Courtesy of Winterthur Library: Printed Book and Periodical Collection

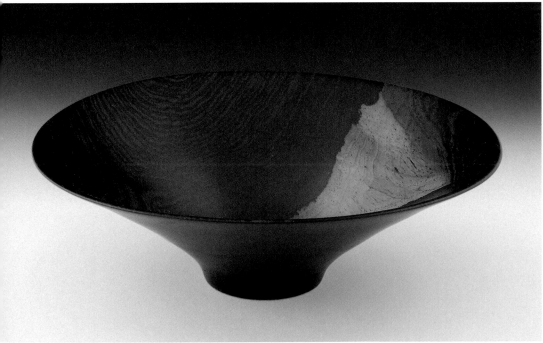

Many people regarded today as the founding generation of contemporary wood turning received their introductions to the lathe at school. Melvin Lindquist (1911–2000), Ed Moulthrop (1916–2003), James Prestini (1908–1993), Bob Stocksdale (1913–2003), and Rude Osolnik (1915–2001) are often heralded for transporting the field from the shop to the gallery (figs. 10, 11, and 12). While their contributions to turning as an artistic medium are undeniable, the path to widespread recognition and acceptance from the larger craft community was long, winding, and far from obvious.

One reason was the focus of their turning. Production work, such as bowls, platters, serving dishes, and candlesticks, encouraged a perception of the lathe as an implement of industrial design. Writing on Prestini's "spare, smooth, and evenly accented" work, Edgar Kaufman Jr. noted that "it achieves no vibrant surfaces charged with personal touch," and that it "has more often borrowed from mechanization than protested against it."[8] This distinction did not enamor proponents of the handmade to early turners but it did garner attention from the design world. In the 1940s and 1950s, turned vessels by John May, Prestini, and Stocksdale were exhibited and accessioned by the Museum of Modern Art.[9] Osolnik also received notice, picking up a National Award for Contemporary Design from the International Wood Manufacturers in 1950 and the Award of Good Design from the Furniture Association of America five years later.[10]

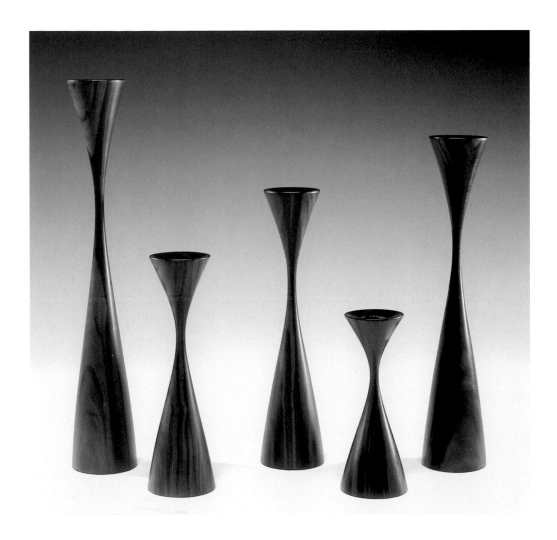

In 1944 Franklin Delano Roosevelt signed into law the Servicemen's Readjustment Act, popularly known as the GI Bill of Rights. The GI Bill provided extraordinary financial support for military personnel returning from war, including beneficial home loans, unemployment insurance, and free tuition to all institutions of higher education. Millions of veterans took advantage of this access to education, propelling a renaissance in academic programs across the country. Departments in the material arts (many new) that provided education in a variety of media—ceramics, fiber, furniture, and metal— were enriched by the sudden influx of students. This education would serve as a foundation for the studio

10 James Prestini, *Platter*, 1933–53. Yellow birch, ⅞ × 10 ¼ in. diam. Gift of the artist, 1970.46.16

11 Bob Stocksdale, *Bowl,* 1988. Brazilian rosewood, 2 ¾ × 8 ¼ in. diam. Gift of Jane and Arthur K. Mason, 1991.169.8

12 Rude Osolnik, *Five Candlesticks*, 1988. Macassar ebony, height: 6 ¼ –14 ¼ in.; diam.: 2 ⅜ in. Gift of Fleur and Charles Bresler, 2003.60.44A–E

craft movement. Within a span of twenty years, the burgeoning field enjoyed a rapidly expanding support network and an increasingly clear path to success. Introductory programs beget graduate programs beget teaching positions and studios, followed in the 1970s by galleries, collectors, and the attention of museum curators.

Not coincidentally, the greatest surge in interest in the handmade since the Arts and Crafts Movement—itself a pointed response to the Industrial Revolution—followed the largest mechanized conflict in human history. It may be, in part, for this reason that the lathe, the first *machine* tool, was largely overlooked in these early years. While analogous technologies, such as the potter's wheel, offered an obvious entrée into handwork and the personalization of objects, the lathe invoked the standardization of form, the very antithesis of modern craft. When in 1969 the studio-craft omnibus exhibition *Objects: USA* toured the country (after opening at the National Collection of Fine Arts, now called the Smithsonian American Art Museum), only three of the two hundred fifty artists included were turners (fewer even than those working in plastic). Stocksdale and Art Carpenter were tidily summed up in the catalogue as "entirely self-taught," while Harry Nohr was captured as a "hobbyist" enjoying a "full-time retirement occupation."[11]

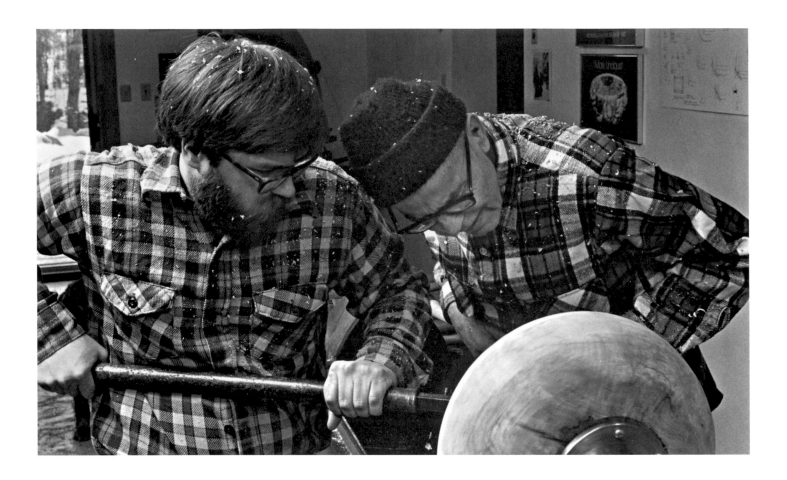

13 Mark (left) and Melvin Lindquist (right) turning a bowl at their Henniker, New Hampshire, studio, about 1980.

Revolution

The rise of wood turning from neglected technique to fast-growing medium is one of the most remarkable and unexpected histories in twentieth-century American craft. Ironically, one early factor spurring the movement's development was the failure of studio craft's burgeoning institutions to explore the lathe's creative potential. Baby boomers, children of the GIs who first packed the studios, came of age during one of the most turbulent periods in postbellum American history. The political, cultural, and ideological battles that defined the 1960s and 1970s would not leave craft unaffected. By the early 1970s, members of that generation had begun to question the boundaries of modern craft as established by academia. For the disenchanted and merely curious, the early success of the studio craft movement was tempered by its exclusive, even conservative, position on acceptable media and modes of expression.

Wood turning, in contrast, existed in a vacuum. The lure of the lathe was the absence of preconceptions of approach, style, or techniques considered unfavorable or incorrect. For early experimenters, turning offered a cathartic release from the confines of cultural norms. "There was a need to find the self of self-expression independent of academia, which I'd had enough of," recalls David Ellsworth, who had already concluded his graduate studies at the University of Colorado. "I needed to prove to myself what I was worth and gain a sense of independence that was directly related to me and not to others."[12]

He would achieve this self-reliance by moving a lathe into a minuscule studio on a mountainside. In 1971 Melvin Lindquist's son, Mark, took a similar route: "I left academia as many in the late 1960s and early 1970s did, ironically, only to get back to what I had begun learning as a child."[13] He abandoned the Pratt Institute's MFA program in sculpture and returned to upstate New York to study turning with his father (fig. 13).[14]

The singular pleasure of turning wood steadily drew converts from outside craft and fine-art departments. Michelle Holzapfel, Todd Hoyer, William Hunter, Craig Nutt, and Norm Sartorius received degrees in fields as diverse as drafting, psychology, and religious studies before settling into the shop. Ron Kent, Ed Moulthrop, and Lincoln Seitzman enjoyed full, unrelated careers as stockbroker, architect, and textile manufacturer, respectively, before leaving lasting impressions on the early development of the field. Melvin Lindquist gained useful experience as a turret-lathe operator and master machinist at General Electric. Only a select few, including Michael Chinn, Stoney Lamar, Betty Scarpino, and Mark Sfirri, were fortunate to gain limited experience on the lathe while enrolled in academic and technical wood-working programs, where it was employed as one tool among many. For most others, fleeting memories of high-school shop classes would serve as the only educational foundation for their métier of choice.

At a time when the nascent environmental movement was finding its voice, many early turners were drawn to the medium's inherent connection to nature. Wood is a living material, among the most organic associated with any craft, and finding it proved to be a common labor of love. The early history of the movement is largely rural—in part because a good woodshop needs space, but also because turners found the raw ingredients for their art on the forest floor. Rather than the largely featureless woods used in industrial turning, where the goal is uniformity, those new to the lathe searched out stock that would bring visual character to their work.

When Ellsworth moved to Quakertown, Pennsylvania, he scoured his property for fallen maple, ash, and oak. Both Lindquists turned woods from their New York land; Moulthrop scavenged stock around his Georgia home; and Derek Bencomo, Kent, and Bruce Mitchell turned Norfolk Island pine, milo, and redwood, respectively, endowing their work with a regionalism often less pronounced in other craft media. Exotic woods have also grown increasingly popular as they have become available. Mahogany, ebony, pink ivorywood, kingwood, rosewood, bloodwood, madrone, purpleheart, and African blackwood are represented in the Bresler collection. Each wood responds differently to being shaped on the lathe, and it is a point of pride among wood artists to understand the physical properties of their materials. Indeed, the rise of wood turning in the second half of the twentieth century has led many turners to become amateur arborists.

The absence of recognition of wood turning as an artistic medium left those impassioned by it without a network with which to establish a community. Although the number of turners across the United States continued to grow

14 Vessels by Bob Stocksdale and Ed Moulthrop in the Renwick's 1978 sale exhibition, *The Art of the Turned Bowl.*

15 David Ellsworth, *Mo's Delight,* 1993. White oak, 3 1/8 x 8 3/4 x 7 1/4 in. Gift of Fleur and Charles Bresler, 2003.60.11

16 Mark Lindquist, *Ascending Bowl #3,* 1981. Black walnut, 8 1/4 x 11 3/8 in. diam. Gift of an anonymous donor, 1981.131

during the 1970s, most worked in isolation, meeting only by happenstance. Gradually, by attending craft shows and organizing workshops, demonstrations, and symposia, the most-proficient turners sent up flares for like-minded individuals in their respective regions. Bereft of more traditional education, these events served as ad hoc schools where knowledge of wood, techniques, and technology could be shared.

The George School symposia—a biannual series held in Bucks County, Pennsylvania, from 1976 to 1981—were perhaps the most influential of these early programs. The first gathering of dozens of turners was remarkable, as craft historian Glenn Adamson has noted, for the "suggestion that there could be a wood turning 'field' at all."[15] The notion that a craft field could be defined by a technique rather than its medium gained further currency in 1978 when the Renwick Gallery opened its first exhibition dedicated solely to turned wood. *The Art of the Turned Bowl* included vessels by the Lindquists, Moulthrop, and Stocksdale (fig. 14). In a glimmer of recognition from the outside world, the Metropolitan Museum of Art acquired works from the exhibition by father and son later that year.

In 1981 Melvin and Mark Lindquist were invited to begin a wood-turning program at the Arrowmont School of Arts and Crafts. Because of the interest sparked by their sessions, Arrowmont emerged as an early center for turning education. Two hundred fifty turners from six countries met at the school in 1985 for a conference titled *Woodturning: Vision and Concept.* Its success led to the foundation of the American Association of Woodturners the next year. David Ellsworth, the AAW's first president, would write in the association's first publication, "It soon became clear that what had brought us to Tennessee was more than just a lust for tools and techniques, it was also a thirst for the process of learning . . . if there was a single thought on everyone's mind, it must have been 'where do we go from here?'"[16] Starting with its first board meeting—held at the Renwick Gallery in 1986, just two weeks before the opening of Edward Jacobson's collection—the association has grown at an exponential rate, today boasting over thirteen thousand members.

The year 1986 also saw the founding of the Wood Turning Center in Philadelphia by Albert LeCoff, who had been a key organizer of the George School symposia and the influential 1981 touring exhibition *A Gallery of Turned Wood Objects.* The center's programming has grown to include the "Challenge Series" of exhibitions and the International Turning Exchange, which brings American

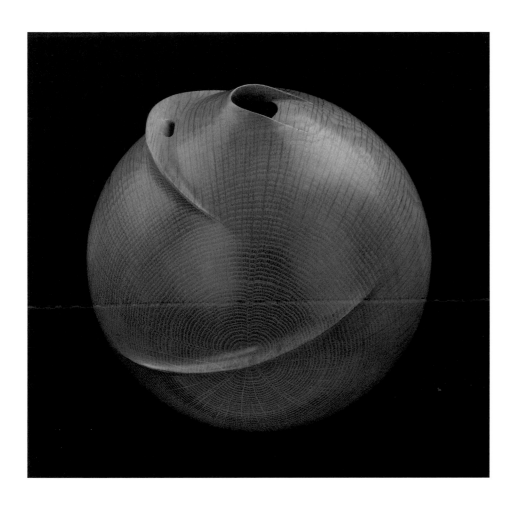

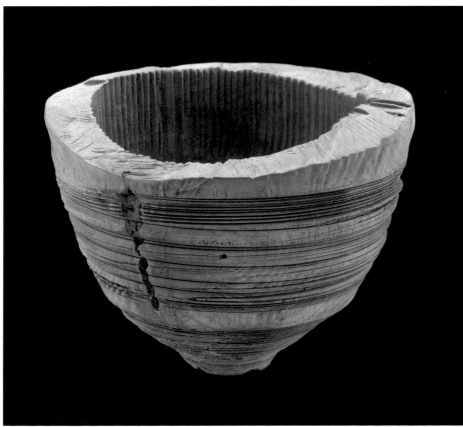

and international turners, furniture makers, sculptors, photojournalists, and scholars together for intensive, summer-long retreats. In collaboration with the Yale University Art Gallery, the Wood Turning Center also organized the landmark publication and touring exhibition *Wood Turning in North America Since 1930*, on view at the Renwick in 2002.

Wood turning's institutional trifecta was completed in 1997 with the founding of the Collectors of Wood Art. The emergence of the CWA reflected both the advances of a financial-support network following the lead of Edward Jacobson and Irving Lipton, as well as a recent (and still developing) sensitivity to the limitations of the word *turning* for a medium growing beyond the lathe.

That the Collectors of Wood Art should consider such a shift in terminology appropriate reveals the unprecedented pace at which the field has evolved from the understated turnings of Rude Osolnik, James Prestini, and Bob Stocksdale. While functional work remains a wood-turning mainstay, several advances during the 1970s pushed the medium into fresh territory. Chief among them were Ellsworth's development of blind turning—whereby a bent scraping tool is used to hollow out a vessel through a small opening—and Mark Lindquist's experiments with roughly hewn wood sculptures, often finished by chain saw. Each artist's vision encouraged others to branch out of functional work and experiment with form to purely aesthetic ends (figs. 15 and 16).

Paired with the shift away from function was a reexamination of the

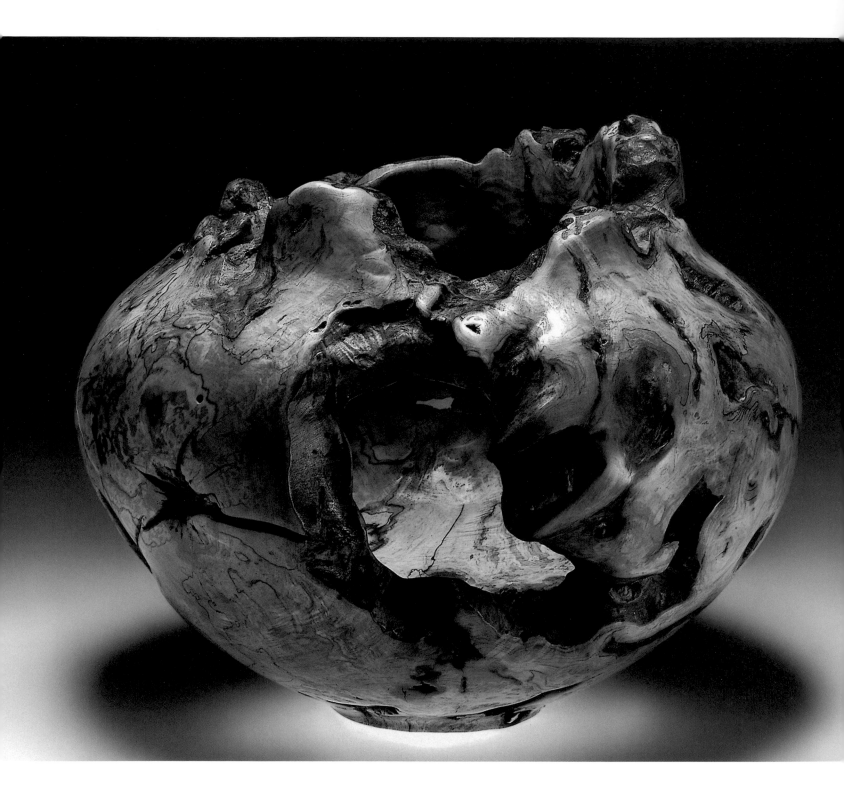

17 Melvin Lindquist, *Hopi Bowl*, 1989.
Spalted maple burl, 11 ⅝ x 14 in. diam.
Gift of Jane and Arthur K. Mason on the
occasion of the twenty-fifth anniversary of
the Renwick Gallery, 1996.98.6

18 Bruce Mitchell, *Canyon Oasis #4*,
1995. Redwood root burl, 6 3/8 x 13 3/4 x
16 1/8 in. Gift of Fleur and Charles Bresler,
2003.60.40

physical properties of wood. While color and grain had always played a role in the selection of wood for turning, stock previously considered inferior became popular. Since the 1960s, Melvin Lindquist had experimented with turning spalted (partially decomposed) wood, which typically exploded on the lathe. By employing carbide-tipped cutting tools capable of adjusting to the changing density of the infected stock, he would eventually succeed in creating vessels boldly marked by disease (fig. 17). At the same time, Dale Nish, a professor of industrial education at Brigham Young University, was turning wormy domestic wood rejected by others as scrap. He revolutionized classical forms and their perceived value by shaping them out of porous stock. Several turners also began to incorporate the natural edge of the wood into their work, partnering with nature in design (fig. 18). By the time the Jacobson collection of bowls opened at the Renwick in 1986, the Bauhaus-inspired forms the Museum of Modern Art admired had evolved into a wholly different animal—expressive, organic, sometimes unpredictable in form, and often detached from wood turning and craft's historical raison d'être: use.

The shift toward a more sculptural body of work inevitably brought into question the limitations of a machine designed to make symmetrical objects. The late 1980s and particularly the 1990s were marked by an examination of

21 William and Marianne Hunter, *Evening Blossom,* 1989. Ebony, 24k gold, sterling silver, enamel, amethyst, and chariote, 4 x 3 ½ x 2⅞ in. with base. Gift of Fleur and Charles Bresler, 2003.60.26A–C

The repercussions of this oversight have not yet dissipated. Ellsworth is quick to point out that wood art is still in its "early adolescence," all the more so for the continued lack of formal educational programs in the field. Without grounding in the histories of art, craft, material culture, or the movement itself, technical prowess is apt to run unchecked by more considered reflection on the nature of aesthetics and functionality. There is hope. The appeal of the lathe has created a nation of like-minded enthusiasts who will take every advantage of new opportunities to understand the medium. This exhibition is such an opportunity: by placing their collection in the public sphere, Fleur and Charles Bresler have opened the door to new perspectives on an ancient craft.

Notes

1 Glenn Adamson, "Circular Logic: Wood Turning 1976 to the Present," in Edward S. Cooke Jr. et al., *Wood Turning in North America Since 1930* (New Haven, Conn.: Yale University Art Gallery / Wood Turning Center, 2001), 116.

2 Fleur Bresler in conversation with Kenneth R. Trapp, Rockville, Maryland, 23 April 2009.

3 Ibid.

4 For an overview of early wood turning, see Robin Wood, *The Wooden Bowl* (Ammanford, Carmarthenshire, UK: Stobart Davis, 2005); for early lathe technology, see Robert S. Woodbury, *History of the Lathe to 1850: A Study in the Growth of a Technical Implement of an Industrial Economy* (Cleveland: Society for the History of Technology, 1961).

5 For further information on a surviving example of an American great-wheel lathe, see Charles F. Hummel, *With Hammer in Hand: The Dominy Craftsmen of East Hampton, New York* (Charlottesville, Va.: University of Virginia Press, 1968), 90–93.

6 Ibid., 245, 345. Extensive business records exist for the Dominy shop (active from about 1760 to 1840), but do not record vessels like the one illustrated in figure 8, suggesting the bowl may have been used by the family. In the *Genealogical History of the Dominy's Family* (1956), Newton J. Dominy writes, "We saw a big wooden bowl, shapped [sic] from a knot of an apple tree on the Dominy place; long ago somebody told one Felix Dominy that he couldn't carve one out in one piece like that; so he did it!"

7 For an overview of wood turning in manual training schools and the development of the movement in the early twentieth century, see Edward S. Cooke Jr., "From Manual Training to Freewheeling Craft: The Transformation of Wood Turning, 1900–76," in Cooke, *Wood Turning in North America,* 12–63.

8 James Prestini and Edgar Kaufmann Jr., *Prestini's Art in Wood* (New York, N.Y.: Pocahontas Press, 1950), n.p.

9 Cooke, *Wood Turning in North America,* 24–33.

10 Jane Kessler and Dick Burrows, *Rude Osolnik: A Life Turning Wood* (Louisville, Ky.: Crescent Hill Books, 1997), 43.

11 Lee Nordness, *Objects: USA—Works by Artist-Craftsmen in Ceramic, Enamel, Glass, Metal, Plastic, Mosaic, Wood, and Fiber* (New York: Viking Press, 1970), 255, 261, 264.

12 David Ellsworth in conversation with the author, Albuquerque, 26 June 2009.

13 Mark Lindquist in correspondence with the author, 4 December 2009.

14 Robert Hobbs, *Mark Lindquist: Revolutions in Wood* (Richmond, Va.: Hand Workshop Art Center / University of Washington Press, Seattle, 1995), 11.

15 Adamson, "Circular Logic," 64.

16 David Ellsworth, "The President's Message," *American Woodturner,* June 1986.

17 Michael Hosaluk in conversation with the author, Albuquerque, 27 June 2009.

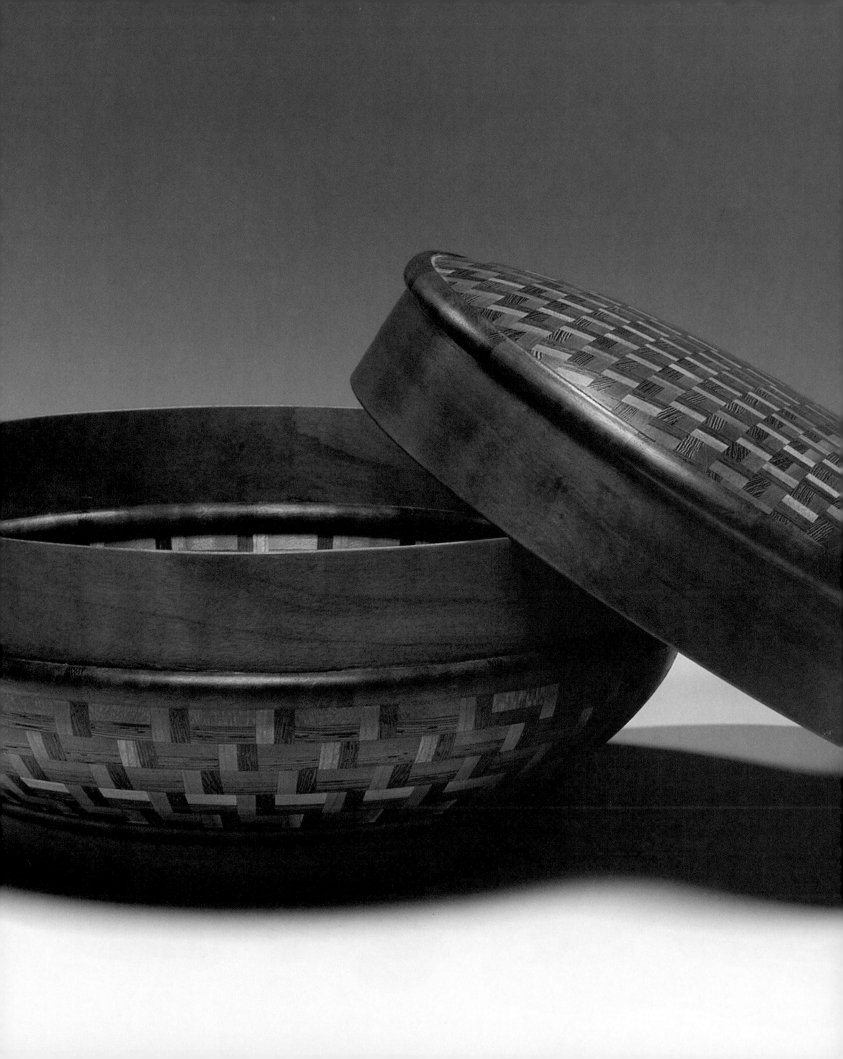

A Conversation with Fleur Bresler

Kenneth R. Trapp

KRT: We are here talking today because of the sixty-six pieces of turned and carved wood that you and Charles donated to the Smithsonian American Art Museum that will be shown in 2010 at the Renwick Gallery. Why did you choose to donate these pieces to American Art?

Fleur Bresler: Our decision to give the Renwick a sizable number of our turned-wood pieces did not come out of the blue. As you know, the decision took us several years to come to terms with. But there were several reasons for our decision. I was born in Washington, D.C., so the District is my birthplace and my first home. I have always worked to support my local communities and museums. And I wanted to help the Renwick because it was there that I had my first memorable encounter with turned wood when I saw the Edward Jacobson collection of turned-wood bowls in 1986. The Jacobson collection was such a revelation. Here were turned-wood bowls shown in an art museum—and that meant they were art. From that unexpected visit, I was smitten with turned wood.

KRT: In selecting the pieces that you and Charles donated to the Smithsonian, you never once tried to influence my decisions. And we never discussed an exhibition or publication based on the collection or other perks that collectors sometimes demand. Is there a reason for such generosity?

FB: By the time we were at the discussion stage for the pieces to go to the Renwick, I had been involved with museums enough to understand a little of how they worked. I had heard enough horror stories, so I made up my mind I wouldn't be one of the horror stories. I heard the stories of people who had dictated to museums that you either take this or you take that, or you won't take anything at all. In raising six children, I learned to compromise.

KRT: You are known in art circles as a collector and advocate of turned wood. What were the circumstances that led you to focus mostly on wood in your collections?

FB: I went from being a museum visitor to a collector after I saw turned-wood bowls at the Renwick. Then in 1986, I visited one of my daughters in Atlanta and saw turned wood exhibited at the Atlanta Arts Festival, where I bought a piece by Bill Hildebrand. I still have the piece, but I have no idea what happened to the artist.

KRT: Was there a time when you knew you had become a serious and committed collector of turned wood?

FB: I never really thought of myself as a collector until others began to tell me I was one. I became a collector slowly and anonymously over more than a decade. My sense that I was a collector-in-the-making came when I was introduced to the Wood Turning Center in 1991 by Lucy Scardino and Peter Lamb. I was at the center for the *Challenge IV* exhibition and while there heard a lecture by Irv Lipton. He said that if you found a turner whose pieces you liked, you should buy at least two pieces, and they should be very different pieces. And that you should follow the artist's career, even if he made something or went through a phase you didn't like, so that you would have a record of his evolution in wood turning. And I took Irv's advice and found a few turners whom I liked and bought at least two pieces from each of them. And that was the beginning of the collection and me as a collector. I wasn't recognized as a serious collector until about 1998. Until then, I was pretty much off the radar.

KRT: Would you say that you have an identifiable "Fleur Bresler" aesthetic?

FB: The nearest I can say is that I am eclectic and quirky in my collecting.

KRT: Please explain further what you mean by quirky.

FB: To me, quirky means buying what I like and not what's in fashion, and that means that sometimes I bring an artist into the collection whose work is considered secondary by some people. I never want to become so rigid in my taste that I can be easily pigeonholed by artists and other collectors. I love the "aha" moment when I see a work of art that calls to me, the moment when my "heart flutters" (a phrase coined by Atlanta gallery owner Martha Connell).

KRT: Tell me more about this heart flutter.

FB: I don't how to explain it any other way—but collecting is an addiction. I use the word "addiction" purposely because I get a high when I find that right piece. My heart flutters. And to me that is clearly a description of an addiction. I would describe being a collector as having an incurable disease. My own opinion is that collectors are born. This need to acquire [works of art], I think, is innate.

KRT: Do you have favorite artists?

FB: I would be lying to say no. The best way to answer that question is to look around the apartment and count the number of pieces by some of the artists. Bill and Marianne Hunter, David Ellsworth, Michelle Holzapfel, Todd Hoyer, Norm Sartorius, and Mark Lindquist all come to mind. As much as I admire these artists, I am also committed to the work of artists who remain relatively unknown. I always begin with the art, and if the artist is someone I like, then so much the better.

KRT: While we are on the subject of collecting, what else do you collect?

FB: The real focus of my collecting is turned wood. But in addition I have a few pieces of turned ivory, jewelry, art quilts, Native American fetishes, miniature pottery and silver boxes, contemporary *netsuke* carvings, and contemporary metal and fiber vessels. In 2000 I gave thirty-eight historic quilts to the Mint Museum [of Craft + Design] in Charlotte [North Carolina], where my maternal grandmother was born. So there was the family connection to that city. I have quilted, embroidered, and done crewelwork since I was young. I grew up with lovely things. My mother was very much a Victorian lady. She monogrammed textiles and rolled napkins—things a well-brought-up lady would do. Besides volunteering as a docent at the Renwick, I volunteer in the Domestic Life Division of the National Museum of American History. So there is another connection to textiles.

KRT: I notice that many of your pieces, no matter the medium, are small, even miniatures. Any reason for this?

FB: Well, look around. The apartment is huge. But where would I put large sculptures? Maybe a few could go on the rooftop, but that would mean we could have only a few pieces. I am not a "few pieces" collector. The real reason I have many small things is because I love small things, beautiful little objects that can be picked up and handled and looked at closely. I like the intimacy of these objects, and I love that such small things demand great skill. I love intricate work because it is so much more demanding than a lot of large work. You can't be sloppy with small-scale works. In my own needlework, I have to be attentive to details.

KRT: I would like to go back to your community service as a docent. Why are you a Renwick docent, and what's important about this experience?

FB: I am a docent because I am of an age when it's a struggle to keep my mind active and to keep it absorbing new knowledge. And I'm very selfish in being a docent in that it's my gift to myself. I get more out of being a docent than I give.

KRT: Do you think collecting and being a docent work together?

FB: Absolutely. The two activities work together because I am involved in craft groups that are strong advocates of collecting, such as the Collectors of Wood Art, the JRA [James Renwick Alliance], the Wood Turning Center, and the American Craft Council. I constantly meet new artists, museum curators, and fellow collectors, and I pick up information that helps me become a more informed docent.

KRT: Do you and Charles collect as a couple?

FB: Charles and I are absolutely not that kind of collector. Charles has vetoed only one piece that ever came into this house. I didn't like it anyhow and sent it back. Ours is not a dual collection at all. It's my collection.

KRT: I notice that your collection is well displayed, much like a fine museum exhibition. Is this your goal?

FB: To do justice to the works of art, substantial money has been spent on lighting, display shelves and cabinets, pedestals, and design. All of this was done for reasons other than my own ego. By showing the collection, especially to museum groups such as the Los Angeles County Museum of Art, the Oakland Museum, and the Museum of Arts and Design, I hope to encourage as many people as I can to pay attention to turned wood. My collection is always open to people. Artists stay with us all the time. I like to help them save money because they have chosen to be artists and not business people.

KRT: Are you also committed to documenting your collection?

FB: Yes. Absolutely. I am on a mission to convince artists to sign and date their pieces. And to keep careful records, maybe even a diary. They should also photograph their work, even if it isn't professional. Anything to help collectors and galleries and museums. I can't say enough about this subject. I know that being an artist is all-consuming, and artists never have time to do anything but make art. But only the artist can be the keeper of his [or her] life's work. Art is made in the present and soon becomes the past, and if artists are lucky, their art is retrieved in the future by a collector or a curator for others to enjoy. I firmly believe this. If I can convince one woodturner to keep careful records, then I have helped the field. But keeping records isn't enough if there are no libraries or universities or museums to take in these records and care for them and save them for others to study.

KRT: What do you hope the Bresler collection exhibition will achieve?

FB: I hope the exhibition will further validate turned wood as an art form. I want it to reveal to viewers the same experience I had with the Jacobson collection. I want turned wood to leave decorative arts and become art without all the qualifications we hear and read about when craft is the issue. I am so tired of seeing turned wood judged by Sunday turners when painting never faces the same silly measure of what is art and what is not. And if the exhibition does not tour, well, that would be a mistake.

KRT: I have two final questions. What are the challenges ahead for turned wood, and how do you hope to be remembered?

FB: How many days do I have to answer? The challenges? Well, where are the young woodturners and the young collectors? Look at any gathering of craft enthusiasts, and you begin to wonder what has happened to the young people. It's as though we're in some science-fiction movie where all young people have disappeared. We're not attracting young blood to the field, those young collectors and young makers who are the next generation.

As to your second question, I hope I will be remembered as someone who helped VisArts in Rockville [Maryland] thrive. My involvement with this visual arts center is a way to give back to the community. The center offers programs for toddlers, young people, adults, people with developmental disabilities, and senior citizens. It has an artist-in-residence program and a summer camp. VisArts is more than a way for me to give back to my community. It's a part of my Jewish upbringing and heritage. The faithful are to help those who are less fortunate. I believe this with all my heart, and I'm committed to helping others because Charles and I have been blessed in so many ways. We can't take our blessings with us, but we can leave some behind.

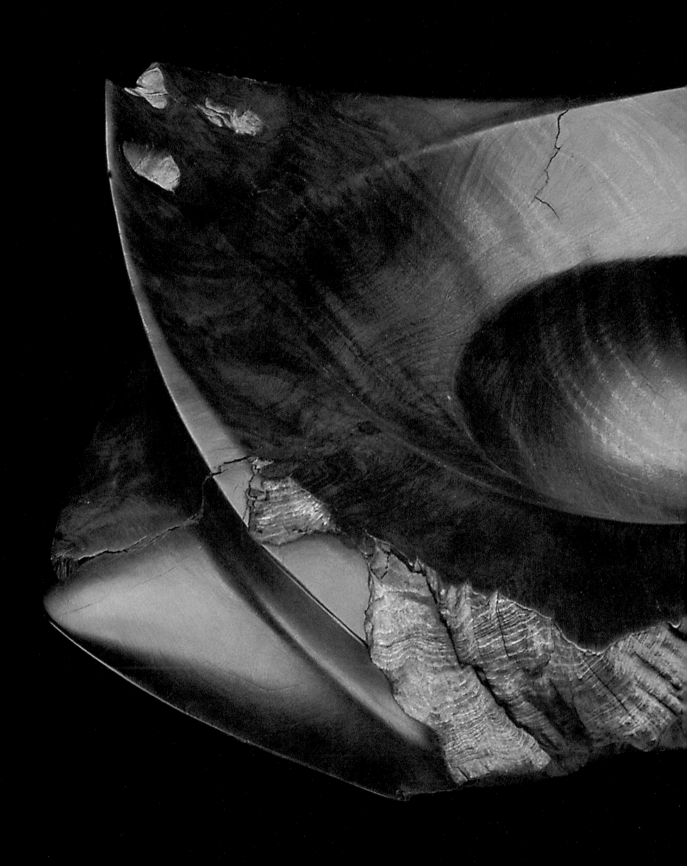

The Bresler Collection

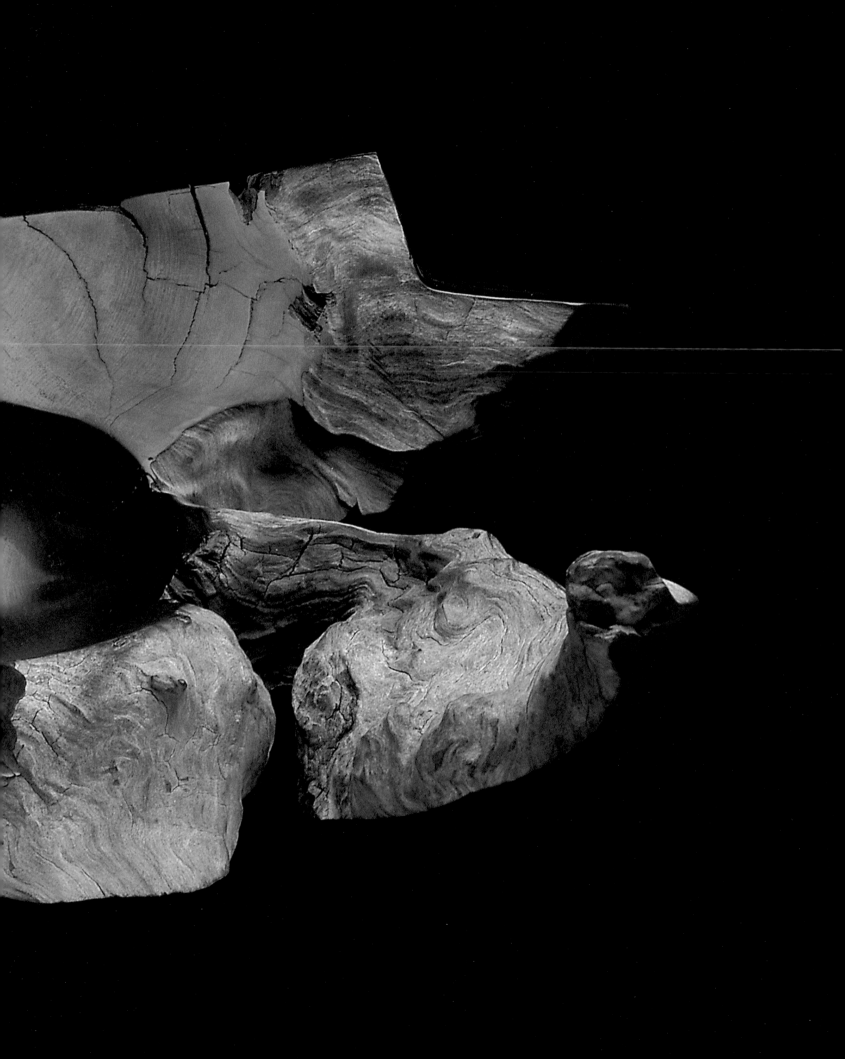

All works are gifts of Fleur and Charles Bresler
in honor of Kenneth R. Trapp, curator-in-charge
of the Renwick Gallery (1995–2003).

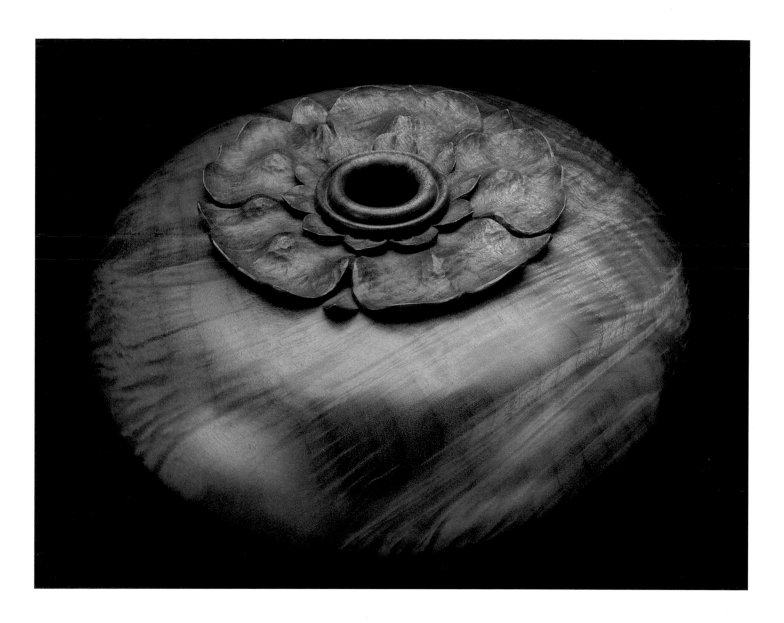

Brenda Behrens

Double Lotus
1995, myrtle
4 ¼ x 8 ¾ in. diam.

Brenda Behrens learned Kamakura-style wood carving from the master Japanese woodcarver Genji Ishihara, while her husband was stationed at the U.S. Navy Air Facility in Atsugi, Japan, in the 1960s. Simply defined, *Kamakura-bori* is low-relief carving covered with layers of lacquer. In this piece she has applied finely carved lotus flowers to the mouth and foot of a modest turned vessel, creating a contemplative object. Behrens prefers to work with myrtle, carob, or olive because the close grain allows for precision in carving.

Derek A. Bencomo

Hana Valley, First View,
from the "Peaks and Valleys Series"
1995–97, milo
8 ¾ x 15 ¾ x 15 ½ in.

Derek Bencomo moved from his native Los Angeles to Hawaii in 1984 to pursue a quieter lifestyle. He became interested in wood turning after being exposed to native woods and the history of island craftsmanship. This work is turned and carved from a century-old section of milo, a wood traditionally used for making vessels and canoes. Its flared edge evokes the rugged landscape of Maui, his home, as well as the curling waves he loves to surf.

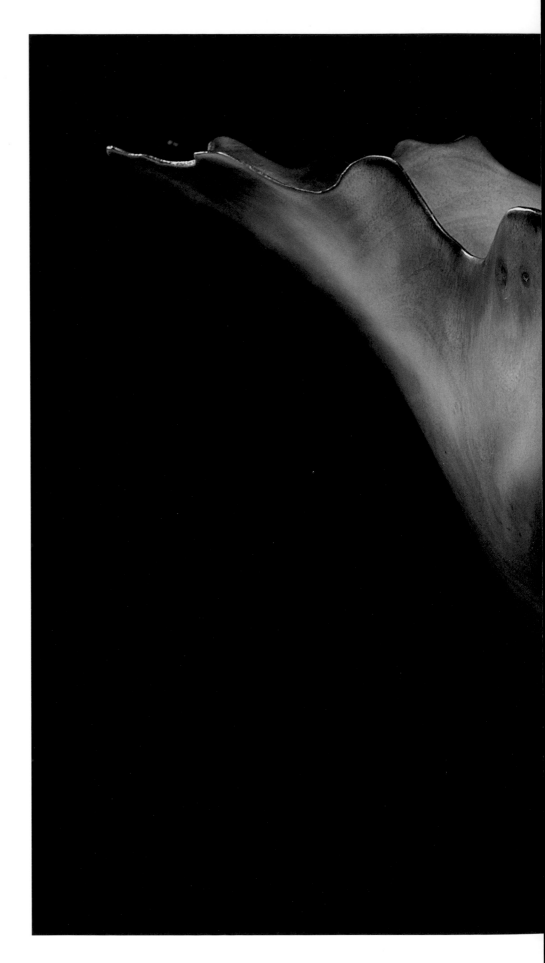

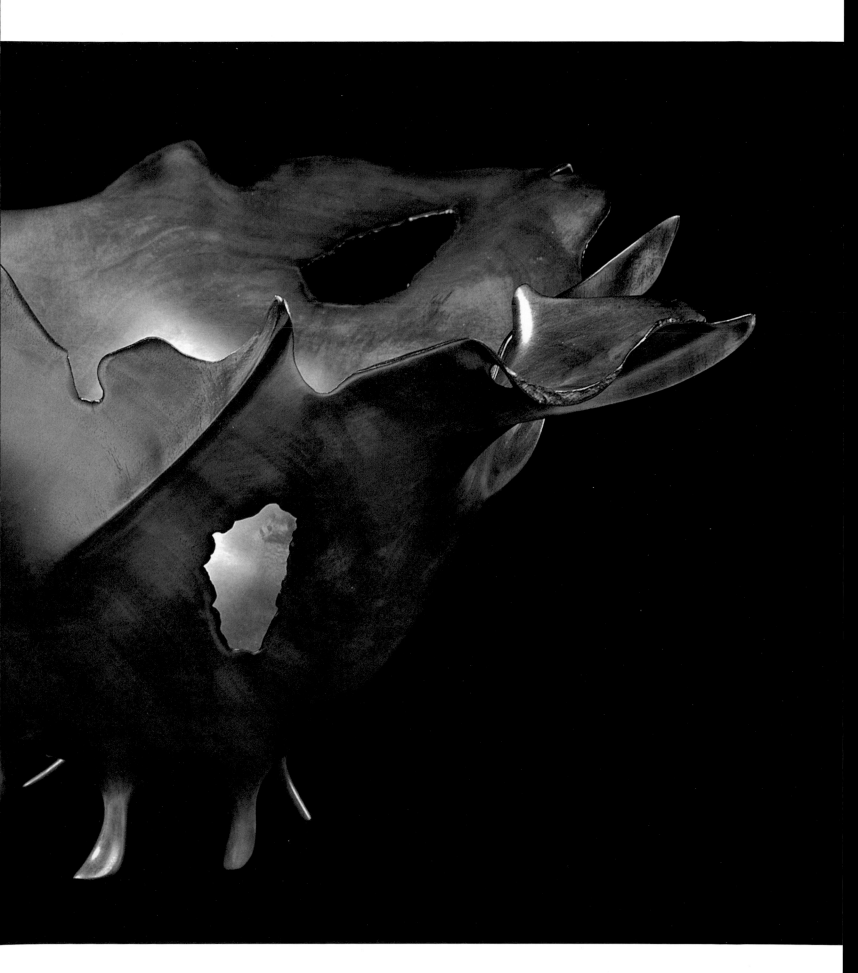

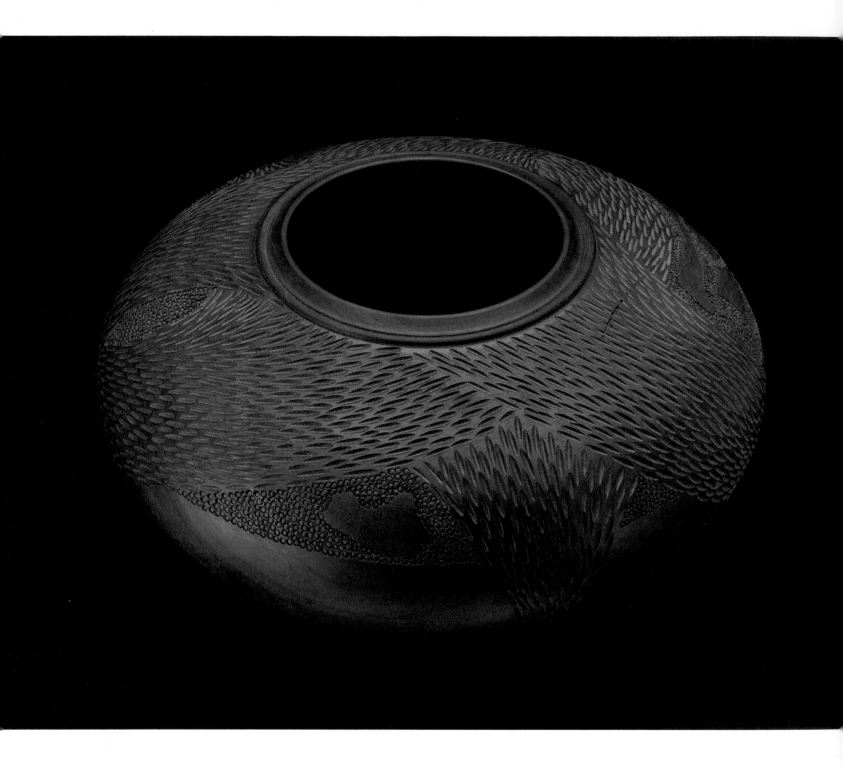

Oliver Hilliard Booth III

Bowl
1996, cherry
6 ¾ x 11 ⅛ x 11 ⅜ in.

Hilliard Booth worked in a cabinet shop before he began to turn wood in 1978. His restrained, simple forms find inspiration in the pottery of classical Greece and southwestern Native American cultures. The textured surface of this piece was created with a reciprocating carver, a small, hand-held power tool that gouges out wood quickly and easily.

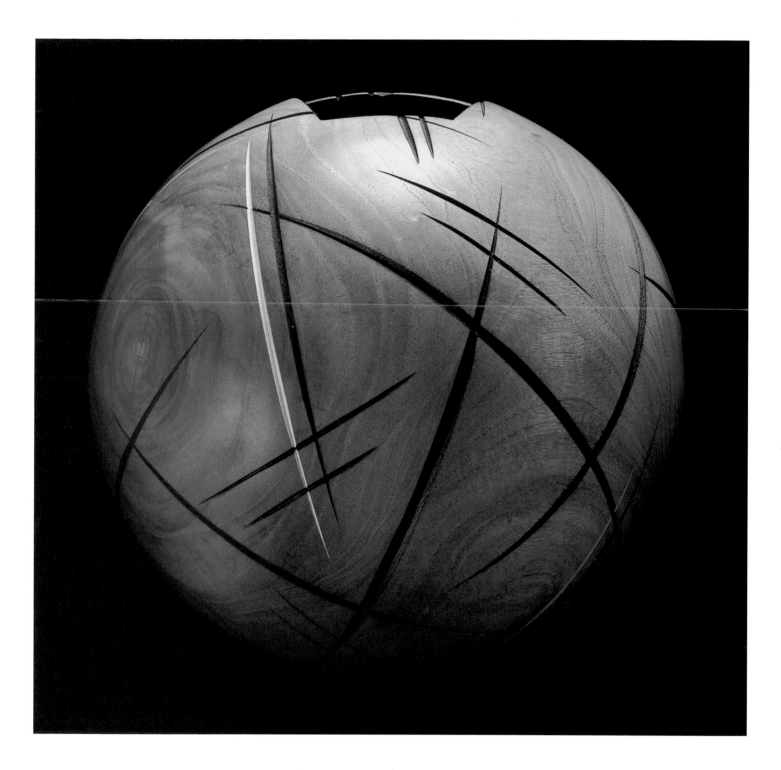

Christian Burchard

Dance, from the "Old Earth Series"
1997, primavera
7⅞ x 8 ¼ in. diam.

Christian Burchard's "Old Earth Series" is one of several by the artist to explore the sphere as sculptural form. One of the most perfect shapes in nature, the sphere is a challenge to turn on the lathe. This work is one of the most ambitious of the series and is the only one turned from primavera, a Hawaiian wood sometimes dubbed "white mahogany" for its light color and attractive figure. The dark irregular opening and carved and painted lines of red, blue, and black enliven what would otherwise be a static form.

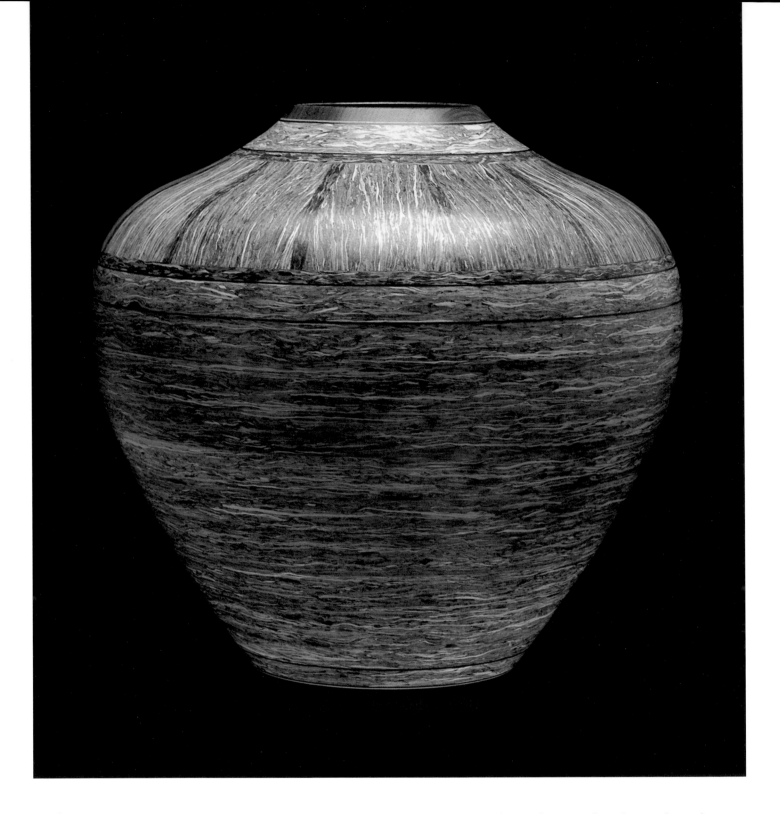

Galen Carpenter

96-4
1996, cristobal and chipboard
11 5/8 x 10 7/8 in. diam.

Galen Carpenter began turning vessels as a diversion from his work as a furniture maker and restorer. He has drawn attention by turning machine-engineered wood products, such as chipboard and oriented strand board, in a field that typically celebrates the natural beauty of wood. Carpenter not only brings a new dimension to the common practice of rescuing scrap wood, he also turns proverbial straw into gold. The hardwood accents and classical form exhibited here are typical of Carpenter's work.

M. Dale Chase

First Gold Box
about 1996, 14k gold
¾ x 1 ½ in. diam.

Ornamental turning is a subfield of contemporary wood art in which specialized lathes are employed to carve intricate geometric patterns at diminutive scale on the surface of wood and other materials. It is practiced by only a few hundred dedicated individuals, in part because the lathes and accompanying tools of choice were manufactured during the nineteenth century and are exceedingly rare.

A vascular surgeon by training, Dale Chase acquired a Holtzapffel lathe in 1974 and retired from medicine almost twenty years later to pursue ornamental turning full time. The title of this work marks the artist's long "sabbatical" from wood, when he turned gold, silver, steel, jade, and quartz boxes. Chase estimates that he made twenty practice pieces before executing the engraving, or *guilloché*, on this box.

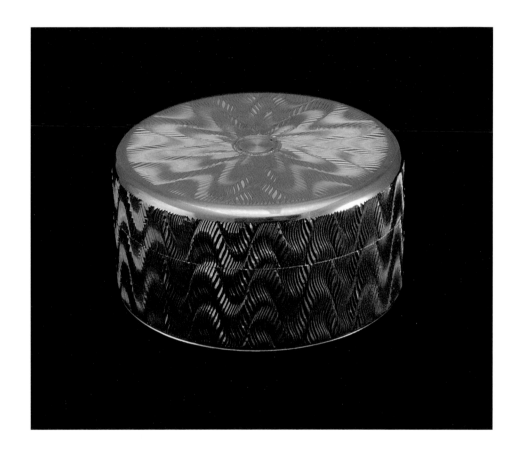

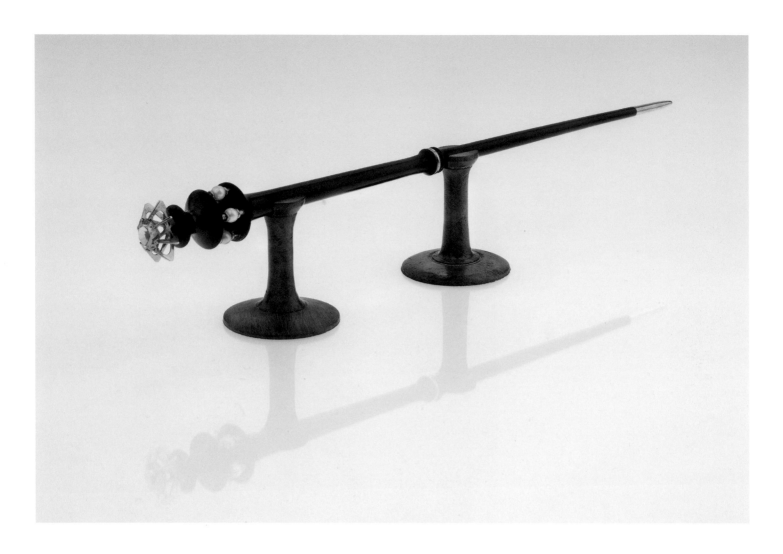

Frank E. Cummings III

Ode to Today
1993, ebony, 18k gold, pearls,
and imperial topaz
overall: 1 ³⁄₈ x 6 ³⁄₄ x 1 ¹⁄₈ in.;
wand: 6 ³⁄₄ x ¹⁄₂ in. diam.;
stands: 1 ¹⁄₈ x 1 ¹⁄₈ in. diam.

Frank Cummings's exquisitely carved and bejeweled objects have earned him the moniker "the Fabergé of wood art." The use of precious metals and stones by the longtime professor of art, design, and craft at California State University (Long Beach and Fullerton) made his work an early standout in the shift toward a less functional and more sculptural school of wood art. In *On the Edge Naturally*, Cummings has carved a self-portrait into the sapwood in a bold statement of identity. The "Ode Series" evolved from a class project in which the artist asked students to describe an event without using words. Cummings wore *Ode to Today* in his hair while attending a reception at the White House for artists included in the Renwick exhibition *The White House Collection of American Crafts*.

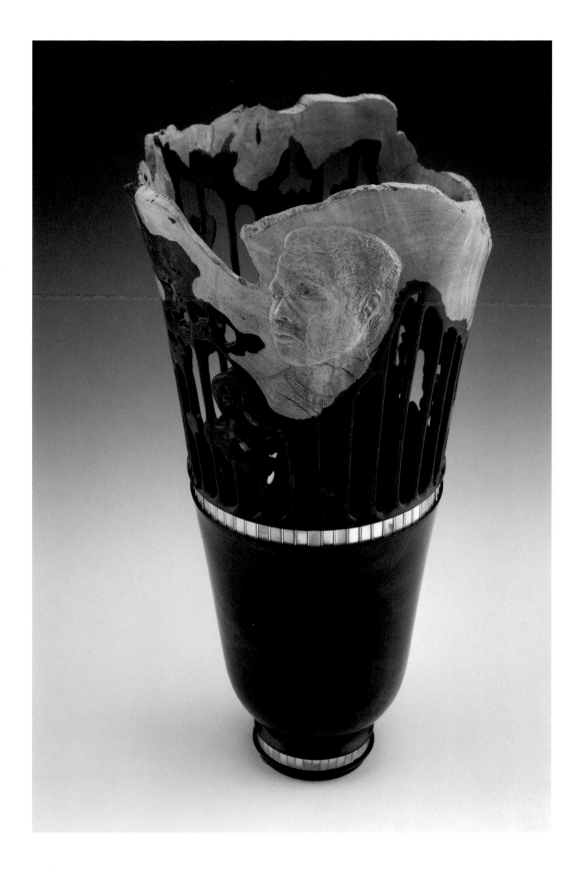

Frank E. Cummings III
On the Edge Naturally
1990, kingwood burl, 18k gold,
and mother-of-pearl
12 ¼ x 6 ⅛ x 7 ¼ in.

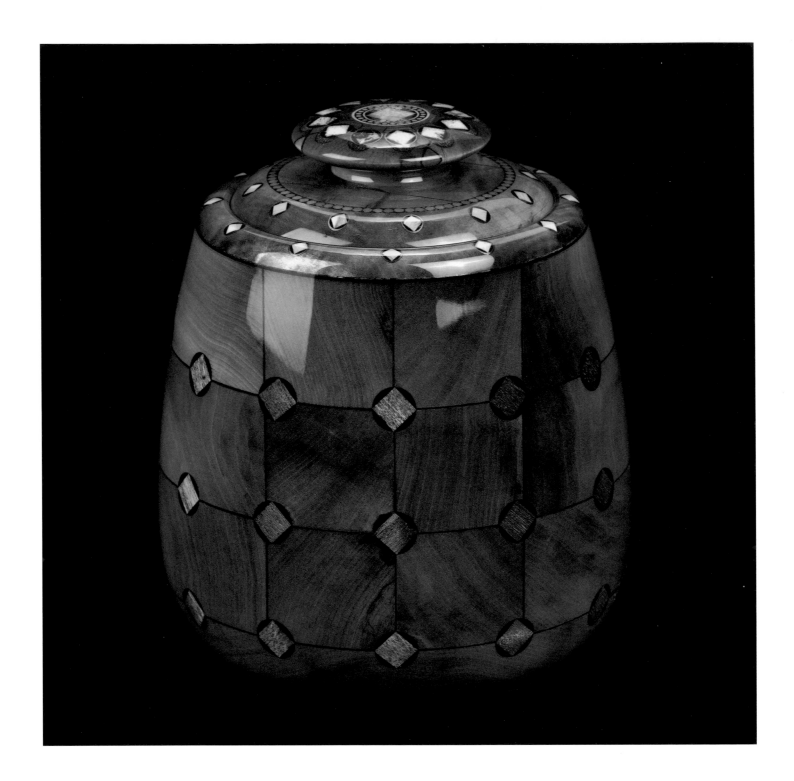

Robert Cutler

Lidded Jar
1996, Alaska diamond willow and willow
burl, mahogany, fossil mammoth tusk, fossil
walrus tusk, fossil bone, moose antler,
brass, copper, and sterling silver
6 ¾ x 5 ⅝ in. diam.

A self-taught wood artist, Robert Cutler explains, "I contribute my accomplishments to the fact that I was not restricted by the preconceived ideas, rules or knowledge of others. . . . I had the freedom to do what the 'experts' would have told me I couldn't do." He is intensely interested in materials from Alaska, where he has lived since before it became a state in 1959. *Lidded Jar* makes dramatic use of a wood occasionally found in the North—diamond willow—the branch of a willow tree that has acquired a diamond shape in response to fungal infection.

Gorst du Plessis

Decorative Top
1999, pink ivorywood
1 ¾ x 2 x 2 ⅛ in. diam.

Dr. Gorst du Plessis uses Holtzapffel and Armbruster rose-engine lathes in his ornamental turning. *Decorative Top* exemplifies how to turn an extremely durable hardwood, often resistant to hand-held tools. Pink ivorywood originates in southern Africa and is renowned for its rarity and color. It is extremely sensitive to ultraviolet exposure.

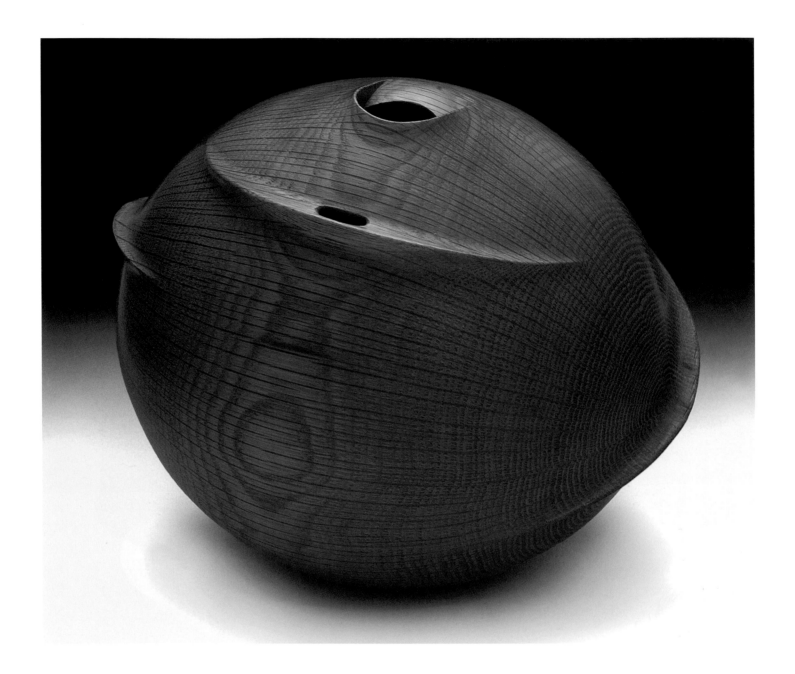

David Ellsworth

Mo's Delight
1993, white oak
3 1/8 x 8 3/4 x 7 1/4 in.

David Ellsworth's pioneering ability to "blind turn" thin-walled vessels through a narrow opening is demonstrated to extraordinary effect in *Mo's Delight* and *Sundown Pot*. He created the teapot as a tribute to Mo Seigel, cofounder of Celestial Seasonings tea company in Boulder, Colorado, where Ellsworth attended the University of Colorado. The artist turned it on four axes to create the spout and handles for left- and right-hand use and to hollow out the interior. The deceptively simple form of *Sundown Pot* masks the skill necessary to turn a vessel that accurately mirrors the void inside.

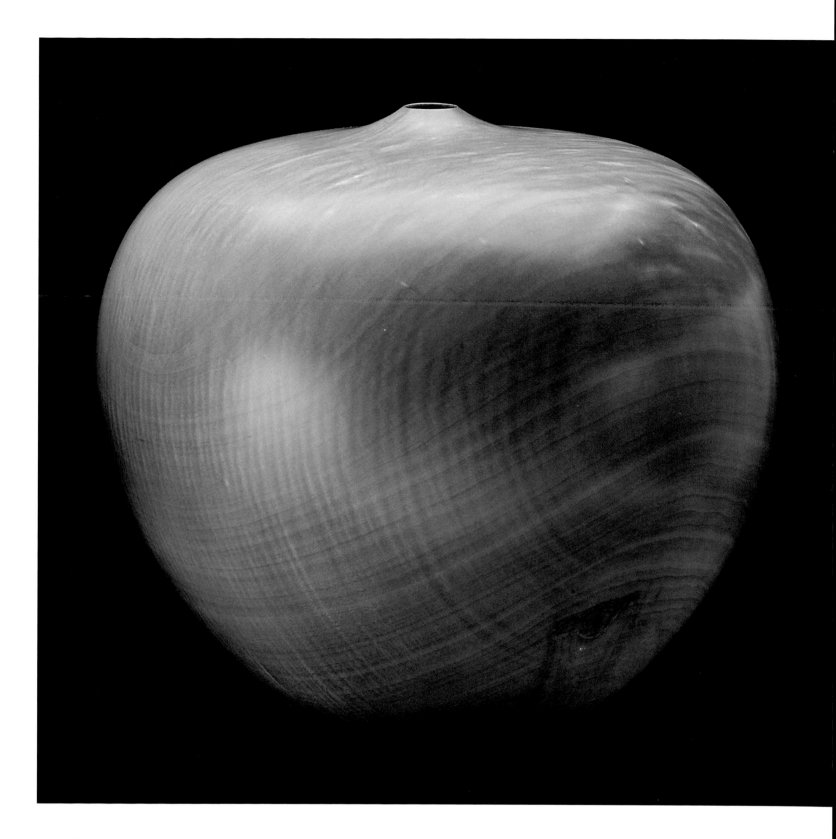

David Ellsworth
Sundown Pot
1995, curly silver maple
10 x 11 1/8 x 10 1/2 in.

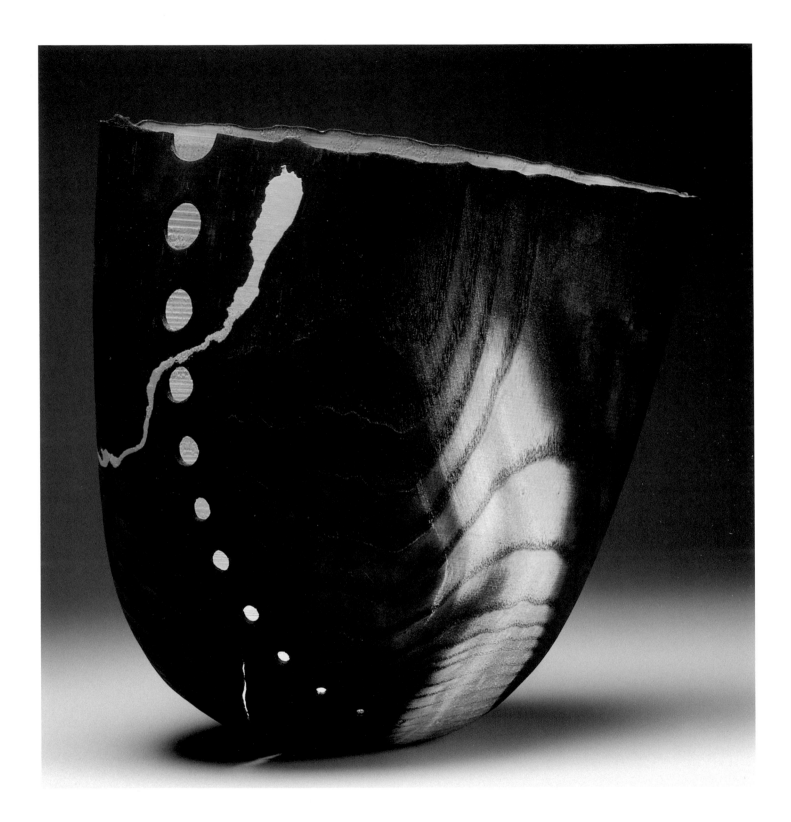

David Ellsworth
Patan, from the "Solstice Series"
1991, ash and metallic fabric paint
11 ½ x 10 ⅜ x 7 ⅞ in.

The "Solstice Series" was David Ellsworth's first foray into applying color to the surface of his work and has been referred to as his "Dylan-goes-electric" moment, because of the initial reactions it elicited (since softened) from the wood-turning community. The charred and painted exteriors evoke the tumultuous political climate at the inception of the series, while the string of holes dramatically reveals the interior of the piece, often inaccessible in Ellsworth's work.

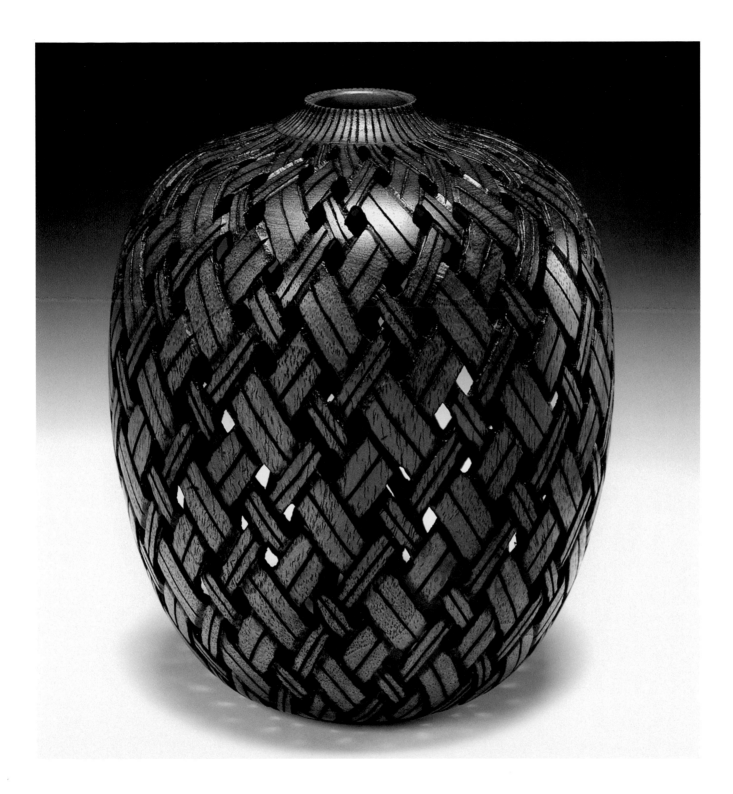

J. Paul Fennell

Mesquite Basket, from the "Lattice Series"
1998, mesquite
6 1/8 x 4 7/8 in. diam.

Paul Fennell began turning wood to relieve the stress of his job as a mission analyst for NASA's Apollo program. His early work reflected a common interest in what he refers to as the "natural beauty of wood"—the color, grain, and texture of found stock—an approach he believes has run its course. *Mesquite Basket* demonstrates Fennell's early attempts to forge his own style by piercing the vessel, a technique he has mastered over the last decade. The Chinese aesthetic of the "Lattice Series" was influenced by childhood visits to the Asian art collections of the Peabody Essex Museum in Salem, Massachusetts.

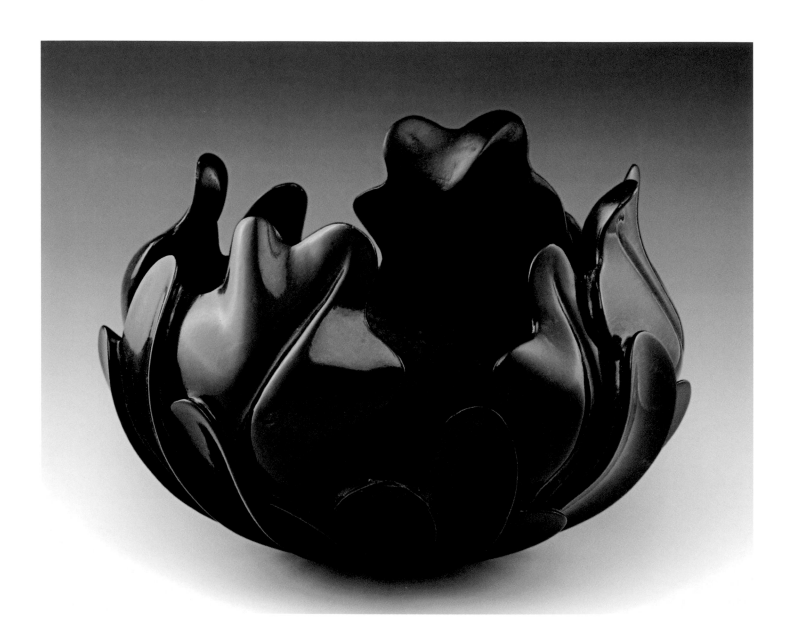

Ron Fleming

Black Lotus
1996, ebony
3 ¾ x 5 ⅝ x 5 ⅞ in. diam.

Perhaps more than any other wood artist working today, Ron Fleming demonstrates that carving can enhance the organic aesthetic so highly desired in wood turning. A graphic illustrator by training, he often sketches out a completed vessel, transfers the design to the surface of the wood, then carves along the figure, or grain, in deference to the wood's inherent design. Inspiration for his floral vessels came from his wife's garden. Patti Fleming was a frequent collaborator in the creation of his work. *Prairie Fire* commemorates a fire that the artist and several friends worked to put out on his Oklahoma farm.

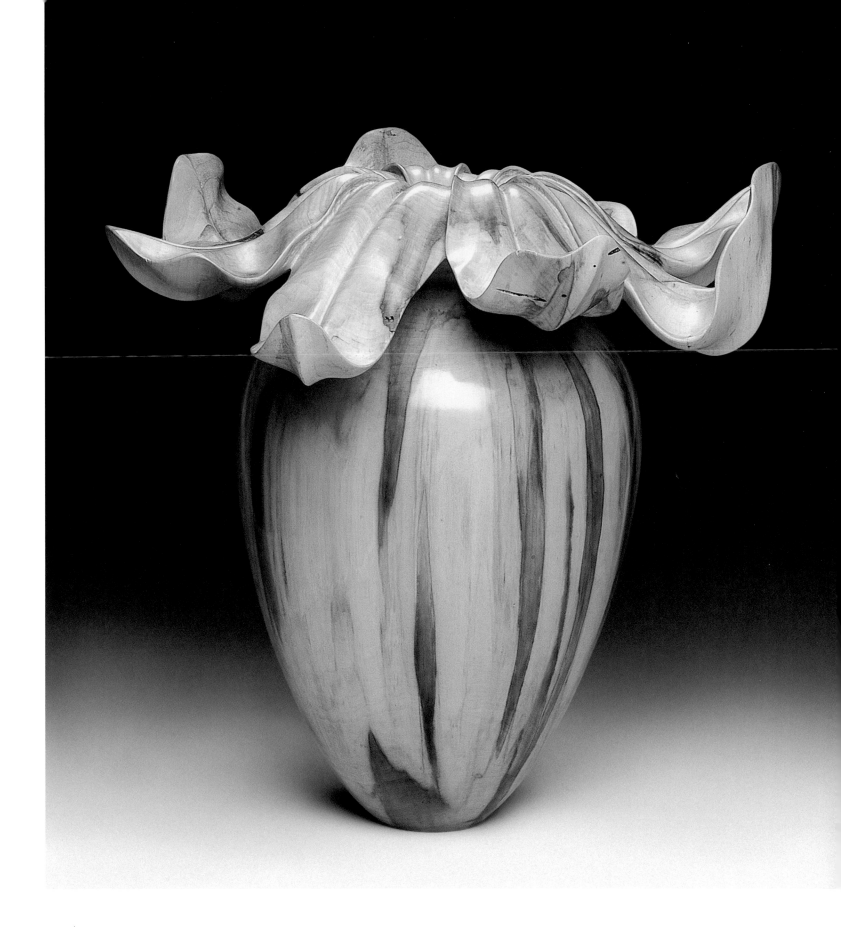

Ron Fleming
Red Fern
1995, box elder
15 ⅞ x 15 ⅝ x 15 ½ in. diam

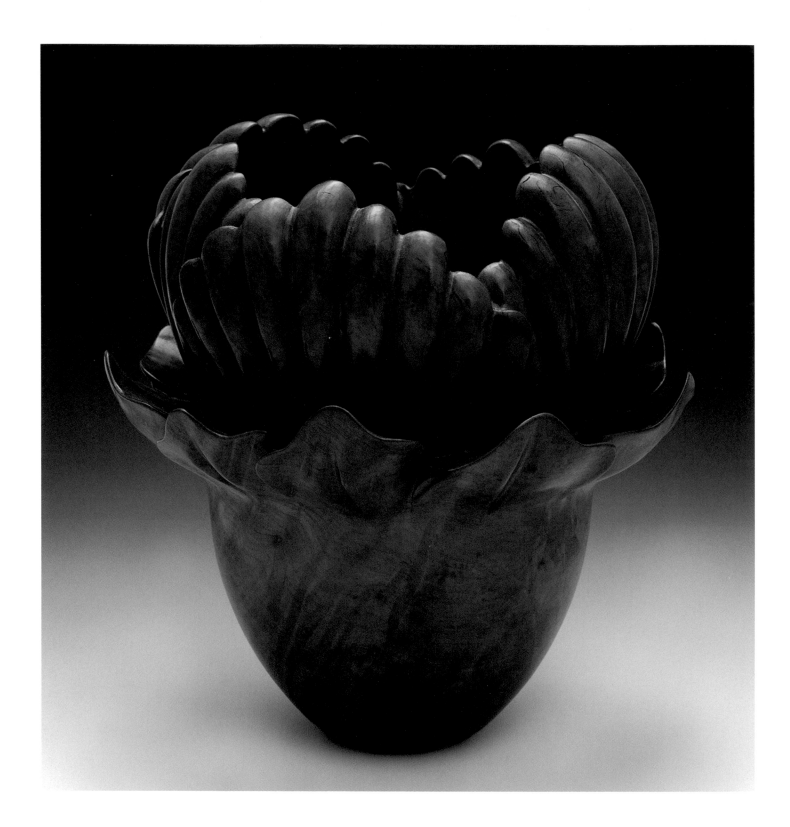

Ron Fleming
Desert Rose
1996, madrone burl
7 ⅛ x 6 ¾ x 6 ¾ in. diam.

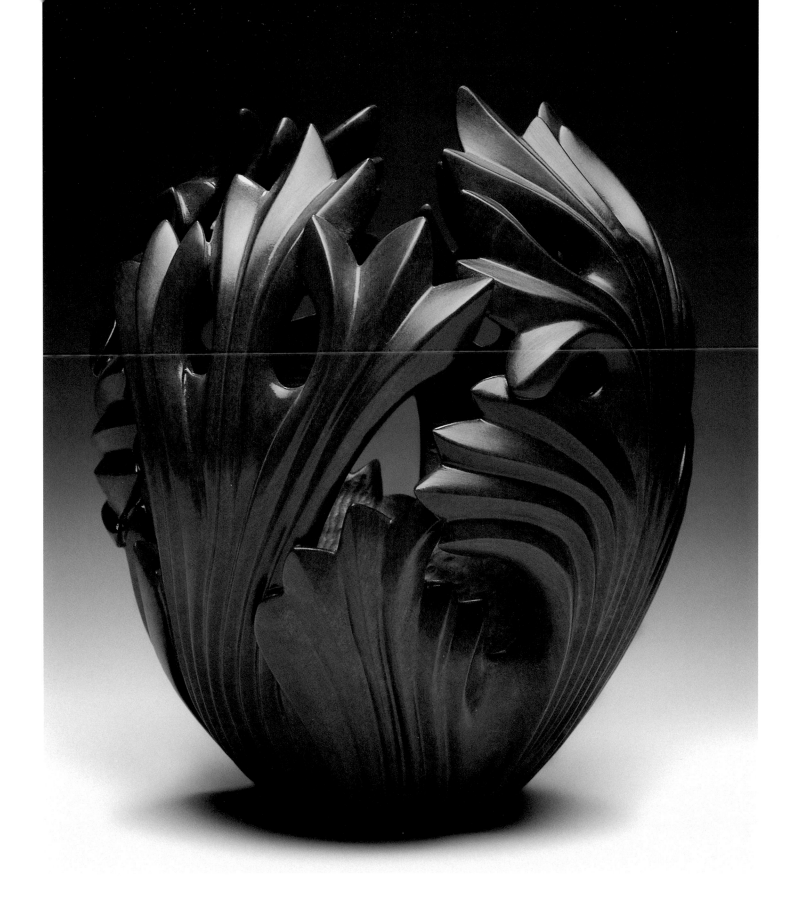

Ron Fleming
Prairie Fire
1996, pink ivorywood
8 ¼ x 6 ¾ in. diam.

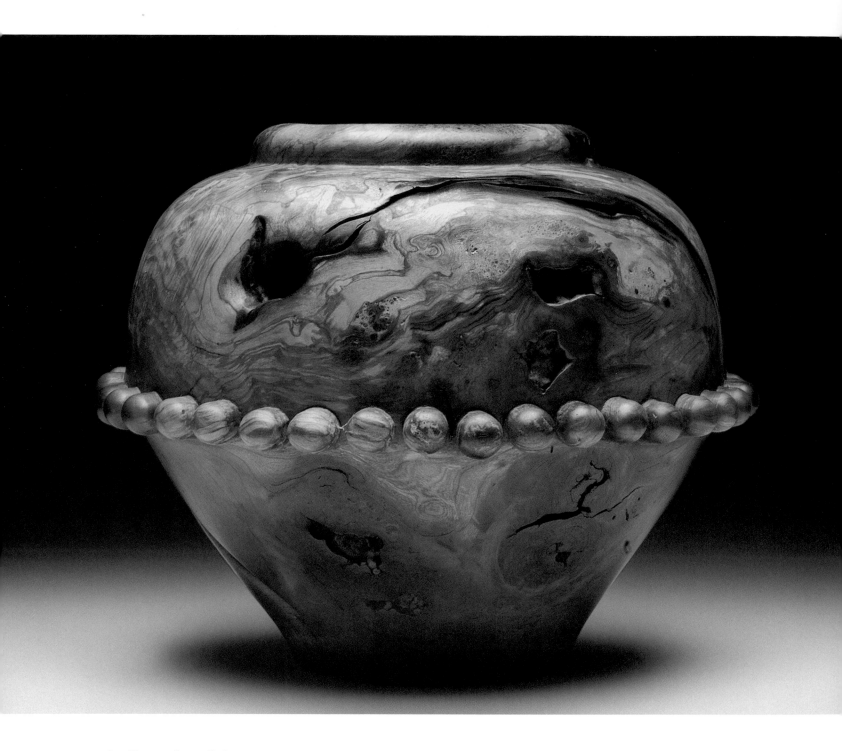

Michelle Holzapfel

Untitled
1986, cherry burl
11 ⅛ x 11 ½ x 3 ½ in.

Michelle Holzapfel has been a leader and innovator in postlathe carving for more than twenty years, as well as an articulate writer and speaker on wood art. Cherry and maple burls that loggers collect near her Vermont home constitute a primary source of material for her work. These pieces illustrate the shift in balance between turning and carving in different stages of Holzapfel's career. In the 1980s, carving complemented her turned objects before it became integral to the structure and form of her later work. *Suspended Ring Vase* demonstrates a maturation of style and comfort with an aesthetic distinct from that achievable on the lathe.

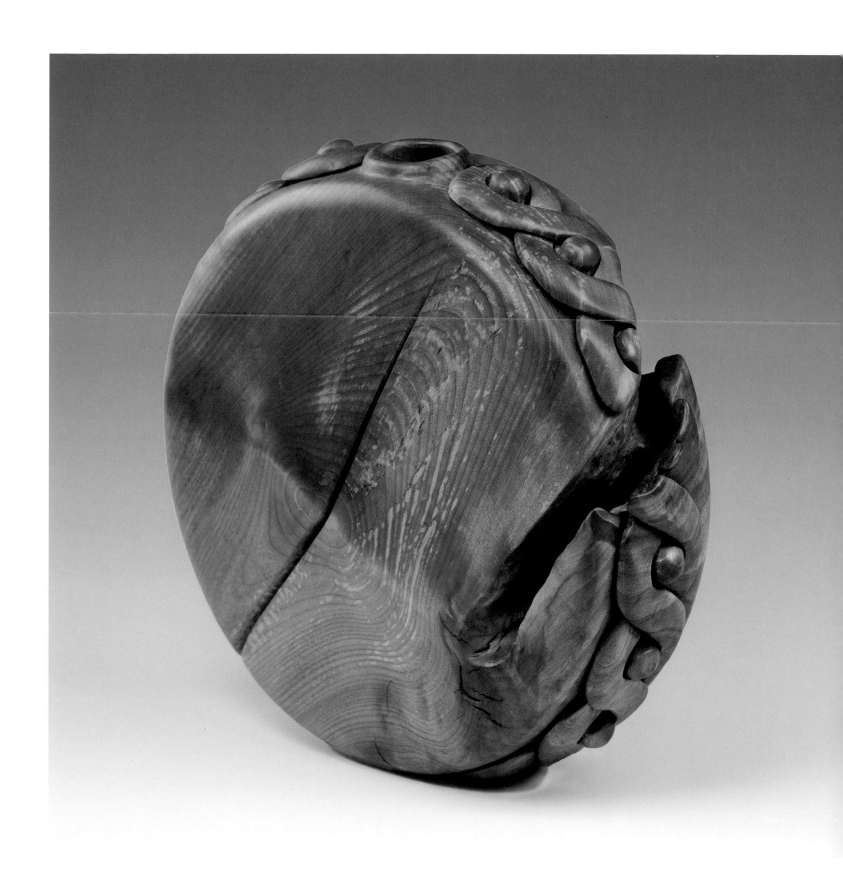

Michelle Holzapfel
Untitled
1986, maple burl
9 ⅝ x 11 ¾ in. diam.

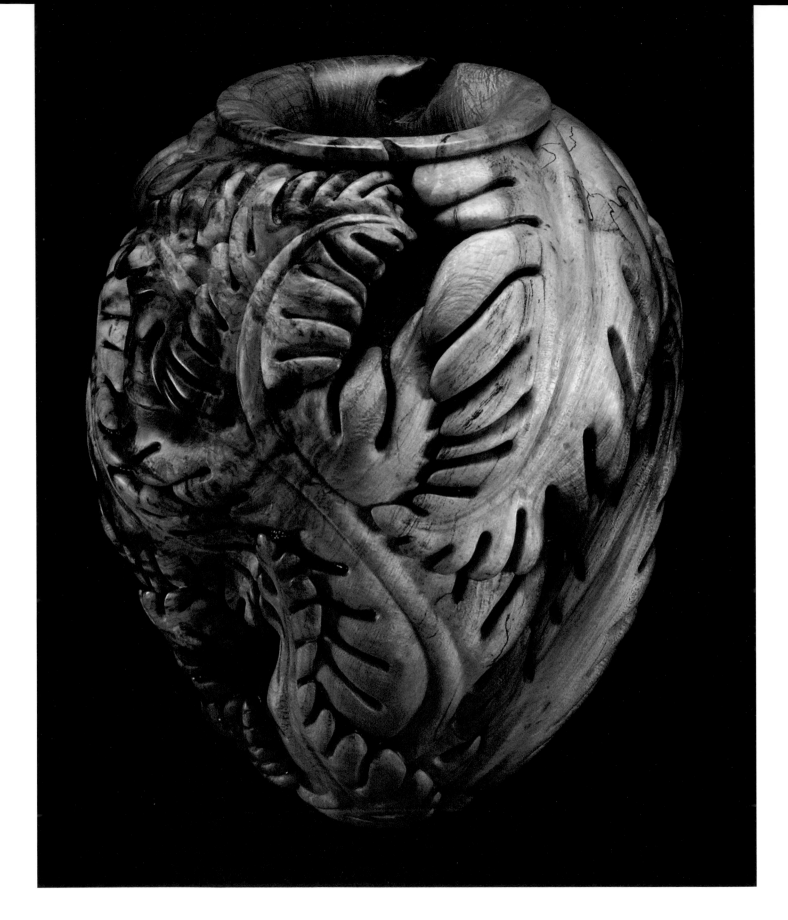

Michelle Holzapfel
Autumn Vase
1993, sugar maple burl
13 ¾ x 10 ⅝ x 10 ⅞ in. diam.

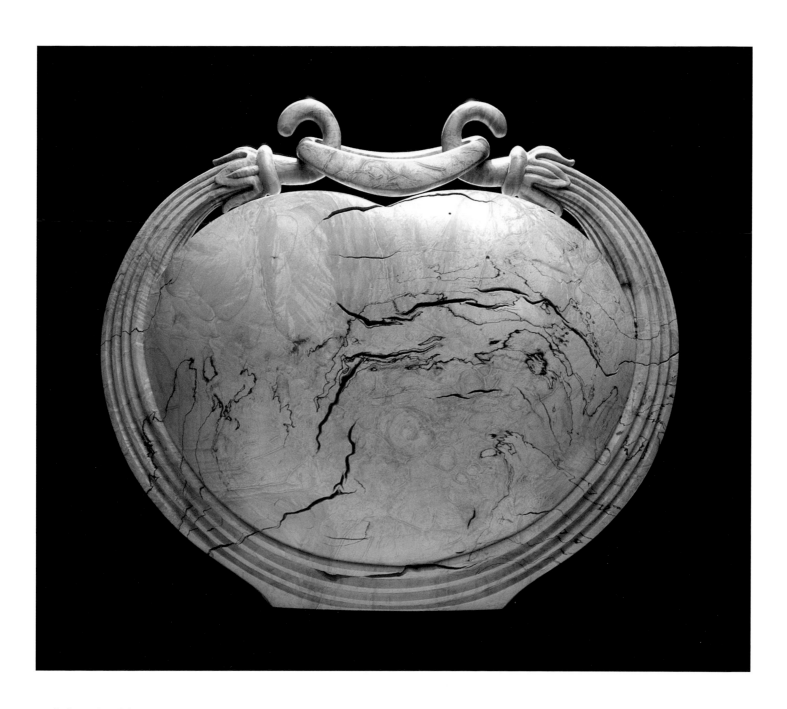

Michelle Holzapfel
Suspended Ring Vase
1996, spalted sugar maple burl
12 ⅝ x 14 ⅜ x 5 ¾ in.

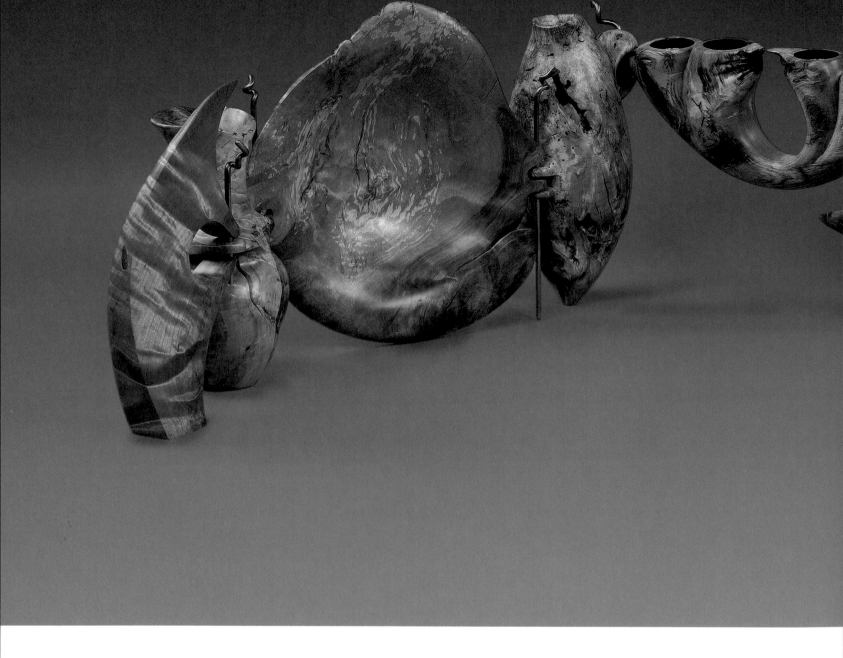

Michelle Holzapfel
Table Bracelet: Promenade Suite
1997, maple, birch, cherry, and brass
15 ⅜ x 87 ⅝ x 11 ⅝ in. (linear)

In 1997 Michelle Holzapfel conducted an "exercise in scale" by creating jewelry for the home rather than the body. Her wall-mounted, seven-by-eleven-foot *Spiral Necklace* was followed by *Table Bracelet*, a flexible centerpiece composed of three bowls, two candleholders, three vases, and two "clasps." Perhaps more than any other object in the Bresler collection, *Table Bracelet* reflects the rapid evolution of wood art away from the conservative forms favored by earlier turners. In spite of this, and its only tangential relationship to the lathe, the *Bracelet* remains highly functional.

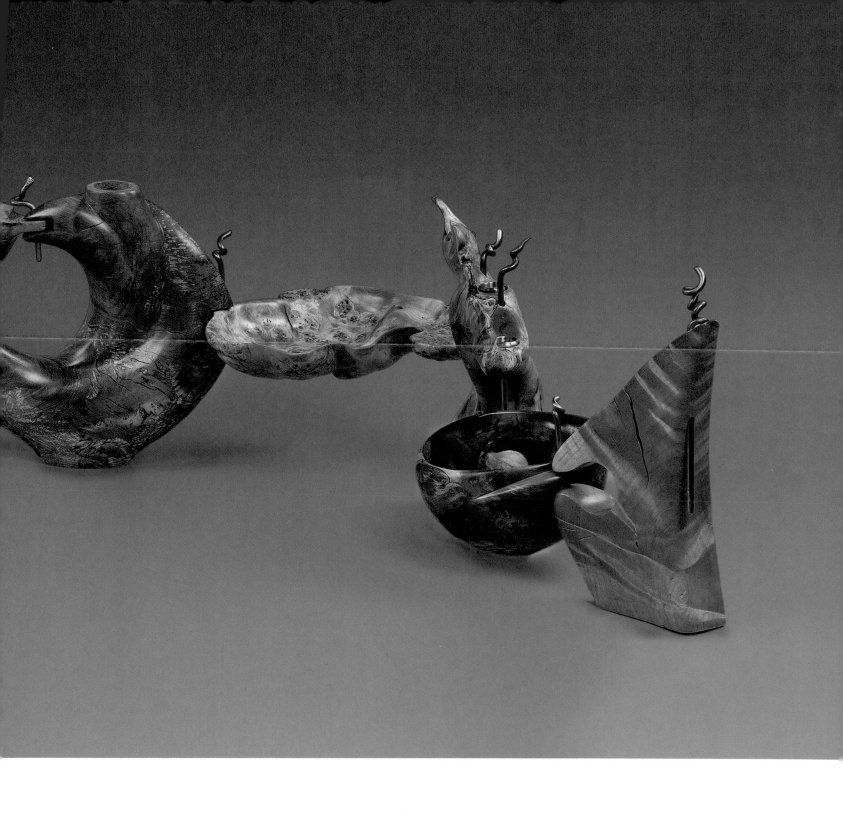

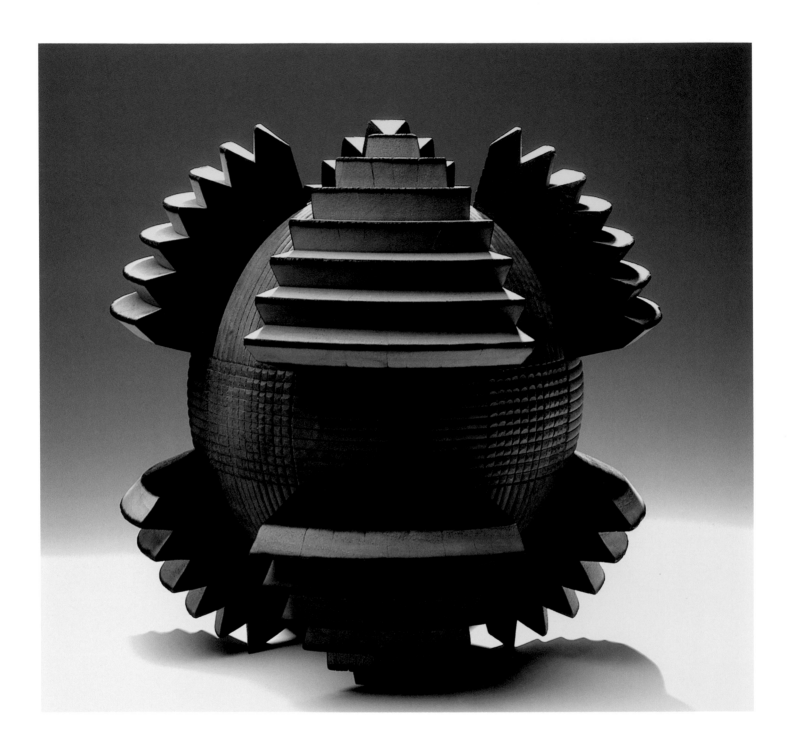

Todd Hoyer

Suspended Sphere
1994, sycamore
12 ¾ x 12 ½ in. diam.

Todd Hoyer's background in mechanical drafting and engineering is revealed in the scribed lines and burned rings that have become his trademark. *Sphere* in particular illustrates the woodturner's challenge of imposing geometric order on a quintessentially organic material. *Suspended Sphere,* its armored counterpart, and the "Ringed Series" developed as emotional responses to a series of disruptions in Hoyer's life that forced a hiatus from the craft. When he returned to the shop, he "no longer wanted to show the pretty side of wood." He began charring pieces and leaving them outside to weather and crack under the Arizona sun, relinquishing the final stage of design to nature. He binds his recent work in wire before placing it outdoors, which forces the wood to struggle to achieve its final form.

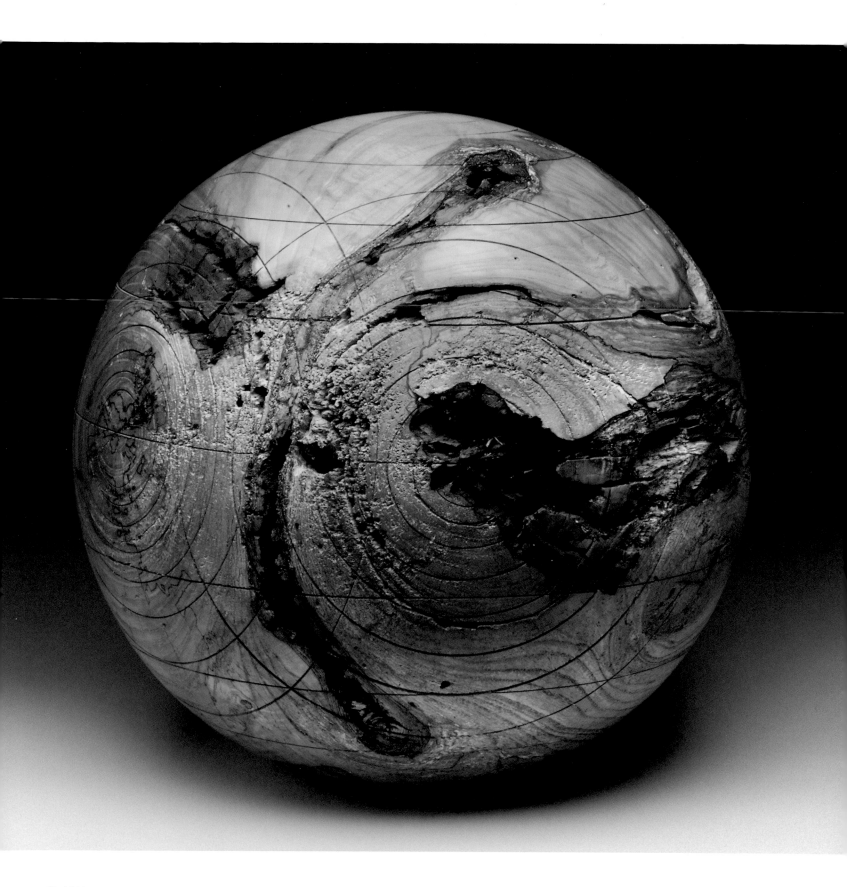

Todd Hoyer
Sphere
1988, Arizona ash
15 ¼ x 15 ¾ in. diam.

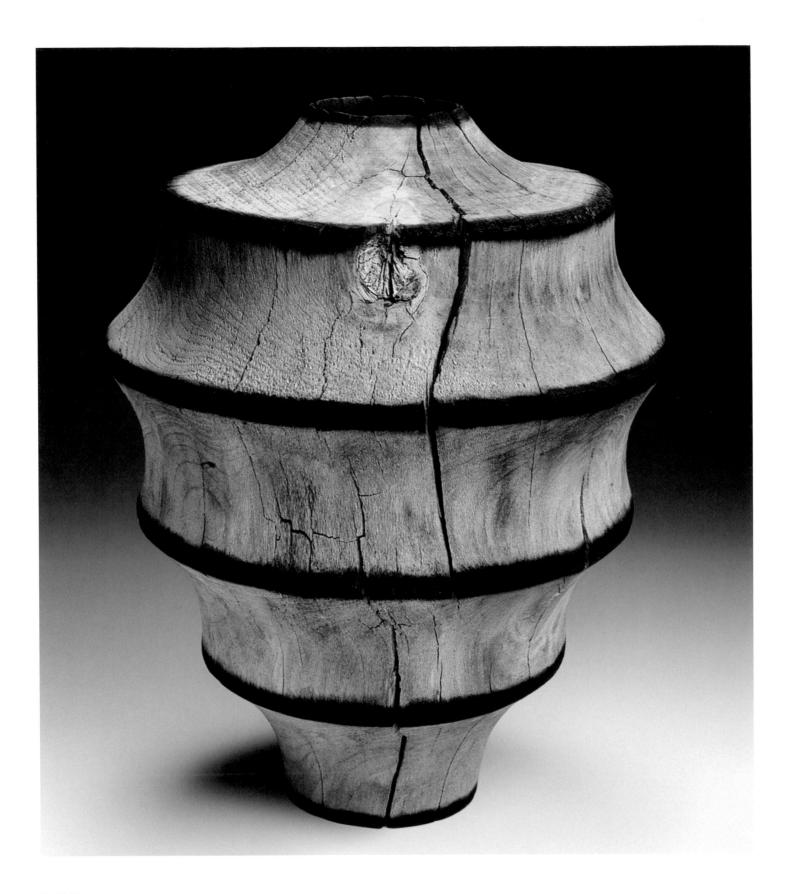

Todd Hoyer
"Ringed Series"
1993, sycamore
11 ½ x 9 in. diam.

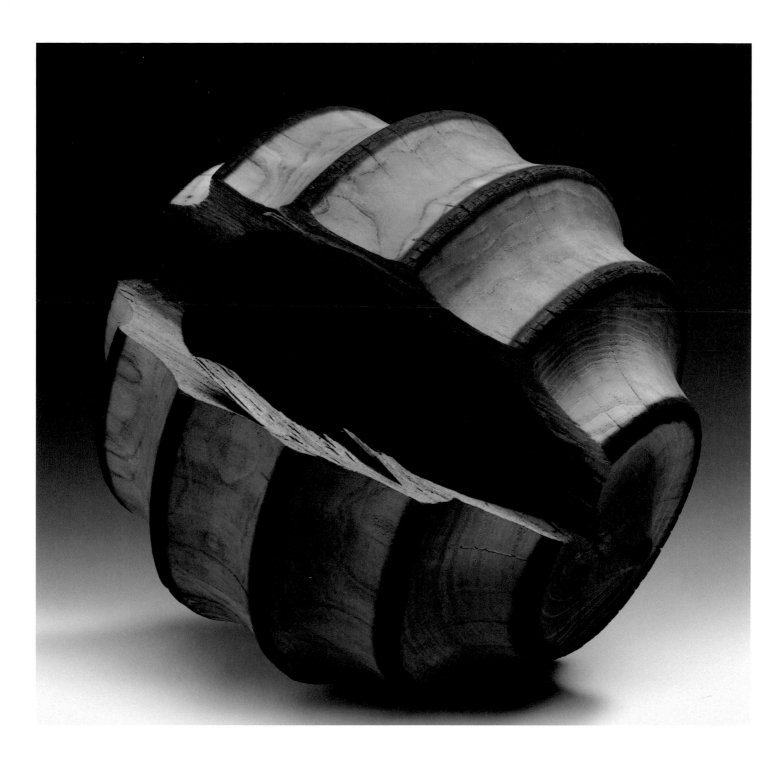

Todd Hoyer
"Ringed Series"
1993, mulberry
13 ¾ x 15 ½ x 15 in.

William Hunter and Marianne Hunter

Evening Blossom (and detail of lid)
1989, ebony, 24k gold, sterling silver,
enamel, amethyst, and charoite
4 x 3 ½ x 2 ⅞ in. with base

Much of William Hunter's work in the 1980s occupied a middle ground between ornamental and full-scale turning. Exquisite pieces in amber and ivory were followed by diminutive wooden vessels, decorated with enamels, precious metals, and stones by his wife, Marianne. Their uncommon preciousness appealed to Fleur Bresler, whose family operated a jewelry store. She acknowledges *Evening Blossom* as the first serious purchase of the collection.

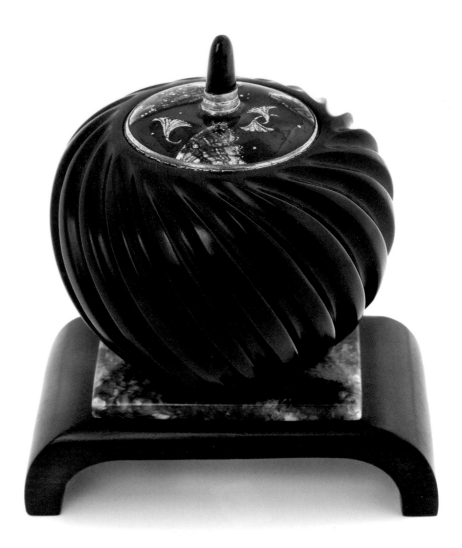

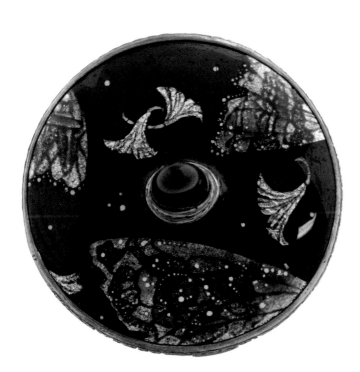

William Hunter and
Marianne Hunter
Africa (and detail of lid)
1990, satinwood, ebony, 24k gold,
sterling silver, fine silver, enamel,
and rutilated quartz
4 5/8 x 3 3/8 x 3 3/8 in. with base

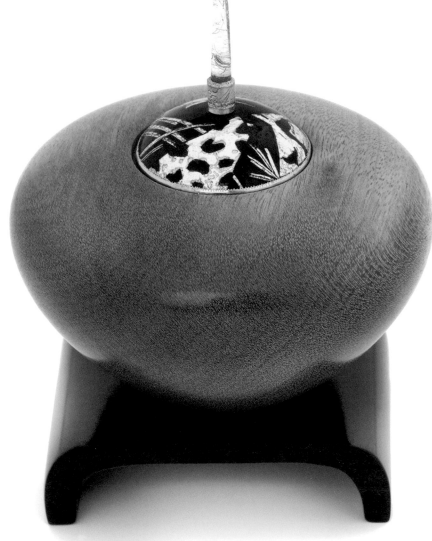

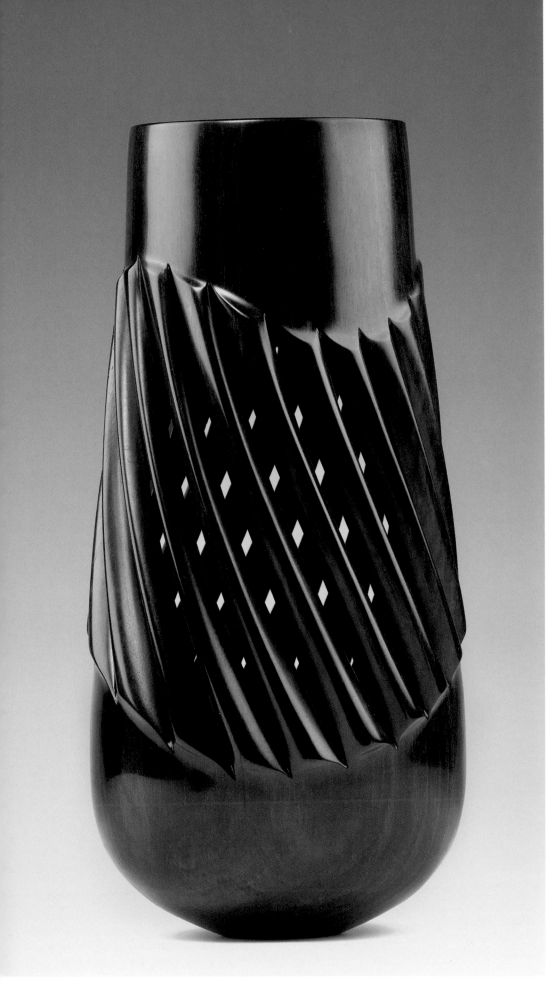

William Hunter's rippled vessels capture wood's creative revolution in form. *Evening Blossom* is typical of the first sensuous iteration of his style, which he calls "motionless movement." *Golden Shell* illustrates the style in transition as the solid body ruptures to reveal its interior. *Even Through Midnight I Can See Diamonds* is a breakthrough piece, representing the next stage in this subtractive process. Recent work explores the continued disintegration of the vessel in movement, leaving only a few strokes of wood to signify the former presence of a closed form.

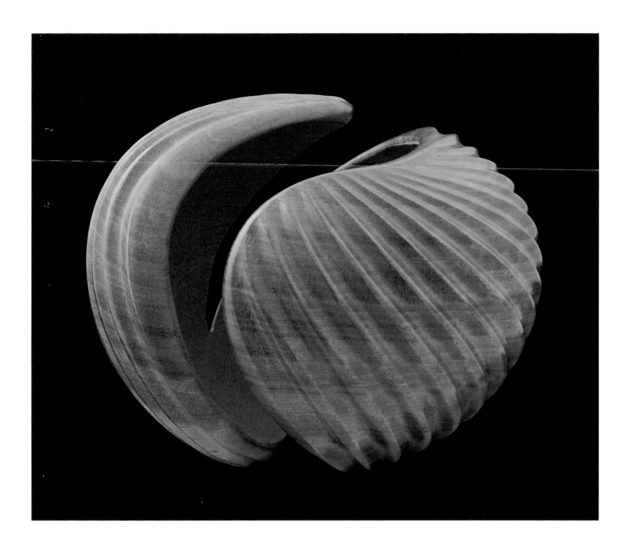

William Hunter
Golden Shell
1994, satinwood
3 ⁷⁄₈ x 4 ¼ x 5 in. diam.

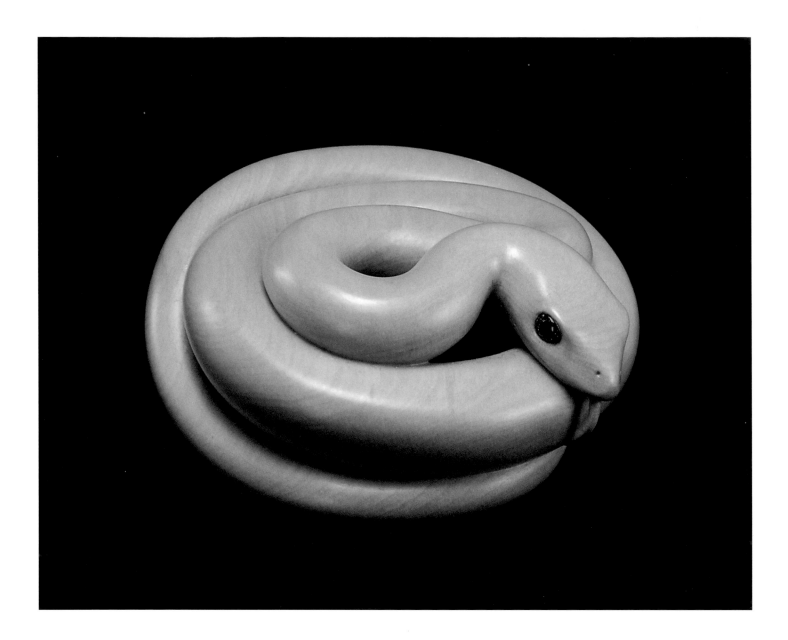

Janel Jacobson

Coiled Snake
1997, boxwood with gold,
antique gold powder,
and cyanoacrylate
⁷/₈ x 1 ⁷/₈ in. diam.

Janel Jacobson enjoyed a long career in ceramics and was recognized for her wheel-thrown porcelain boxes with shallow-relief lids, before transferring her skills to wood, which she finds more sculptural than clay. She now carves *netsuke* (a toggle used to fasten a small nested box to a kimono sash) and *ojime* (a sliding bead to hold the boxes together) inspired by the plant and animal life surrounding her rural Minnesota home. *Coiled Snake* was exhibited in the 2000 inaugural Renwick Craft Invitational *Five Women in Craft*.

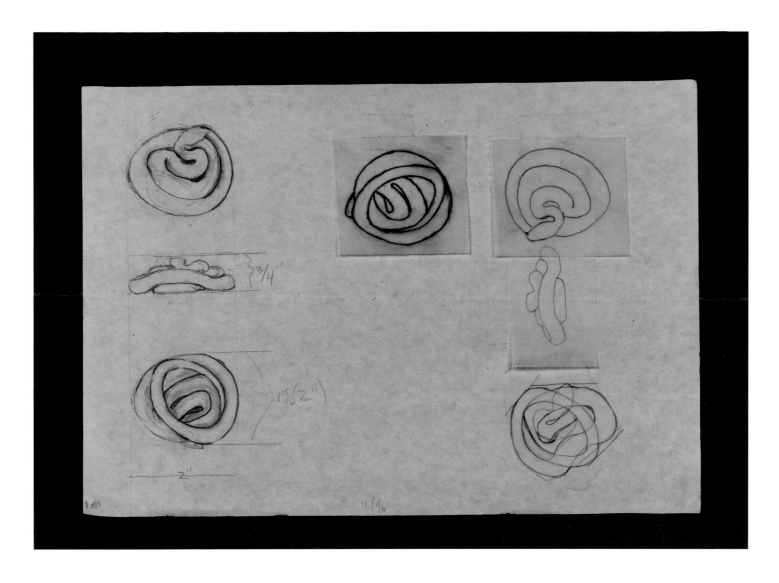

Janel Jacobson
Untitled (Studies for *Coiled Snake*)
1996, graphite on paper
9 x 11 ¾ in.

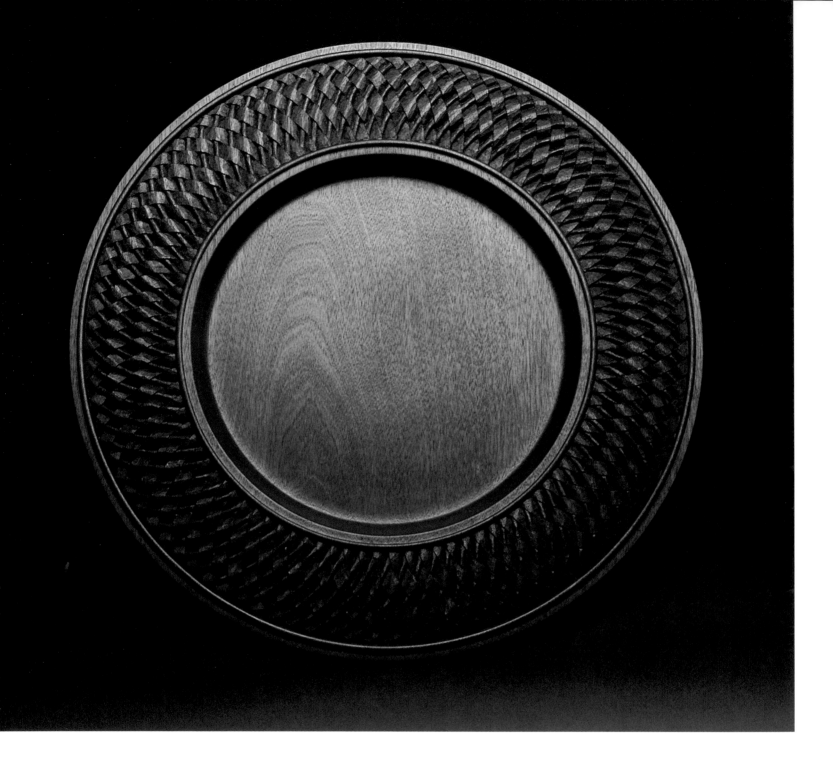

Charles Kegley
and Tami Kegley

Untitled, from the "Woven Series"
1997, Honduras mahogany
27 1/8 x 27 x 2 3/8 in. diam.

The extraordinary carving on this turned platter represents the complementary partnership of Charles Kegley, a self-taught turner, and his wife, Tami, a trained studio jeweler. The Kegleys began collaborating in wood in 1983, making a series of basket forms over several years. They created *Untitled* for Fleur Bresler in gratitude for her continued support. This is the last piece that Charles created in the "Woven Series."

Bonnie Klein

Top Secrets II
1994, pink ivorywood and ebony
2 ½ x 1 ⅞ in. diam.

Bonnie Klein believes strongly that small-scale turning can open up the craft to the uninitiated and has taught diminutive and ornamental turning to diverse audiences for more than twenty years. Tops are her most common form. They can be turned quickly on the miniature lathe of her own design, and they demonstrate to children the accessibility and usefulness of turning. With its familiar form and signature chatterwork, *Top Secrets II* could be mistaken for a toy, but the choice of stock—ebony and pink ivorywood—make this sophisticated cousin of her production work more exotic than playful. The piece opens to reveal its secret—a miniscule top housed inside.

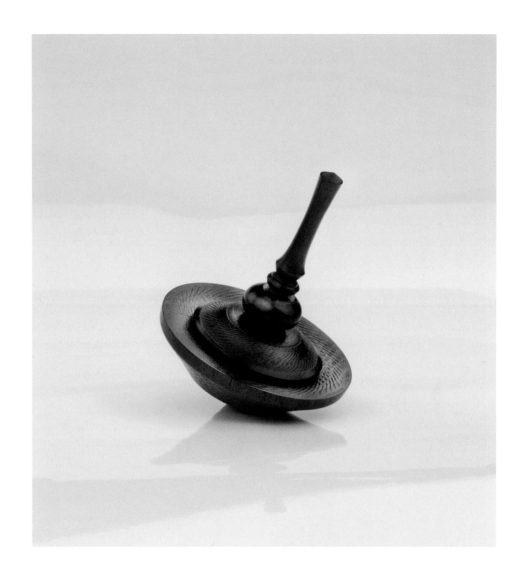

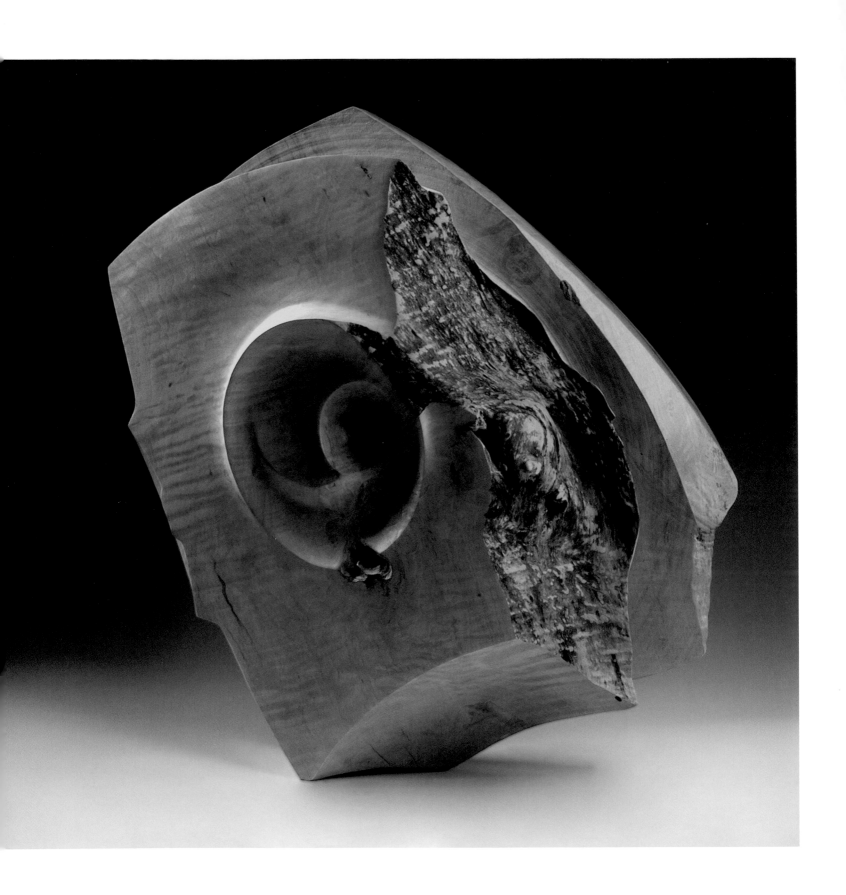

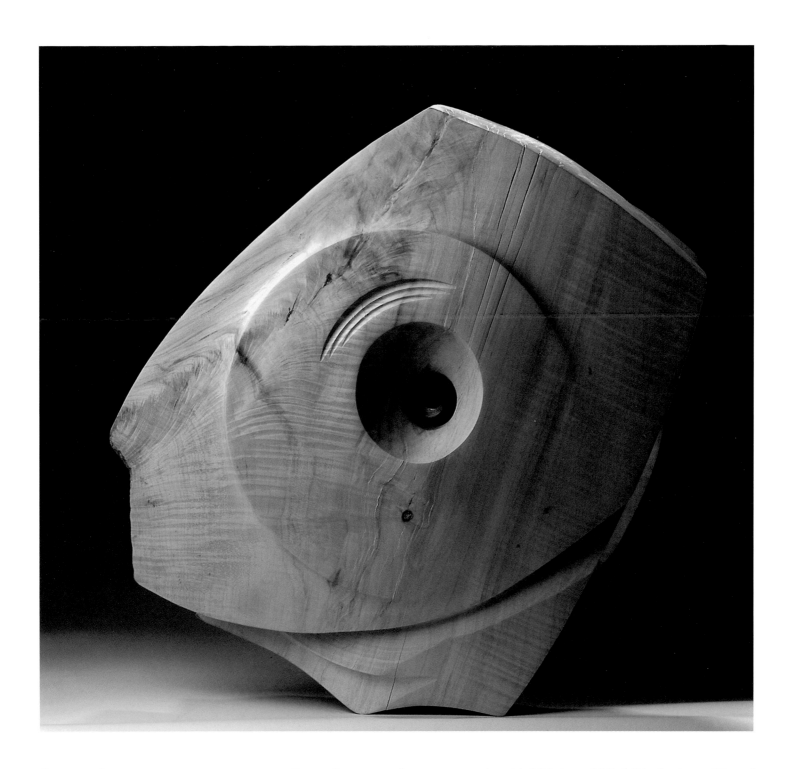

Stoney Lamar

Self-Portrait
1992, box elder
17 ⅞ x 18 ¼ x 6 ½ in.

Stoney Lamar was fortunate to train with Melvin and Mark Lindquist and David Ellsworth in the early 1980s, an experience that gave him the confidence to break away from what writer and wood artist Terry Martin has called the "tyranny of the circular form." By turning on multiple axes, Lamar achieves a paradoxical effect—subtractive work that appears to grow in scale through its sharp angles and shifts in contours between a block and a vessel. *Self-Portrait* is a sly take on a subject typically addressed in different media, a nod to the work's sculptural qualities.

Bud Latven

Integration
1992, maple and African blackwood
13 ⅝ x 3 ⅝ in. diam.

Bud Latven was an established furniture maker working in New Mexico when, with only limited lathe experience, he famously accepted a large order for turned goblets. The speed with which he mastered the skill was revealed when he published an influential article on segmented turning in *Fine Woodworking* three years later. Latven experimented with various styles of laminated work before removing segments from the walls of his vessels to create dramatic voids. *Integration* immediately predates these deconstructed objects. The ambiguous divide between its light and dark sections hints at the artist's search for a new aesthetic, just before the breakthrough.

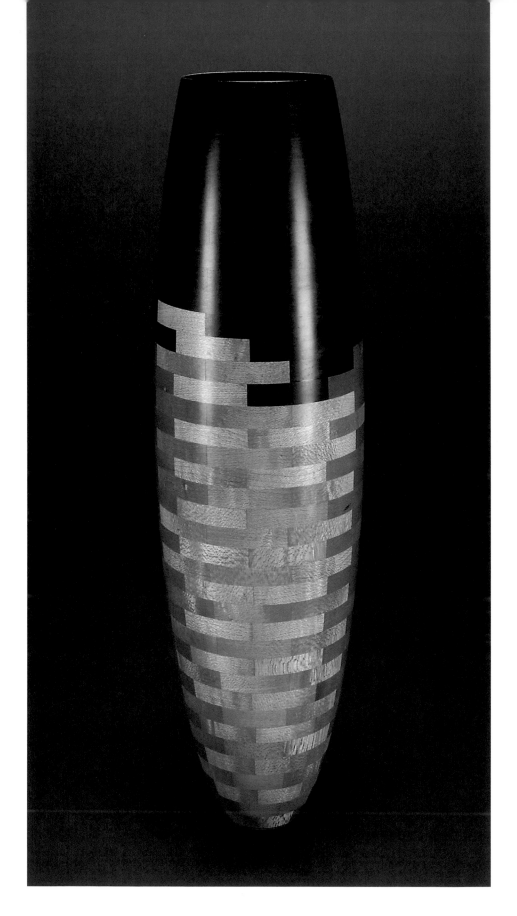

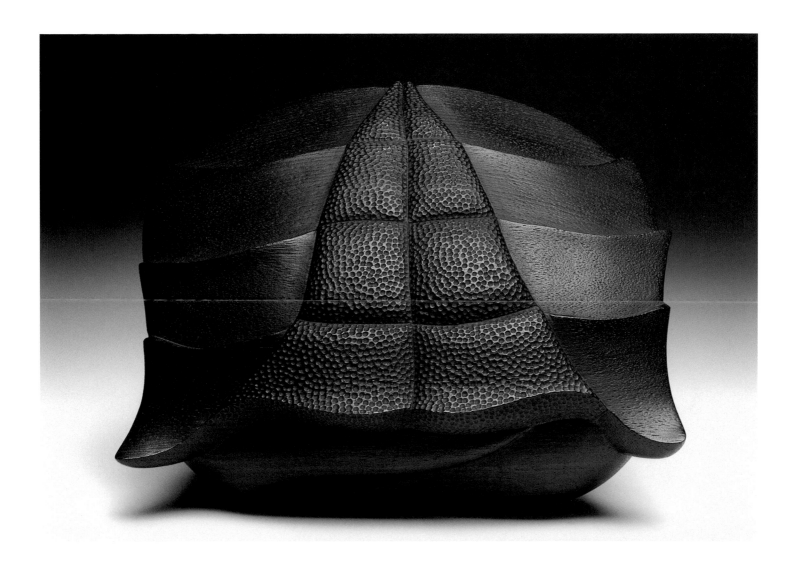

Michael Lee

Armored Crab
1998, kingwood
$2\,^5/_8 \times 5\,^7/_8 \times 5\,^1/_8$ in.

After buying a lathe on a whim, Michael Lee taught himself to turn simple vessels before training at the Arrowmont School of Arts and Crafts in Tennessee in the early 1990s. Since then, he has primarily used the lathe to fashion a rough form before continuing with extensive carving. Like his most recent work, *Armored Crab* employs native wood and is inspired by both the live and fossilized sea life near his Hawaiian home.

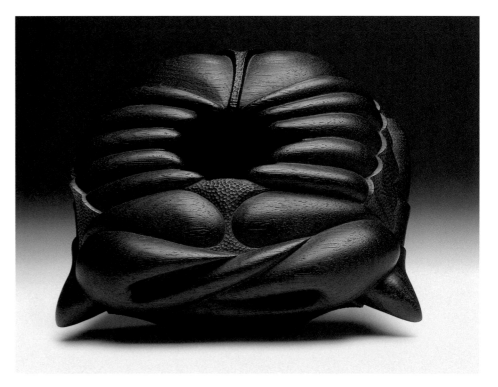

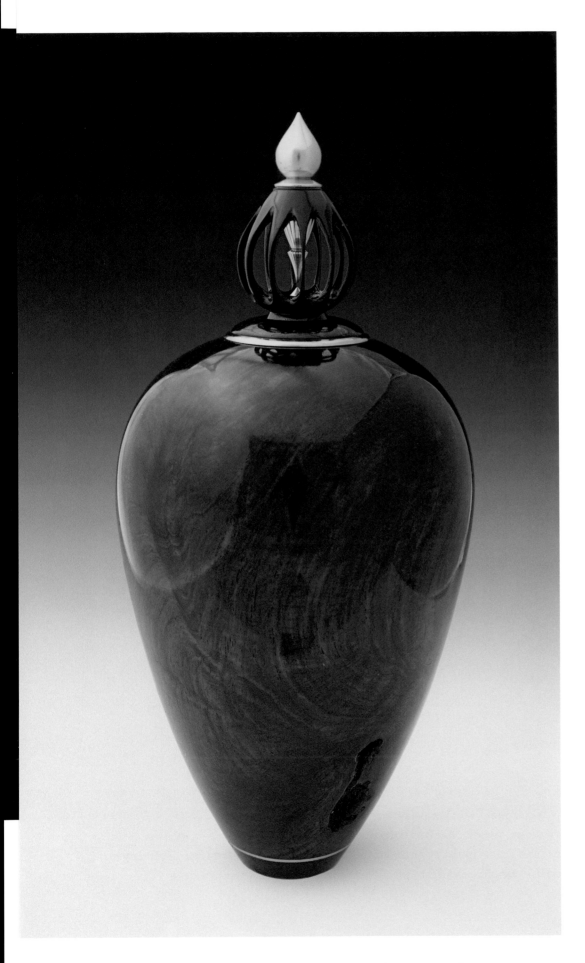

Barry T. Macdonald

Bottiglia Barrocco
1994, rosewood burl, ebony, and brass
9 ¾ x 4 ½ in. diam.

Contemporary turned vessels
are often in dialogue with their
historical antecedents, but none
so openly as Barry Macdonald's
superb classical forms. Aided by a
high-gloss finish, they recall line
by sensuous line the clay, glass, and
polished stoneware of earlier civili-
zations. The brass and ebony finial
atop *Bottiglia Barrocco* provides
a fitting cap to this fantasy, until
the eye wanders downward and is
surprised by a gaping wound in the
rosewood burl—a clever reminder
of the work's true era and material
of origin.

Barry T. Macdonald
Carob Jar #192
about 1993, carob, ebony,
and bloodwood
12 x 7 ⅞ in. diam.

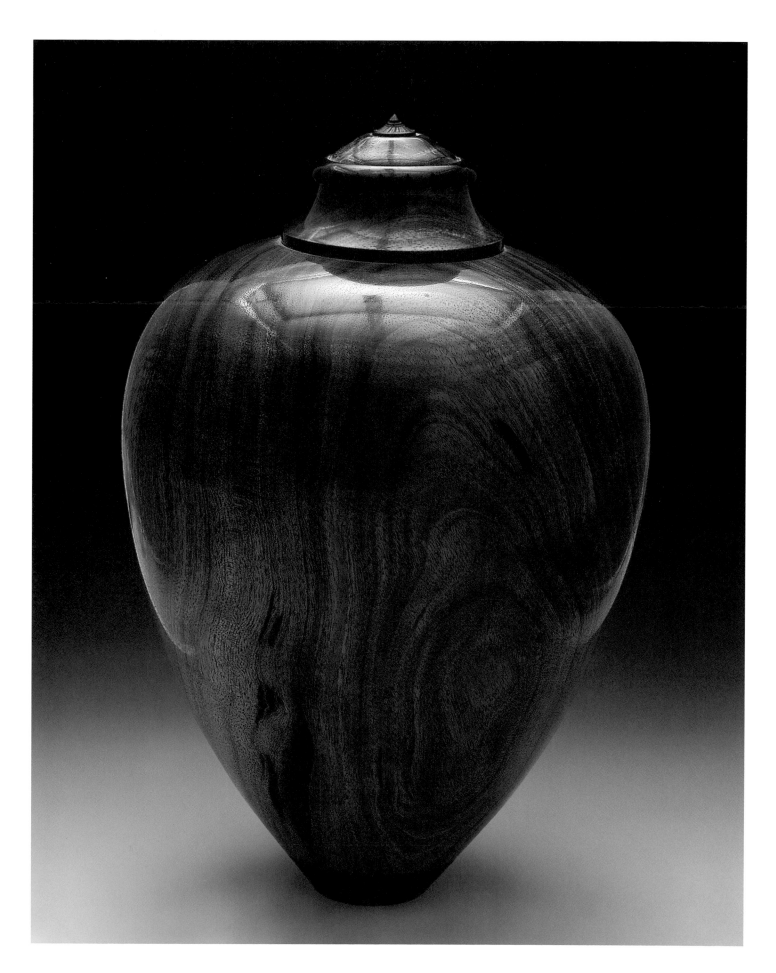

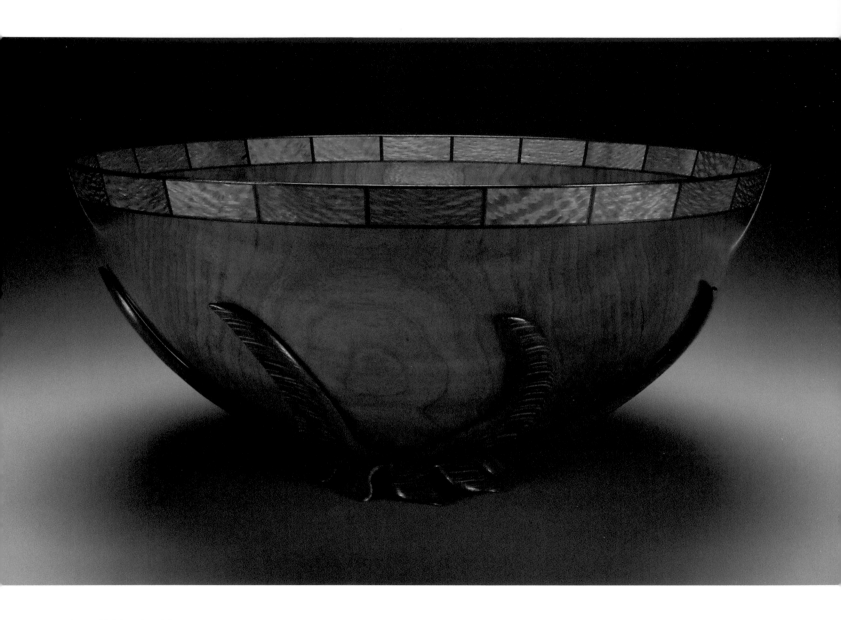

Barry T. Macdonald
Large Bowl
1991, black walnut, lacewood,
and padauk
9 1/8 x 19 in. diam.

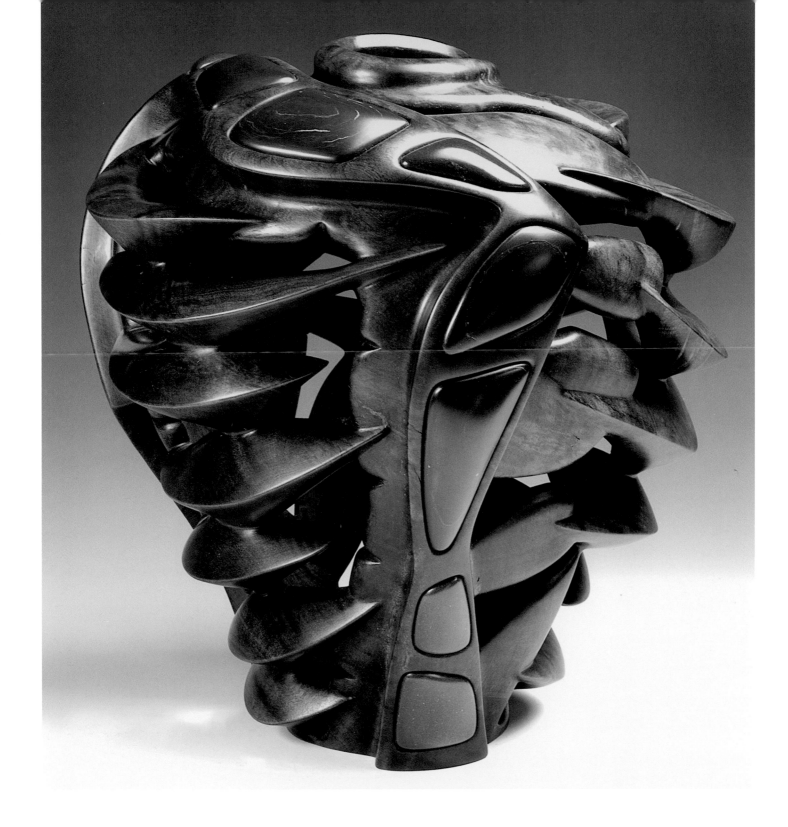

Hugh E. McKay

Morata
1997, madrone burl and pipestone
10 ¼ x 9 ⅜ in. diam.

Hugh McKay is a master of multi-axis turning whose work often seems to exist just beyond the assumed range of what can be achieved on a lathe. *Morata* exhibits this virtuosity and the almost violent aesthetic he attributes to nature's "chaotic character," which he considers a "higher order of reality." McKay has long experimented with materials, both by casting wood sculptures in glass and bronze and by incorporating glass, metal, and stone into his turned pieces. The pipestone mantel adorning *Morata* complements the madrone and provides a focal point amid the turmoil.

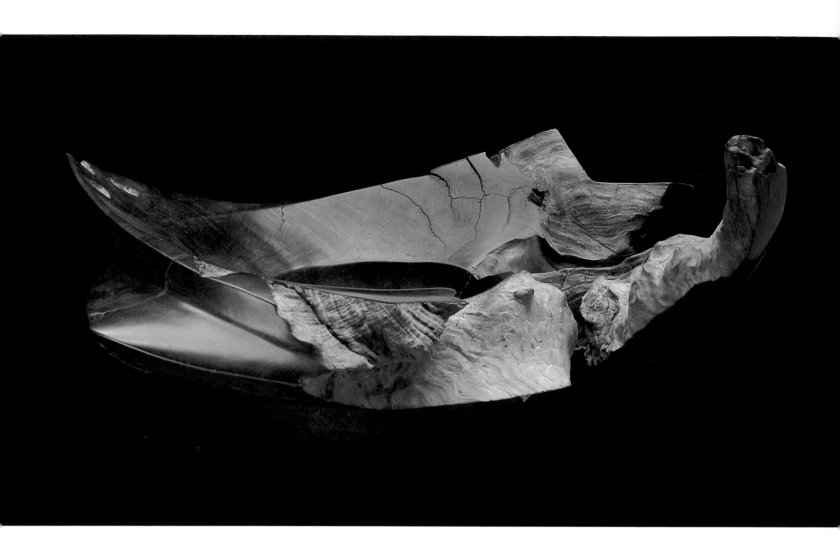

Bruce Mitchell

Canyon Oasis #4
1995, redwood root burl
6 ³⁄₈ x 13 ³⁄₄ x 15 ¹⁄₈ in.

Bruce Mitchell worked in J. B. Blunt's California studio for eight years beginning in 1969, the year the influential craftsman's furniture was featured in the exhibition *Objects: USA*. During this time, Mitchell developed a deep appreciation for the rough-hewn redwood Blunt favored and began turning bowls. This piece reflects the roots of Mitchell's education in wood, though with a more adventurous natural edge. The shallow depression implies function without imposing it. Cracks show the wood, which Mitchell turns green, adjusting to its new form.

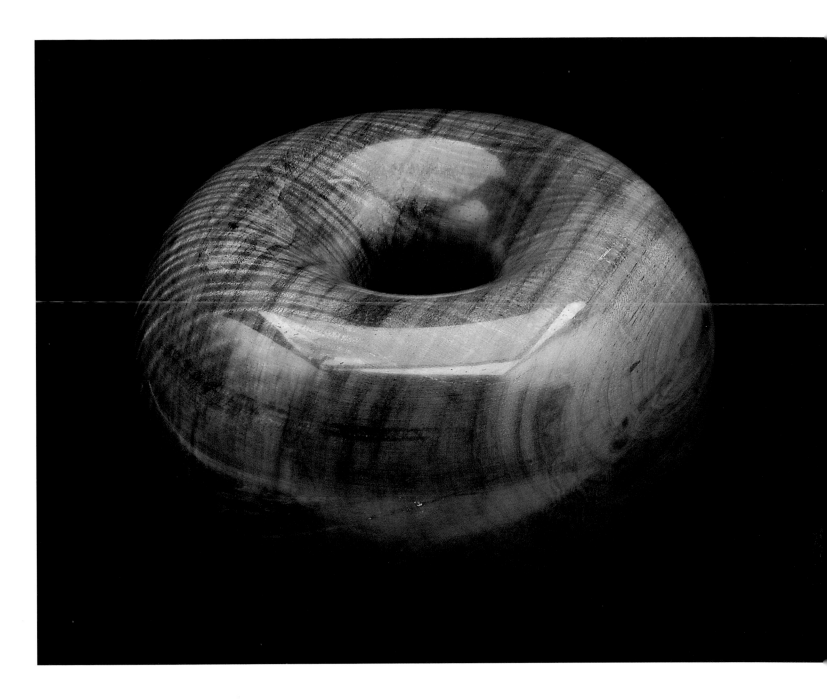

Edward Moulthrop

Donut Bowl
about 1990, maple
5 ¼ x 8 ½ in. diam.

Ed Moulthrop's best-known achievements in wood are his mammoth bowls and goblets, examples of the technical prowess that allowed him to venture into unexplored creative territory. In comparison, this unassuming *Donut Bowl* might be overlooked except for the whimsy of its familiar form. Rather than awe, it beguiles with its intimate scale, soft-sloping hole, and trademark plastic-resin finish, which highlights the maple's figure. Moulthrop turned donut bowls throughout his career as sculptural interludes between his larger vessels.

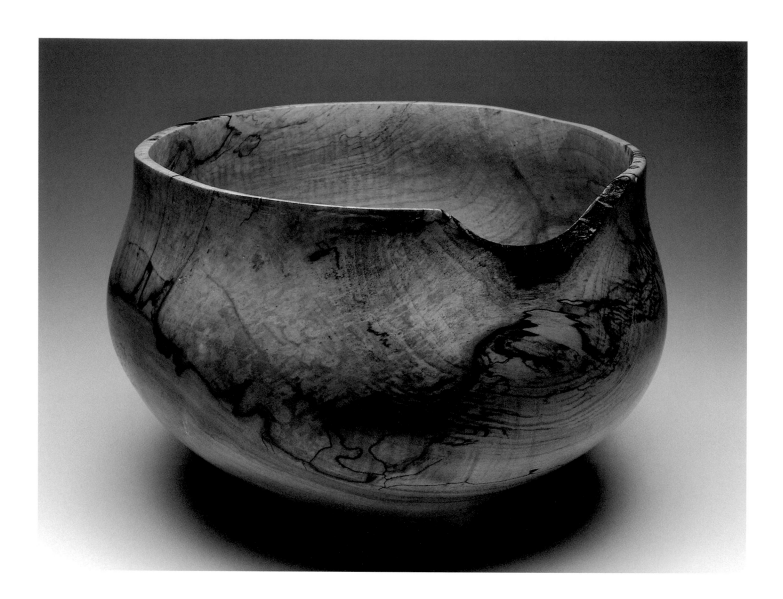

Rude Osolnik

Bowl
1984, spalted maple
8 ⅞ x 13 in. diam.

Rude Osolnik claimed to have turned more than one hundred fifty thousand candlesticks in his career, a form that achieved widespread commercial popularity through its pure modern aesthetic and obvious functionality. Deployed in homes across the country, the candlesticks helped educate the American public about the benefits of a previously neglected art. The spalted maple and natural edge in the *Bowl* above illustrate Osolnik's evolving interest in materials and forms that gained credence among woodturners only late in his career.

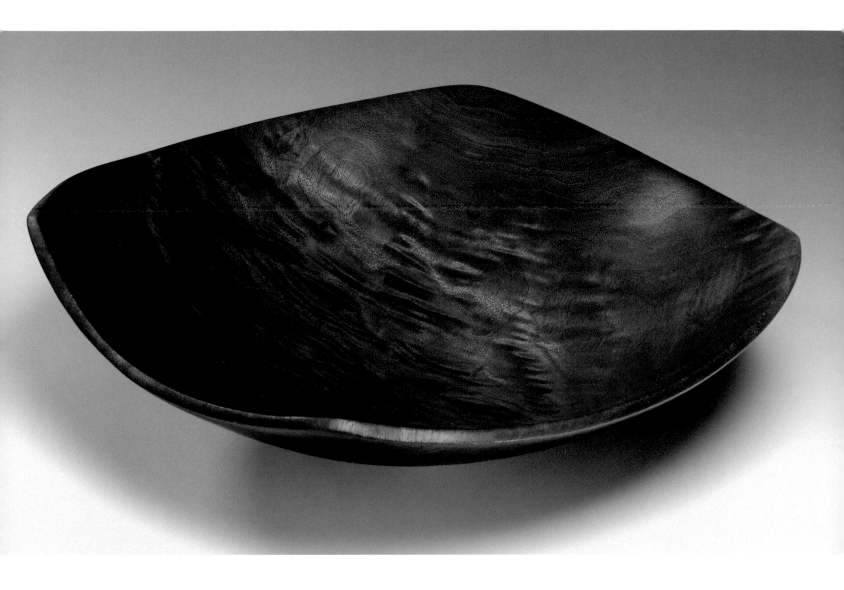

Rude Osolnik
Bowl
1983, walnut
5 ⅛ x 16 ⅞ x 16 ¼ in.

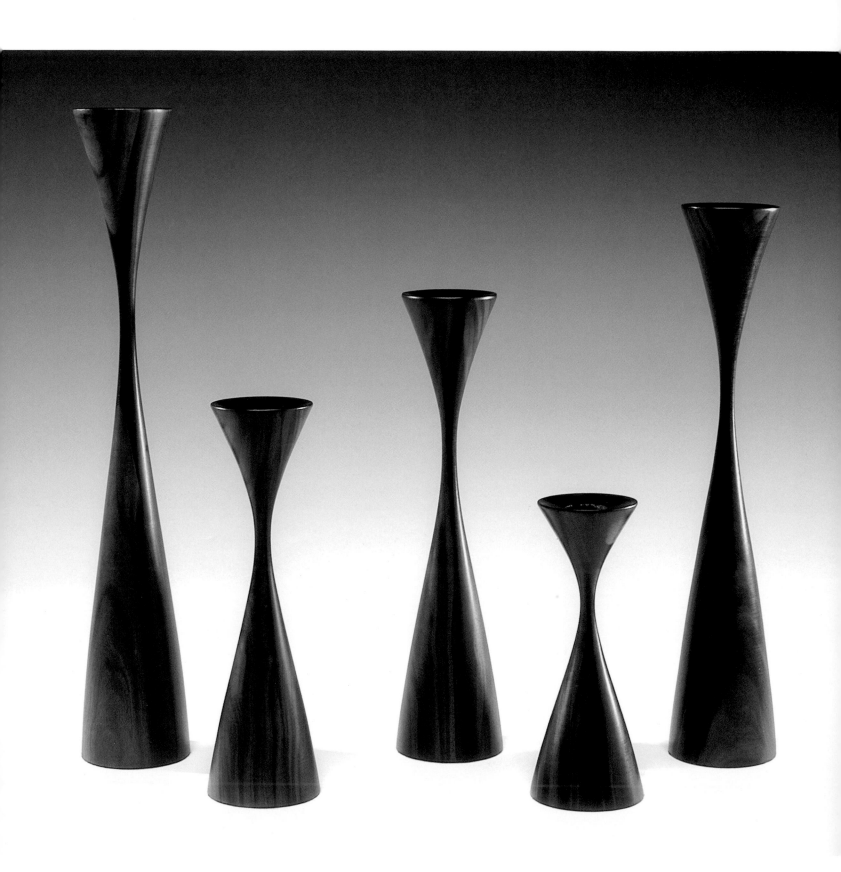

Rude Osolnik
Five Candlesticks
1988, macassar ebony
height: 6 ¼–14 ¼ in.; diam.: 2 ⅜ in.

Michael Peterson

Bird House
1994, madrone
9 ¾ x 6 x 4 ¾ in.

Michael Peterson's organic aesthetic is deeply influenced by dramatic natural locations such as his native Southwest and his longtime home on Washington's Puget Sound. *Mesa* dates from a period exploring textures and forms that soften the human imprint on vessels (inherently cultural objects) crafted from wood. Soon after, Peterson largely abandoned turning and the vessel to carve increasingly amorphous objects that might have been discovered, rather than created, by the artist. *Bird House* records this transition.

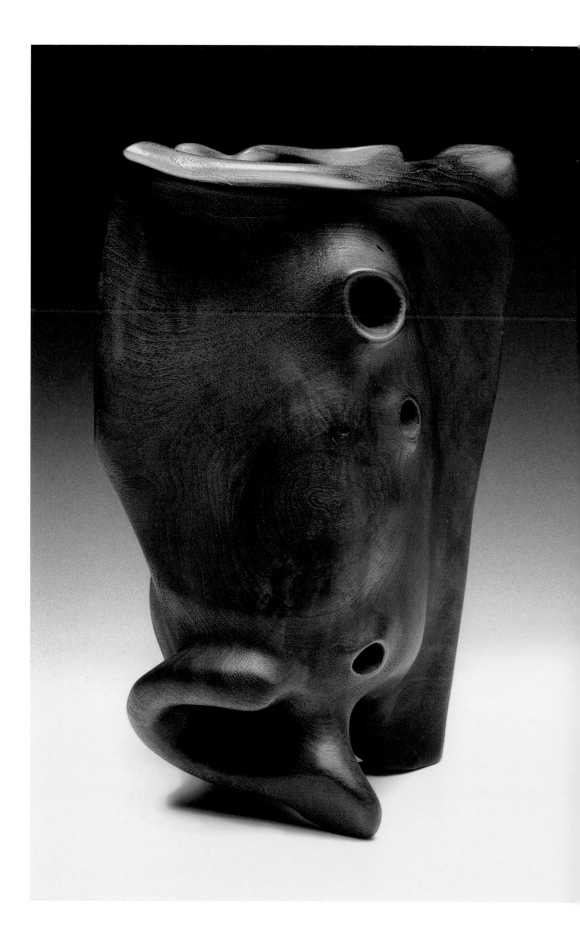

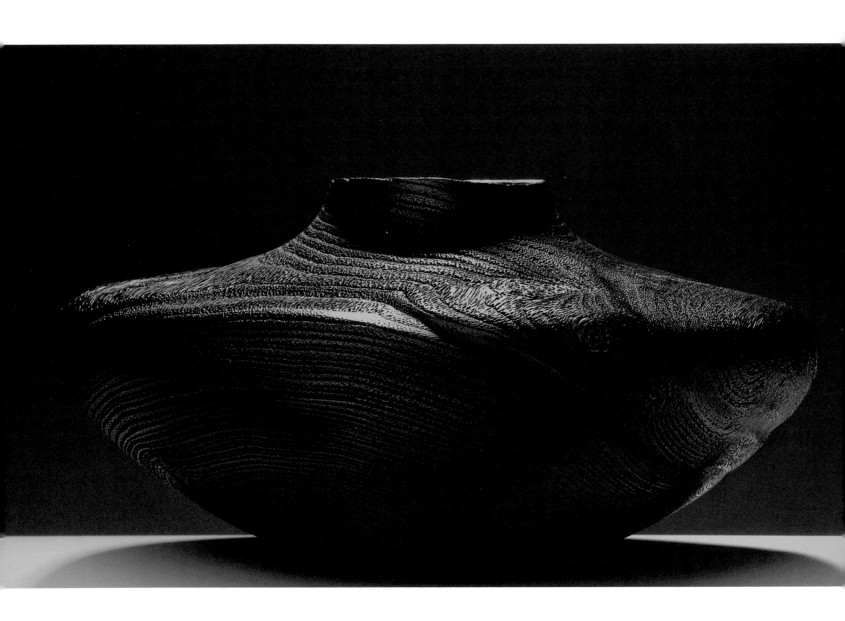

Michael Peterson
Mesa, from the "Landscape Series"
1993, locust and india ink
5 x 9⅞ in. diam.

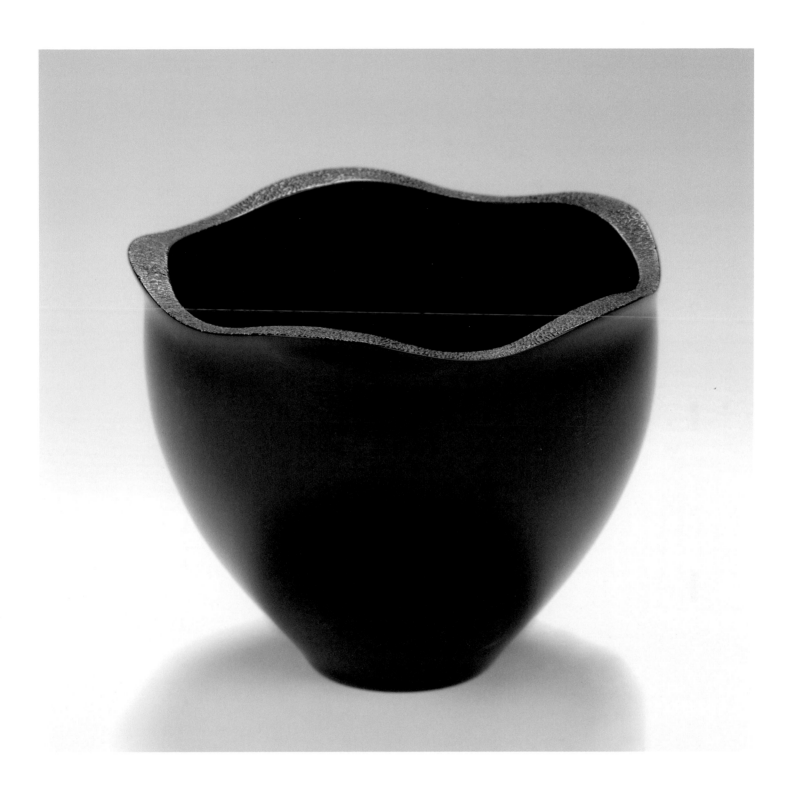

Gene Pozzesi

Untitled
about 1996, Gabon ebony
4 1/8 x 4 7/8 in. diam.

Gene Pozzesi began turning seriously in retirement and mastered the lathe under the tutelage of Del Stubbs. The revolutionary nature of his uncomplicated style becomes fully apparent only when it is viewed in conjunction with the work of any other artist. The classically inspired form is so strikingly pure and his favorite ebony so deep and uniform in color that the vessel compels attention. The spell is broken only by the softly mottled lip, where Pozzesi has carefully melted, rather than burned, the wood.

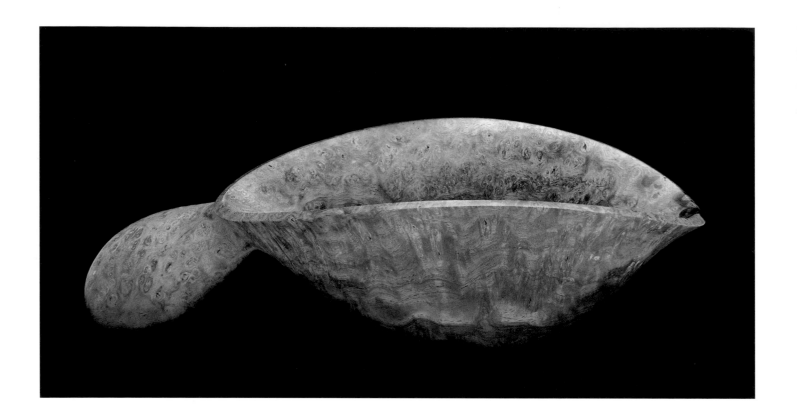

Norm Sartorius

Pita Bread Spoon
1994, amboyna burl
2 ³⁄₈ x 8 ⁷⁄₈ x 3 ¼ in.

Norm Sartorius was drifting through life as a "disenchanted social worker" when he was rescued by the offer to apprentice at a Baltimore woodshop in the early 1970s. He quickly fell into small-scale production work and nurtured an early and uncommon interest in spoons, which he considers just another category, similar to "bowl," "plate," or "teapot." Spurred by the interest and encouragement of others, Sartorius gradually developed his spoons into objects more appropriate for contemplation than everyday use. The unique design of each spoon is governed by the individual properties of its stock. The appeal of his work derives from its tactility and the inherent value of its function.

Norm Sartorius
Obsession
1998, maple
2 ⅛ x 20 ¾ x 5 ⅞ in.

Norm Sartorius
Algerita Family
1998, algerita burl
a: 3 1/8 x 16 3/4 x 3 7/8 in.;
b: 1 3/4 x 9 7/8 x 2 3/4 in.;
c: 1 1/4 x 7 1/4 x 1 in.

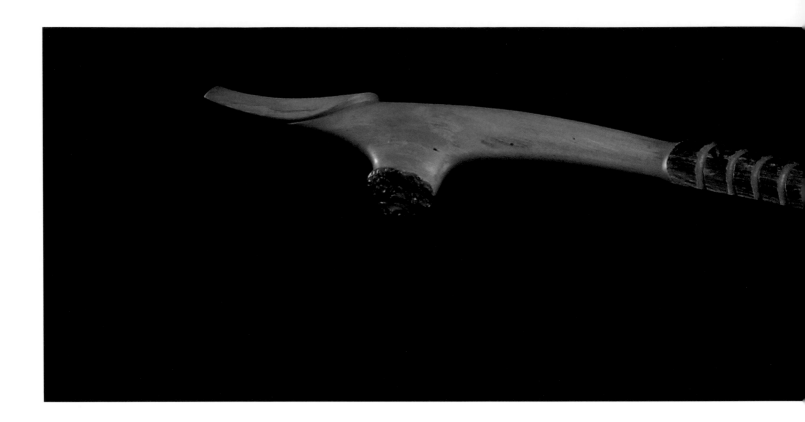

Norm Sartorius
Spear Spoon
1997, African blackwood
$^7/_8$ x 20 $^7/_8$ x 2 $^1/_2$ in.

Norm Sartorius
Mutation
1999, Mexican blue oak burl
2 $^1/_2$ x 9 x 4 in.
Gift of John and Robyn Horn, Fleur Bresler,
and Kenneth R. Trapp

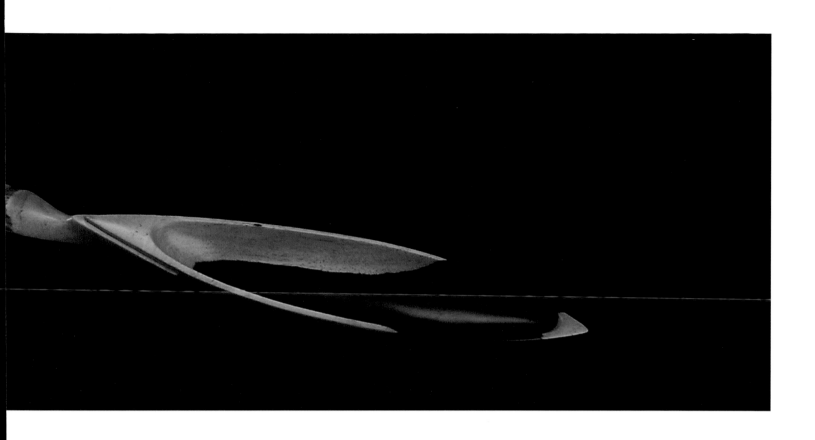

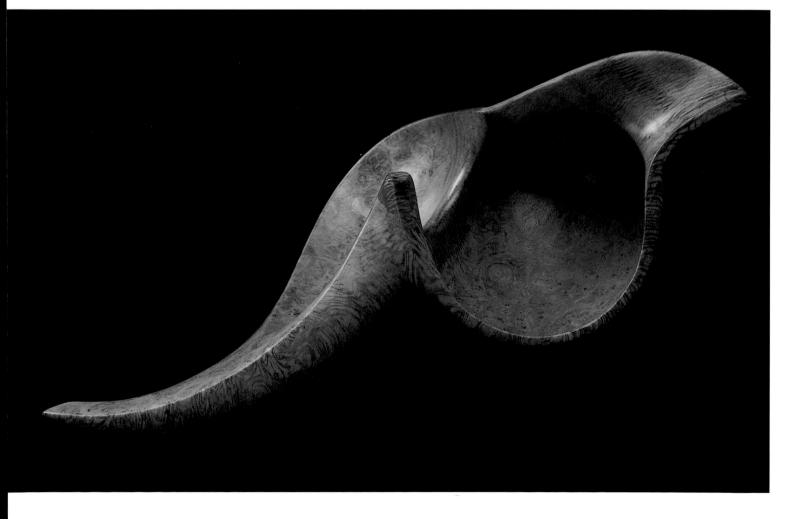

Jon Sauer

Zig Zag Bottle
1993, African blackwood and boxwood
6 ¼ x 1 ⅞ in. diam.

Jon Sauer grew passionate about turning after discovering exotic hardwoods, favored for their density in ornamental turning. He primarily turns boxes and perfume bottles on his refurbished 1868 Holtzapffel lathe. The baroque style and regal top of this bottle reveal architectural influences and Sauer's continuing interest in the rich European history of ornamental turning.

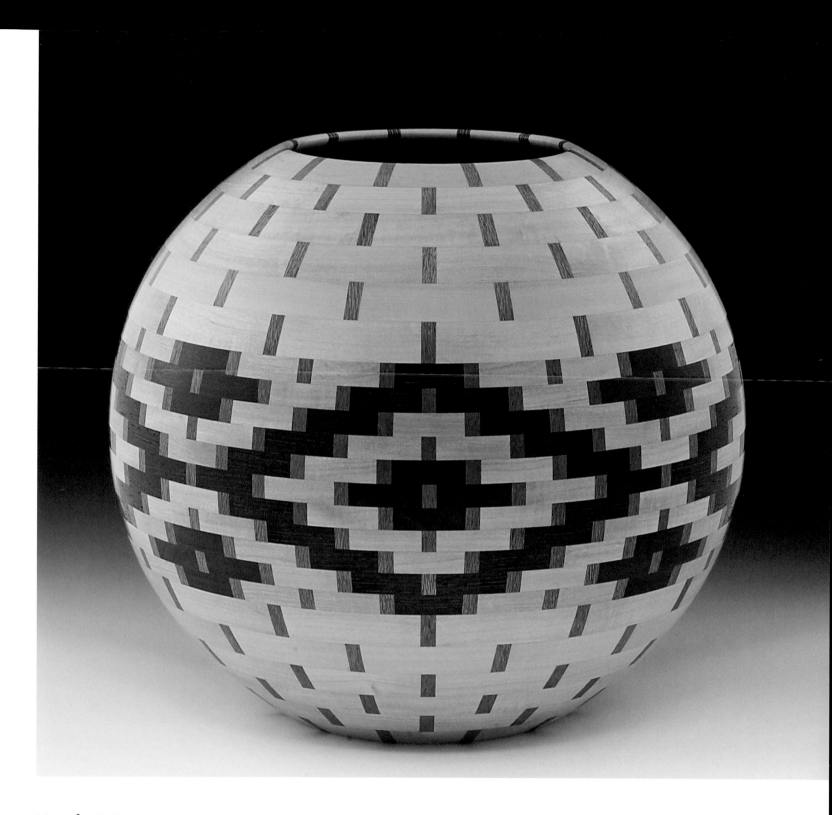

Lincoln Seitzman

Petrified Hopi Basket—Second Mesa
1993, guatambu, wenge, bloodwood,
and lacewood
13 ⅛ x 14 ⅝ in. diam.

Lincoln Seitzman earned a degree in aeronautical engineering and operated his family's textile manufacturing business for thirty-five years before pursuing turning as an avocation. This unique background prepared him to create some of the most complex works in contemporary wood art. With a mature understanding of physical bodies and the structure of weaving, Seitzman meticulously drafts each basket "illusion" on paper before constructing it from as many as five thousand segments. The results are not meant to fool in the tradition of trompe-l'oeil, but to celebrate the sophistication of fiber art in diverse cultures through an unexpectedly complementary medium.

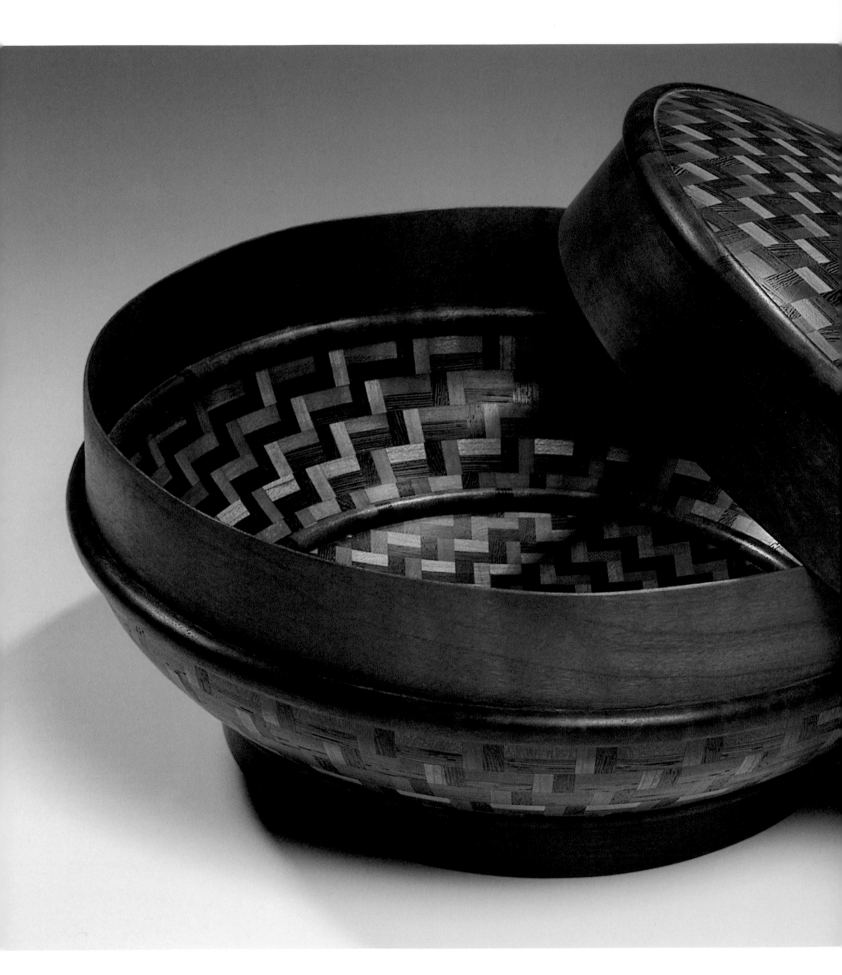

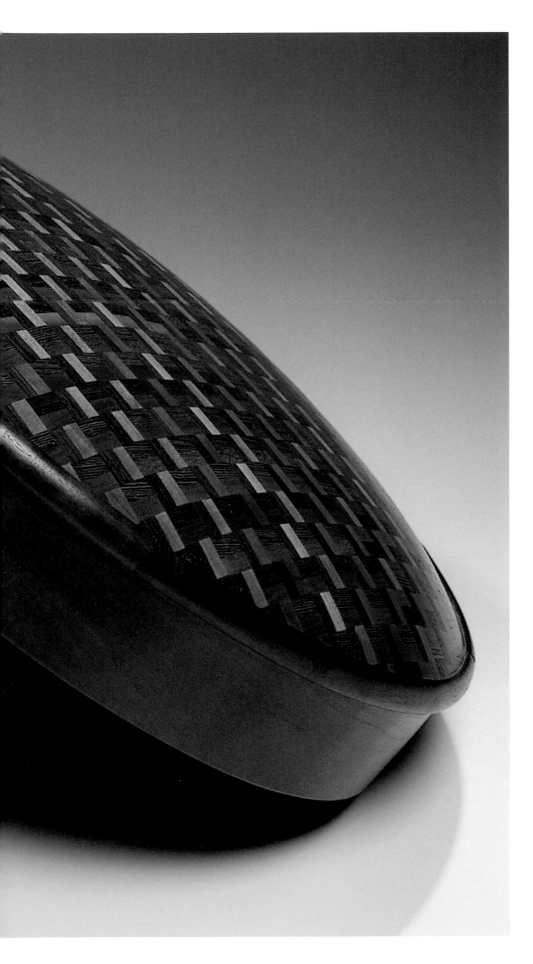

Lincoln Seitzman
Petrified Sewing Basket
1995, cherry, wenge, and imbuia
6 7/8 x 12 7/8 in. diam.

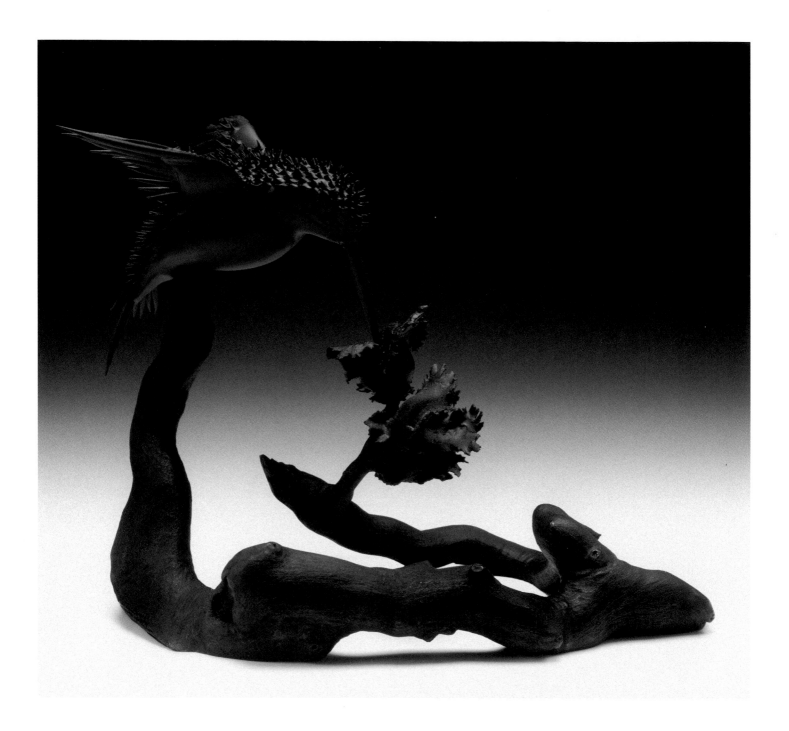

David Sengel

Hummingbird Box
1996, box elder, rose thorns, locust,
trifoliate orange thorns, laurel root,
hazelnut husks, india ink, and lacquer
5 ¾ x 7 ½ x 5 ⅛ in.

David Sengel's best-known work incorporates thorns, which are collected for him by friends and colleagues. Both delicate and dangerous, these prickly objects clarify the position of contemporary wood art in relation to function. *Hummingbird Box* commemorates the birds that fly into the artist's North Carolina studio. Sengel turned the bird on multiple axes and glued thorns to its back before mounting it on a found laurel root. The back of the bird's neck serves as the lid of the box and is held in place by a magnet. As is typical of many of Sengel's works, it is finished with a black spray lacquer that both unifies the disparate elements and lends the final object a mysterious quality.

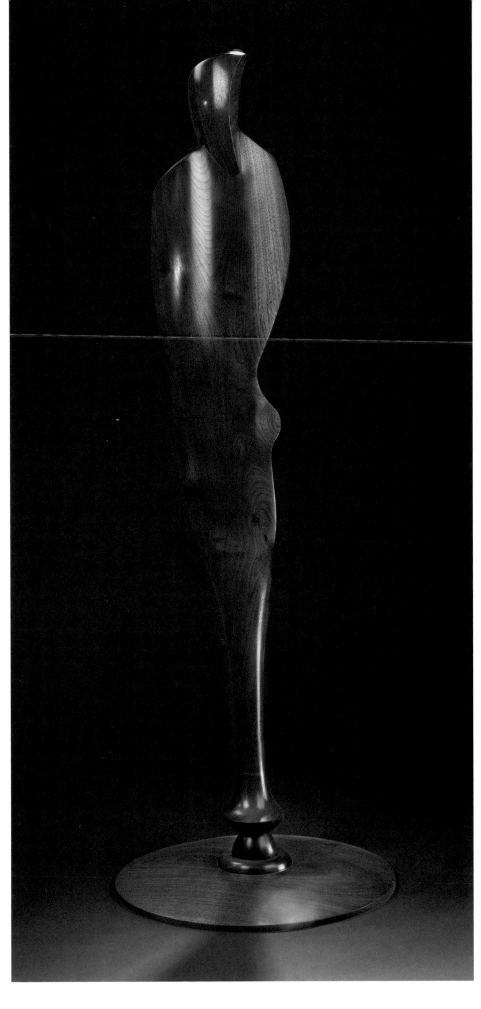

Mark Sfirri

Glancing Figure
1997, walnut
46 x 15 ¾ in. diam.

Mark Sfirri studied furniture
making at the Rhode Island School
of Design under the influential
woodworker Tage Frid, who encour-
aged him to use the department's
lathe. Sfirri now teaches at Bucks
County Community College in
Pennsylvania, which offers the rare
opportunity to turn wood in an
academic environment.

Turned from walnut, a wood
popular in early Pennsylvania furni-
ture, *Glancing Figure* unfurls from a
traditional eighteenth-century table
leg with a padfoot to a figural form,
capturing the evolution of wood
turning from functional craft to
sculptural medium.

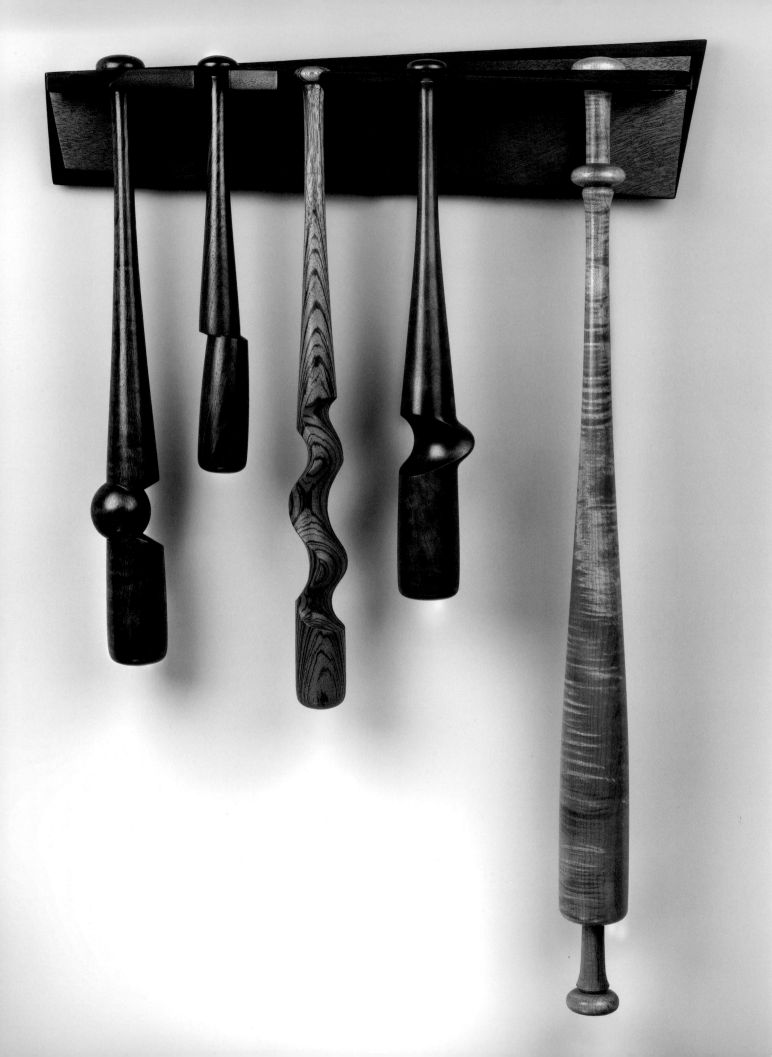

Mark Sfirri
Rejects from the Bat Factory
1996, mahogany, curly maple, cherry,
zebrawood, cocobolo, and lacewood
overall: 37 7/8 x 25 3/8 x 5 5/8 in.
bats: height: 15 5/8 – 37 1/8 in.
width: 2 1/8 – 2 3/4 in.

Sfirri's interest in multi-axis turning
grew after observing the technique
employed in the manufacture of
seventeenth-century chairs. After
his son requested a home-turned
bat for little-league games, the artist
realized that the classic American
form offered the perfect vehicle
for experimenting with multi-axis
techniques.

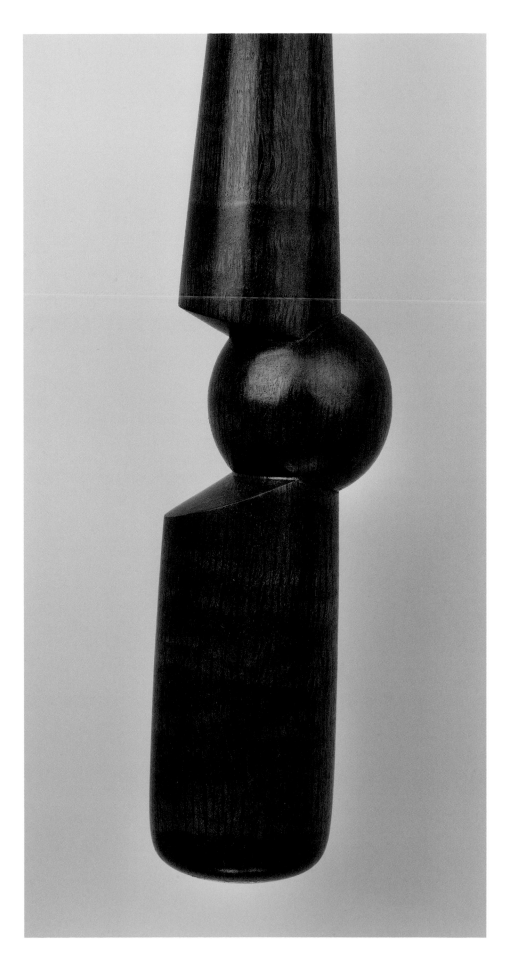

Mike Shuler

Satinwood Bowl #458
1989, satinwood, bloodwood,
and amaranth, with French polish
4 ¾ x 11 ⅝ in. diam.

Mike Shuler began turning on his
father's lathe after questioning how
the legs on a family heirloom chair
came to be round. Entirely self-
taught, he now specializes in two
distinct bodies of work.

 Satinwood Bowl illustrates
his extraordinary ability to engi-
neer complex, segmented forms
that exploit the graphic power of
different-colored woods.

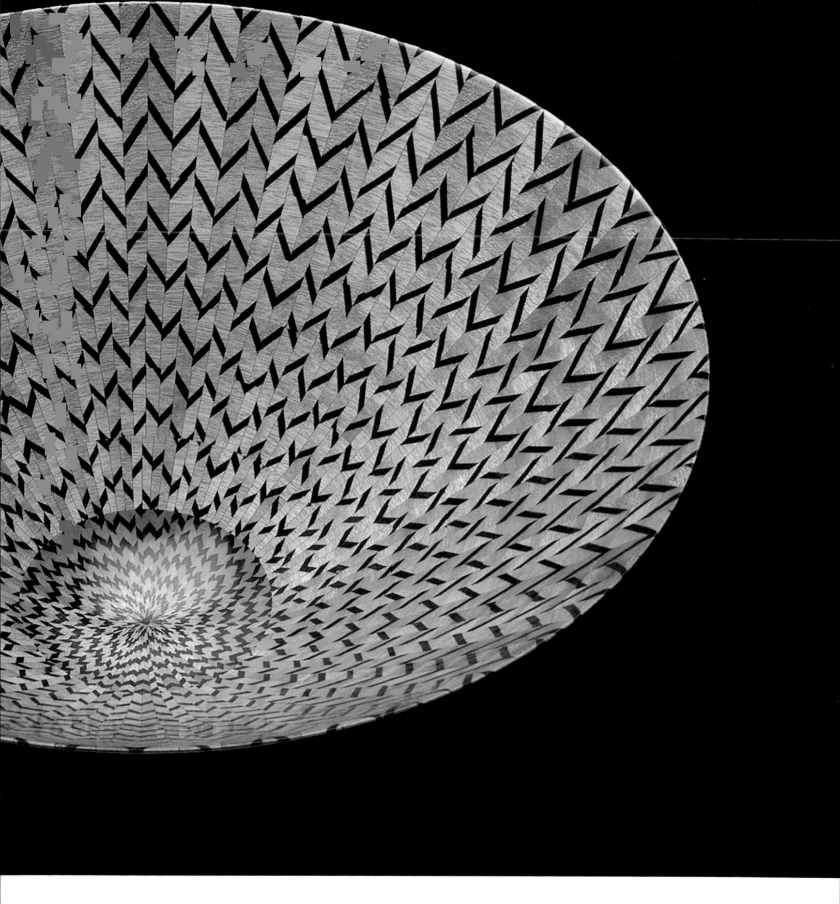

A series of vases called "Organica" explores the turning properties of unusual materials, unlikely to have met the lathe before. *Monterey Pinecone Vase* follows the contemporary turner's natural predilection to use every part of the tree to a logical, yet surprising, conclusion.

With *Protea Blossom Vase*, Shuler goes further, crafting a simple vessel from a material that is anything but simple—a flower blossom encased in resin. This work begs the question if future proponents of the lathe will not only question the term *turning* to describe their medium but the word *wood* as well.

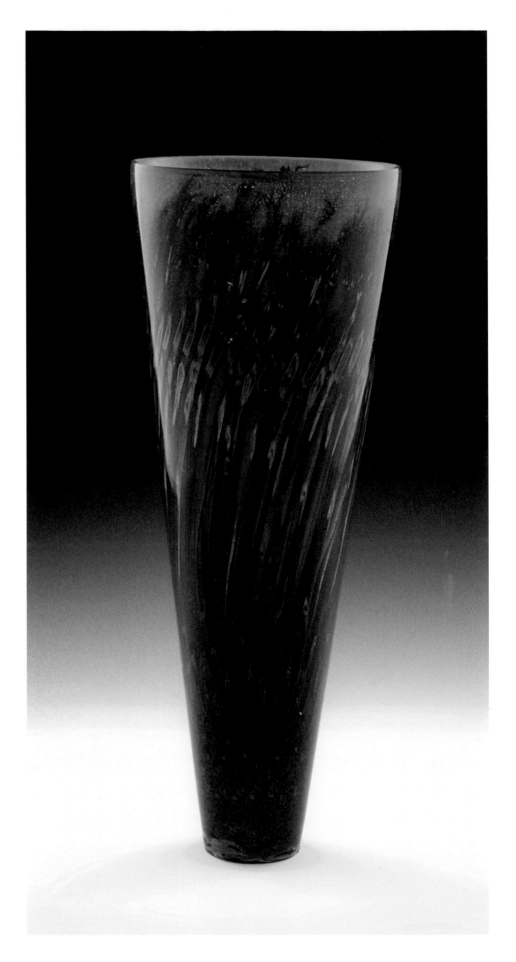

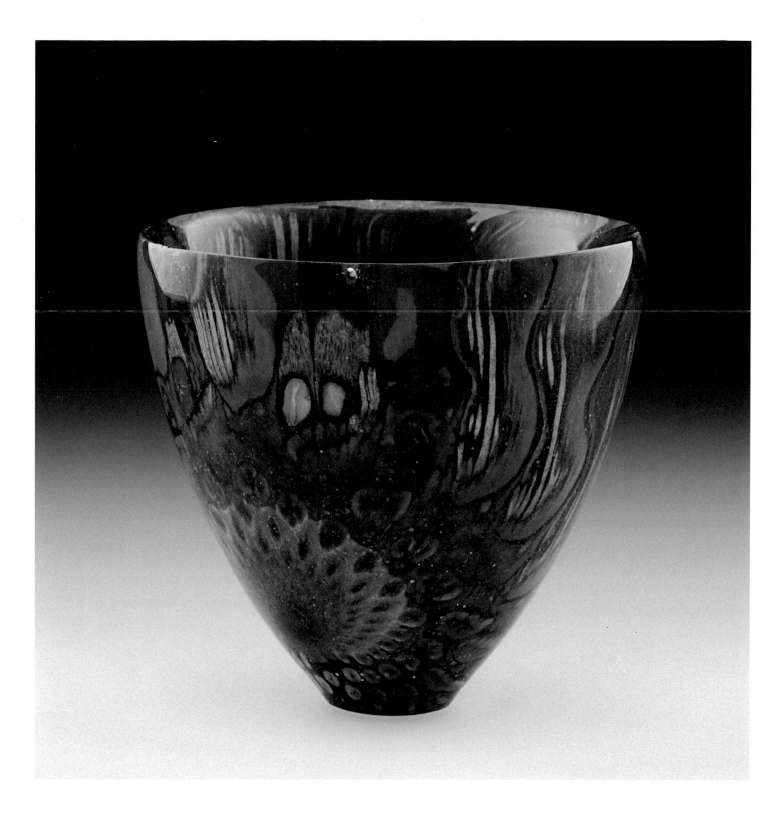

Mike Shuler
Monterey Pinecone Vase #602
1991, Monterey pine with epoxy resin
2 ¼ x 2 ⅜ in. diam.

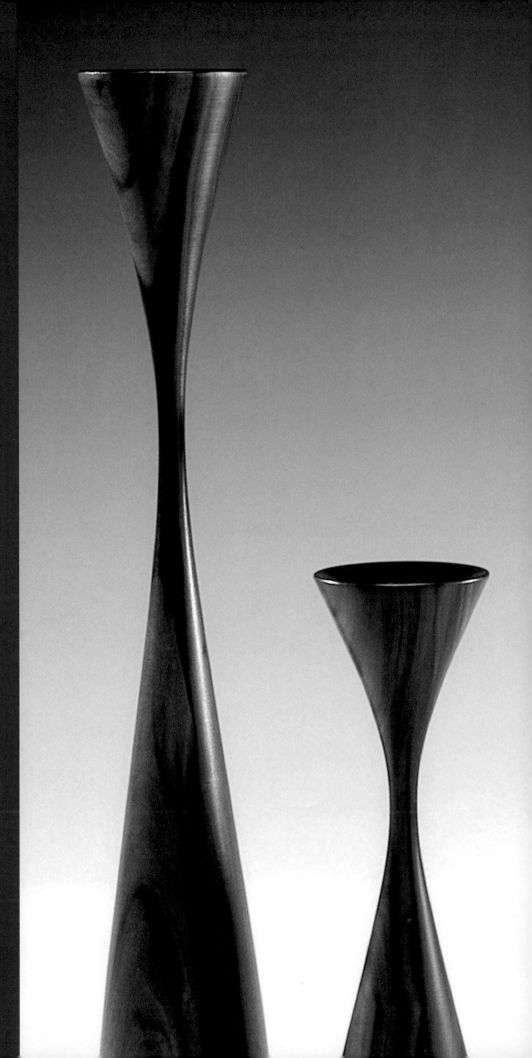

Wood Art at the Renwick Gallery

This section illustrates all wood-based art in the Renwick Gallery's permanent collection, excluding furniture.

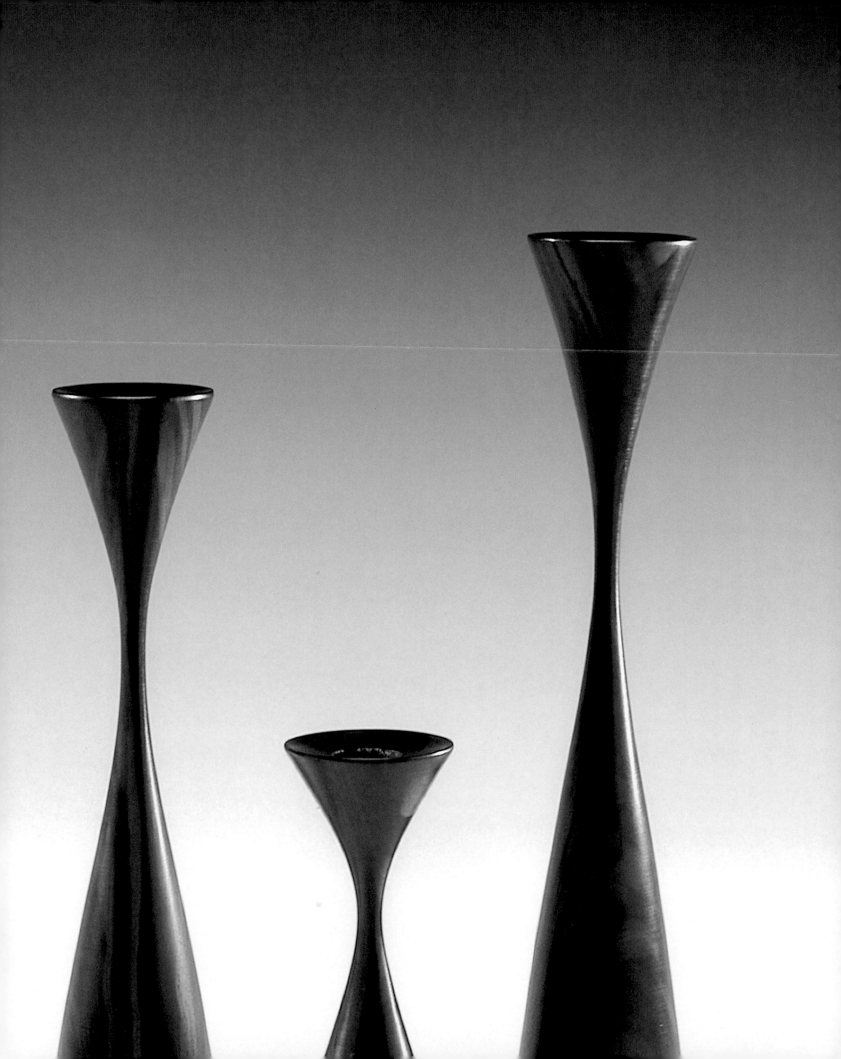

Ray Allen
born Dickson, TN 1930—died Yuma, AZ 2000
Vase, 1990. Maple and ebony, 8¾ x 10½ in.
diam., Gift of George Peter Lamb and Lucy
Scardino in memory of Natalie Rust Lamb,
1995.100.1

Diane Banks
born New York City; 1942;
Red Cone, 1996. Bamboo, tarlatan, glue, ink,
and thread, 33¼ x 8¼ in. diam. Gift of the
artist in honor of Sarah Moss, 1998.76.2

Diane Banks
Blue Cone, 1997. Spruce, glue, paint, ink, and
metallic powders, 26 x 19½ in. diam. Gift of
the artist in honor of Matthew Moss, 1998.76.1

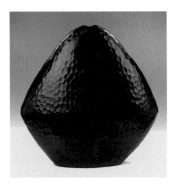

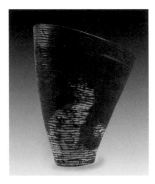

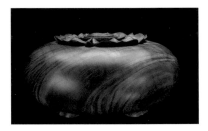

Michael Bauermeister
born Indianapolis, IN 1957
Buckeye, 2001. Linden, acrylic paint, hide glue,
stain, and lacquer, 29¾ x 29 x 9 in. Gift of
Jane and Arthur Mason, 2005.31.1

Michael Bauermeister
Cherry Arc, 2001. Cherry and acrylic paint,
14¾ x 13¾ x 8⅝ in. Gift of Francine and
Michael Goldberg, 2009.17

Brenda Behrens
born Topeka, KS 1940
Double Lotus, 1995. Myrtle, 4¼ x 8¾ in. diam.
Gift of Fleur and Charles Bresler in honor of
Kenneth R. Trapp, curator-in-charge of the
Renwick Gallery (1995–2003), 2003.60.1

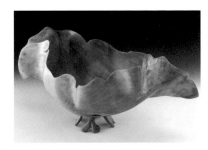

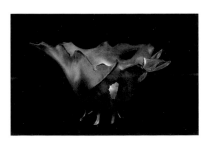

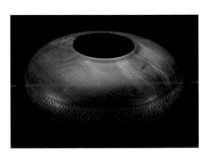

Derek A. Bencomo
born Torrance, CA 1962
Gift from the Sea, 1996. Norfolk Island pine,
11 x 22¾ x 13½ in. Gift of the artist,
1996.75

Derek A. Bencomo
Hana Valley, First View, from the "Peaks and
Valleys Series," 1995–97. Milo, 8¾ x 15¾ x
15½ in. Gift of Fleur and Charles Bresler in
honor of Kenneth R. Trapp, curator-in-charge
of the Renwick Gallery (1995–2003),
2003.60.2

Oliver Hilliard Booth III
born Columbia, SC 1940—died Annapolis, MD 1996
African Dance, 1988. Black walnut, 8½ x
17¼ in. diam. Gift of George Peter Lamb and
Lucy Scardino in memory of Natalie Rust Lamb,
1995.100.2

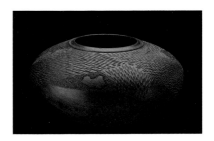

Oliver Hilliard Booth III
Bowl, 1996. Cherry, 6 ⅜ x 11 ⅛ x 11 ⅜ in.
Gift of Fleur and Charles Bresler in honor of
Kenneth R. Trapp, curator-in-charge of the
Renwick Gallery (1995–2003), 2003.60.3

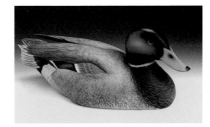

C. Don Briddell
born Crisfield, MD 1944
Drake Mallard, 1975. Balsa and pine with
acrylic paint, 6 ⅝ x 16 ¾ x 7 ⅝ in. Museum
purchase, 1975.167.1

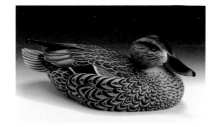

C. Don Briddell
Hen Mallard Waiting for Eggs. . . ., 1975.
Balsa and pine with acrylic paint, 6 ¼ x 16 ½
x 7 ½ in. Museum purchase, 1975.167.2

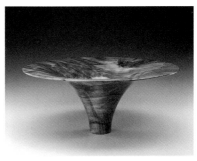

Phil Brown
born Denver, CO 1937
Maple Vessel, 1995. Maple, 7 ¼ x 17 ⅛ in.
diam. Museum purchase through the Renwick
Acquisitions Fund, 1995.61

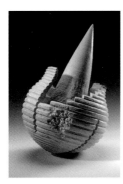

Christian Burchard
born Hamburg, Germany 1955
Ziggurat, 1992. Bleached madrone burl,
15 x 10 ⅝ in. x 11 ⅛ in. Gift of Anita and
Ronald Wornick, 1998.74

Christian Burchard
"Basket Series," 1997.
Madrone, height: ⅜–14 in.; width: ½–15 in.;
diam.: ½–13 ¾ in. Gift of John and Robyn
Horn, 1998.2A–I

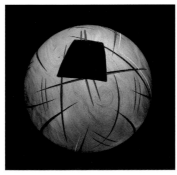

Christian Burchard
Dance, from the "Old Earth Series," 1997.
Primavera, 7 ⅞ x 8 ¼ in. diam. Gift of Fleur
and Charles Bresler in honor of Kenneth R.
Trapp, curator-in-charge of the Renwick Gallery
(1995–2003), 2003.60.4

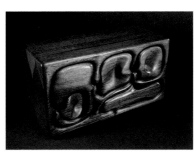

Arthur Espenet Carpenter
born New York City 1920—died Bolinas, CA 2006
Band Saw Box, 1972. Hyedua, 8 ¾ x 16 ⅛
x 7 ¼ in. Gift of David L. Davies and John D.
Weeden, 1998.130A–L

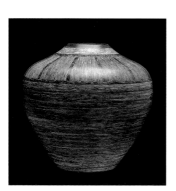

Galen Carpenter
born Newton, Kansas 1946
96-4, 1996. Cristobal and chipboard,
11 ⅝ x 10 ⅞ in. diam. Gift of Fleur and
Charles Bresler in honor of Kenneth R. Trapp,
curator-in-charge of the Renwick Gallery
(1995–2003), 2003.60.5

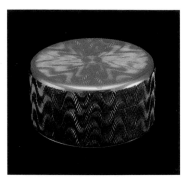

M. Dale Chase
born Grand Rapids, MI 1934—
died Penn Valley, CA 2007
First Gold Box, about 1996. 14k gold,
¾ x 1 ½ in. diam. Gift of Fleur and Charles
Bresler in honor of Kenneth R. Trapp,
curator-in-charge of the Renwick Gallery
(1995–2003), 2003.60.6A–B

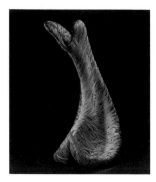

Barbara Cooper
born Philadelphia, PA 1949
Ova, 1994. Maple and cherry veneer, 73 x
34 x 40 in. Gift of W. Nikola-Lisa in honor of
Frances and Cecil Cooper, 2000.98

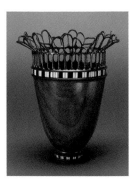

Frank E. Cummings III
born Los Angeles, CA 1938
Lady Lace with New Shoes, 1989. Black walnut,
ivory, gold, and onyx, 11¼ x 9 in. diam.
Gift of George Peter Lamb and Lucy Scardino in
memory of Natalie Rust Lamb, 1995.100.4

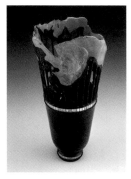

Frank E. Cummings III
On the Edge Naturally, 1990. Kingwood burl,
18k gold, and mother-of-pearl, 12¼ x 6⅛
x 7¼ in. Gift of Fleur and Charles Bresler,
2002.66A–B

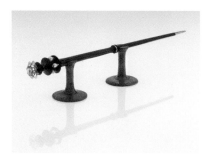

Frank E. Cummings III
Ode to Today, 1993. Ebony, 18k gold, pearls,
and imperial topaz, overall: 1⅜ x 6¾ x
1⅛ in.; wand: 6¾ x ½ in. diam.; stands: 1⅛
x 1⅛ in. diam. Gift of Fleur and Charles Bresler
in honor of Kenneth R. Trapp, curator-in-charge
of the Renwick Gallery (1995–2003),
2003.60.7A–C

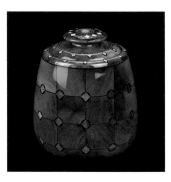

Robert Cutler
born Wendeler, ID 1944
Lidded Jar, 1996. Alaska diamond willow and
willow burl, mahogany, fossil mammoth tusk,
fossil walrus tusk, fossil bone, moose antler,
brass, copper, and sterling silver, 6¾ x 5⅝ in.
diam. Gift of Fleur and Charles Bresler in honor
of Kenneth R. Trapp, curator-in-charge of the
Renwick Gallery (1995–2003), 2003.60.8A–B

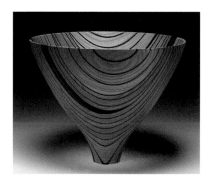

Virginia Dotson
born Newton, MA 1943
"Dunes Series #3," 1990. Ash, wenge, and
walnut, 8 x 9⅞ in. diam. Gift of Jane and
Arthur K. Mason on the occasion of the 25th
anniversary of the Renwick Gallery, 1996.98.1

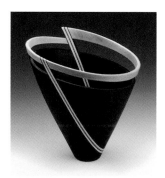

Virginia Dotson
Shadow Play #1, 1994.
Birch, maple, and aniline dye, 9½ x 8¾ in.
diam. Gift of George Peter Lamb and Lucy
Scardino in memory of Natalie Rust Lamb,
1995.100.5

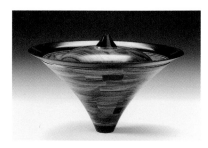

Addie Draper
born Albuquerque, NM 1952
Closed Vessel, 1989. Tulipwood, ebony, and
holly, 4¾ x 7⅜ in. diam. Gift of George Peter
Lamb and Lucy Scardino in memory of Natalie
Rust Lamb, 1995.100.6

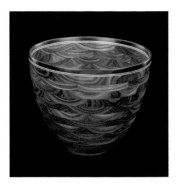

Addie Draper
Escher #2, 1990. Kingwood, ebony, holly, and birch veneers with dye, 4⅝ x 5 in. diam. Gift of Jane and Arthur K. Mason, 1991.169.2

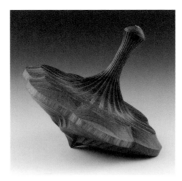

Gorst du Plessis
born Walton-on-Thames, Surrey, England 1938
Decorative Top, 1999. Pink ivory, 1¾ x 2 x 2⅛ in. diam. Gift of Fleur and Charles Bresler in honor of Kenneth R. Trapp, curator-in-charge of the Renwick Gallery (1995–2003), 2003.60.9

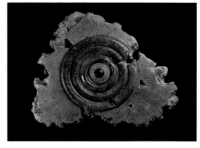

Dennis Elliott
born London, England 1950
Untitled (Wall Sculpture), 1992. Big-leaf maple burl, African blackwood, metal, and avonite, 34¼ x 39⅝ x 3 in. Gift of Honor Scott, 1992.44

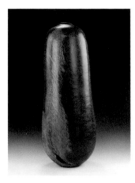

David Ellsworth
born Iowa City, IA 1944
Redwood Vessel, 1989. Redwood burl, 28¾ x 10½ in. diam. Gift of Jane and Arthur K. Mason, 1991.169.1

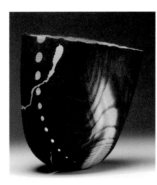

David Ellsworth
Patan, from the "Solstice Series," 1991. Ash and metallic fabric paint, 11½ x 10⅜ x 7⅞ in. Gift of Fleur and Charles Bresler in honor of Kenneth R. Trapp, curator-in-charge of the Renwick Gallery (1995–2003), 2003.60.10

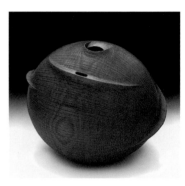

David Ellsworth
Mo's Delight, 1993. White oak, 3⅛ x 8¾ x 7¼ in. Gift of Fleur and Charles Bresler in honor of Kenneth R. Trapp, curator-in-charge of the Renwick Gallery (1995–2003), 2003.60.11

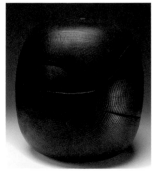

David Ellsworth
Black Pot, 1994. White ash, 14⅛ x 13½ in. diam. Gift of Jane and Arthur K. Mason on the occasion of the 25th anniversary of the Renwick Gallery, 1996.98.2

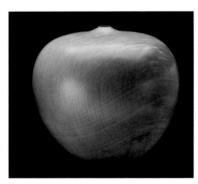

David Ellsworth
Sundown Pot, 1995. Curly silver maple, 10 x 11⅛ x 10½ in. Gift of Fleur and Charles Bresler in honor of Kenneth R. Trapp, curator-in-charge of the Renwick Gallery (1995–2003), 2003.60.12

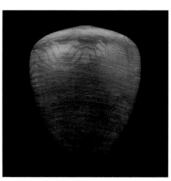

J. Paul Fennell
born Beverly, MA 1938
Vase, from the "Fraxinus Coloratus Series," 1989. Ash, 7¼ x 6 in. diam. Gift of George Peter Lamb and Lucy Scardino in memory of Natalie Rust Lamb, 1995.100.7

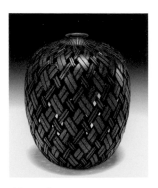

J. Paul Fennell
Mesquite Basket, 1998. Mesquite, 6 1/8 x 4 7/8 in. diam. Gift of Fleur and Charles Bresler in honor of Kenneth R. Trapp, curator-in-charge of the Renwick Gallery (1995–2003), 2003.60.13

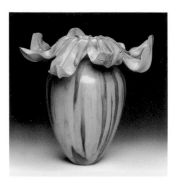

Ron Fleming
born Oklahoma City, OK 1937
Red Fern, 1995. Box elder, 15 7/8 x 15 5/8 x 15 1/2 in. diam. Gift of Fleur and Charles Bresler in honor of Kenneth R. Trapp, curator-in-charge of the Renwick Gallery (1995–2003), 2003.60.15

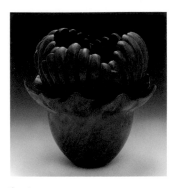

Ron Fleming
Desert Rose, 1996. Madrone burl, 7 1/8 x 6 3/4 x 6 3/4 in. diam. Gift of Fleur and Charles Bresler in honor of Kenneth R. Trapp, curator-in-charge of the Renwick Gallery (1995–2003), 2003.60.14

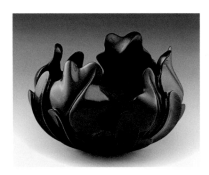

Ron Fleming
Black Lotus, 1996. Ebony, 3 3/4 x 5 5/8 x 5 7/8 in. diam. Gift of Fleur and Charles Bresler in honor of Kenneth R. Trapp, curator-in-charge of the Renwick Gallery (1995–2003), 2003.60.16

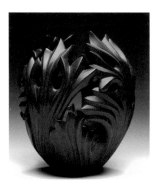

Ron Fleming
Prairie Fire, 1996. Pink ivory, 8 1/4 x 6 3/4 in. diam. Gift of Fleur and Charles Bresler in honor of Kenneth R. Trapp, curator-in-charge of the Renwick Gallery (1995–2003), 2003.60.17

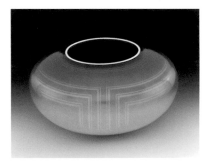

Giles Gilson
born Philadelphia, PA 1942
Sunset, 1987. Basswood and aluminum with lacquer, 12 1/4 x 24 in. diam. Gift of George Peter Lamb and Lucy Scardino in memory of Natalie Rust Lamb, 1995.100.8

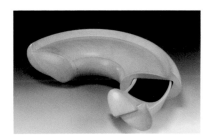

Michael N. Graham
born Stockton, CA 1943
Split Ellipse, 1988. Bleached maple and flock, 3 7/8 x 15 3/4 x 7 1/2 in. Gift of George Peter Lamb and Lucy Scardino in memory of Natalie Rust Lamb, 1995.100.9A–B

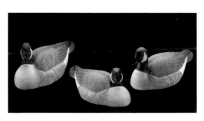

Delwyn Herbert
born Coaldale, PA 1942
Aleutian Canada Geese, 1999. Tupelo and acrylic paint, part A: 10 x 16 x 9 in.; part B: 16 x 13 x 9 in.; part C: 11 x 15 x 7 1/2 in. Gift of Del and Judy Herbert, 1999.61A–C

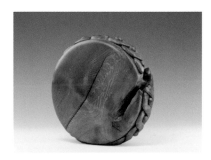

Michelle Holzapfel
born Woonsocket, RI 1951
Untitled, 1986. Maple burl, 11 1/8 x 11 1/2 x 3 1/2 in. Gift of Fleur and Charles Bresler in honor of Kenneth R. Trapp, curator-in-charge of the Renwick Gallery (1995–2003), 2003.60.18

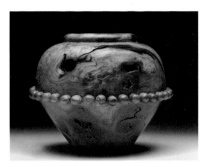

Michelle Holzapfel
Untitled, 1986.
Cherry burl, 9⅝ x 11¾ in. diam. Gift of Fleur and Charles Bresler in honor of Kenneth R. Trapp, curator-in-charge of the Renwick Gallery (1995–2003), 2003.60.19

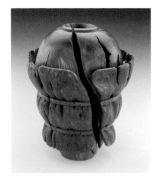

Michelle Holzapfel
Bound Vase, 1989.
Cherry burl, 15 x 12½ in. diam. Gift of Jane and Arthur K. Mason on the occasion of the 25th anniversary of the Renwick Gallery, 1996.98.3

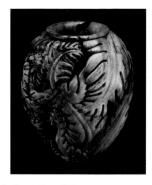

Michelle Holzapfel
Autumn Vase, 1993. Sugar maple burl, 13¾ x 10⅝ x 10⅞ in. diam. Gift of Fleur and Charles Bresler in honor of Kenneth R. Trapp, curator-in-charge of the Renwick Gallery (1995–2003), 2003.60.20

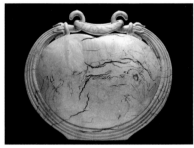

Michelle Holzapfel
Suspended Ring Vase, 1996.
Spalted sugar maple burl, 12⅝ x 14⅜ x 5¾ in. Gift of Fleur and Charles Bresler in honor of Kenneth R. Trapp, curator-in-charge of the Renwick Gallery (1995–2003), 2003.60.21

Michelle Holzapfel
Table Bracelet: Promenade Suite, 1997. Maple, birch, cherry, and brass, 15⅜ x 87⅝ x 11⅝ in. (linear) Gift of Fleur Bresler, 1999.8A–J

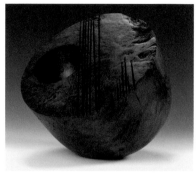

Robyn Horn
born Fort Smith, AR 1951
Seven Liner, 1991. Redwood burl, 12 x 11½ x 12 in. Gift of the artist, 1996.73

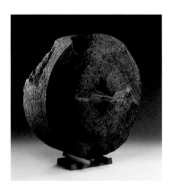

Robyn Horn
Slashed Millstone, 1996. Ebonized redwood burl and ebony, 21⅜ x 19⅝ x 8 in. Gift of Margot R. Heckman, 2003.30A–B

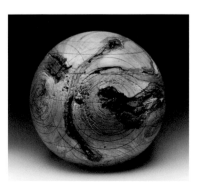

Todd Hoyer
born Beaver Dam, WI 1952
Sphere, 1988. Arizona ash, 15¼ x 15¾ in. diam. Gift of Fleur and Charles Bresler, 1998.11.1

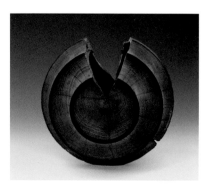

Todd Hoyer
"Ringed Series," 1993. Mulberry, 13¾ x 15½ x 15 in. Gift of Fleur and Charles Bresler, 1998.11.2

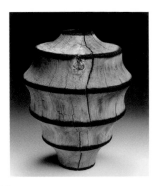

Todd Hoyer
"Ringed Series," 1993. Sycamore, 11 ½ x 9 in. diam. Gift of Fleur and Charles Bresler in honor of Kenneth R. Trapp, curator-in-charge of the Renwick Gallery (1995–2003), 2003.60.23

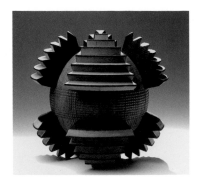

Todd Hoyer
Suspended Sphere, 1994. Sycamore, 12¾ x 12½ in. diam. Gift of Fleur and Charles Bresler in honor of Kenneth R. Trapp, curator-in-charge of the Renwick Gallery (1995–2003), 2003.60.22

William Hunter
born Long Beach, CA 1947
Visions, 1987. Cocobolo, 14 ⅛ x 7 ⅞ in. diam. Gift of Jane and Arthur K. Mason, 1991.169.4

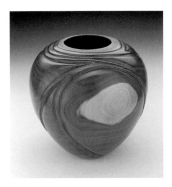

William Hunter
Cuzco Moon, 1987. Vera, 14¼ x 14½ in. diam. Gift of Jane and Arthur K. Mason on the occasion of the 25th anniversary of the Renwick Gallery, 1996.98.4

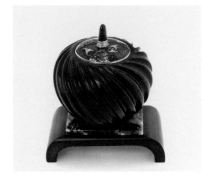

William Hunter born Long Beach, CA 1947
Marianne Hunter born Los Angeles, CA 1949
Evening Blossom, 1989. Ebony, 24k gold, sterling silver, enamel, amethyst, and charoite, 4 x 3½ x 2⅞ in. with base. Gift of Fleur and Charles Bresler in honor of Kenneth R. Trapp, curator-in-charge of the Renwick Gallery (1995–2003), 2003.60.26A–C

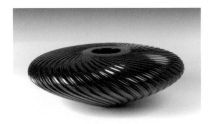

William Hunter
Ascending Flutes, 1990. Cocobolo, 4⅞ x 13¼ in. diam. Gift of George Peter Lamb and Lucy Scardino in memory of Natalie Rust Lamb, 1995.100.10

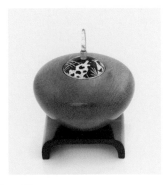

William Hunter
Marianne Hunter
Africa, 1990. Satinwood, ebony, 24k gold, sterling silver, fine silver, enamel, and rutilated quartz, 4⅝ x 3⅜ x 3⅜ in. with base. Gift of Fleur and Charles Bresler in honor of Kenneth R. Trapp, curator-in-charge of the Renwick Gallery (1995–2003), 2003.60.27A–C

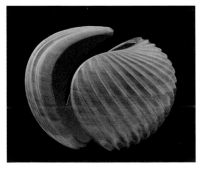

William Hunter
Golden Shell, 1994. Satinwood, 3⅞ x 4¼ x 5 in. diam. Gift of Fleur and Charles Bresler in honor of Kenneth R. Trapp, curator-in-charge of the Renwick Gallery (1995–2003), 2003.60.24

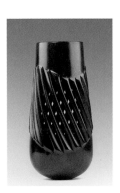

William Hunter
Even Through Midnight I Can See Diamonds, 1995. Gabon ebony, 14 x 6⅝ in. diam. Gift of Fleur and Charles Bresler in honor of Kenneth R. Trapp, curator-in-charge of the Renwick Gallery (1995–2003), 2003.60.25

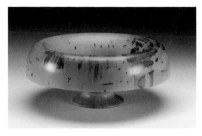

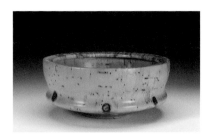

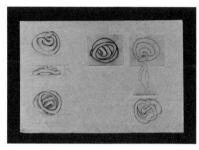

Marshall Elliott Jacobs
born Washington, DC 1923—
died Chevy Chase, MD 2006
Water Fall, 1994. Norfolk Island pine, 4½ x
10¾ in. diam. Gift of Shirley and Marshall
Jacobs, 1998.29.1

Marshall Elliott Jacobs
Knots, 1994. Norfolk Island pine, 6 x 13⅜ in.
diam. Gift of Shirley and Marshall Jacobs,
1998.29.2

Janel Jacobson
born Minneapolis, MN 1950
Untitled (Studies for Coiled Snake), 1996.
Graphite on paper, 9 x 11¾ in. Gift of Fleur
and Charles Bresler, 2006.32

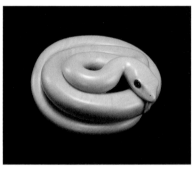

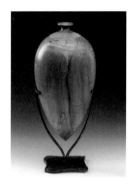

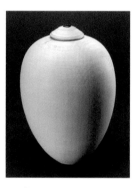

Janel Jacobson
Coiled Snake, 1997. Boxwood with gold and
antique gold powder, and cyanoacrylate, ⅞ x
1⅞ in. diam. Gift of Fleur and Charles Bresler
in honor of Kenneth R. Trapp, curator-in-charge
of the Renwick Gallery (1995–2003),
2003.60.28

John Jordan born Nashville, TN 1950
Joe Miller born Hartford, MI 1944
Amphora, 1990. Red maple, steel, and string,
16⅜ x 6½ x 6⅜ in. Gift of George Peter
Lamb and Lucy Scardino in memory of Natalie
Rust Lamb, 1995.100.11A–B

John Jordan
Lidded Jar, 1991. Bleached box elder and pink
ivory, 11⅝ x 8 in. diam. Gift of George Peter
Lamb and Lucy Scardino in memory of Natalie
Rust Lamb, 1995.100.12A–B

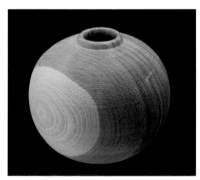

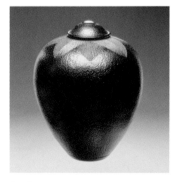

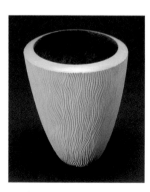

John Jordan
Vase, 1991. Honey locust, 5 x 5½ in. diam. Gift
of George Peter Lamb and Lucy Scardino in
memory of Natalie Rust Lamb, 1995.100.13

John Jordan
Black Textured Jar, 1994. Box elder, fossilized
ivory, india ink, and lacquer, 11⅞ x 9 in. diam.
Gift of the Smithsonian Women's Committee in
honor of Michael W. Monroe, Renwick Gallery
curator-in-charge, 1986–1995, 1995.41A–B

John Jordan
Vase, 1994. Bleached box elder and patinated
pigment, 6⅝ x 5¼ in. diam. Gift of George
Peter Lamb and Lucy Scardino in memory of
Natalie Rust Lamb, 1995.100.14

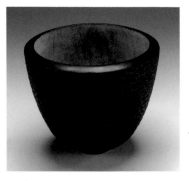

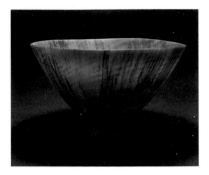

John Jordan
Vase, 1994. Box elder and patinated pigment,
4¾ x 5⅝ in. diam. Gift of George Peter Lamb
and Lucy Scardino in memory of Natalie Rust
Lamb, 1995.100.15

Charles Kegley born Houston, TX 1952
Tami Kegley born Waco, TX 1961
Untitled, 1997. Honduras mahogany, 27⅛
x 27 x 2⅜ in. diam. Gift of Fleur and
Charles Bresler in honor of Kenneth R. Trapp,
curator-in-charge of the Renwick Gallery
(1995–2003), 2003.60.29

Ron Kent
born Chicago, IL 1931. *Translucent Bowl,* 1986.
Norfolk Island pine, 9 x 14⅜ in. diam. Gift of
the James Renwick Alliance, 1987.42

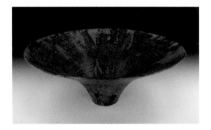

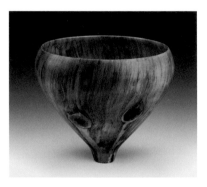

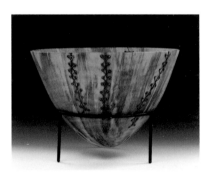

Ron Kent
Untitled, about 1988. Norfolk Island pine, 6¾ x
18⅛ in. diam. Gift of Eleanor T. and Samuel J.
Rosenfeld, 2002.8.6

Ron Kent
Footed Vessel, 1994. Norfolk Island pine, 9¼ x
10¼ in. diam. Gift of the artist, 1994.103

Ron Kent
Untitled, from the "Post-Nuclear Series," 2000.
Norfolk Island pine and copper, 9⅛ x 12¼ in.
diam. Gift of Helen Williams Drutt English and
H. Peter Stern in honor of the 35th anniversary
of the Renwick Gallery, 2007.47.17A–B

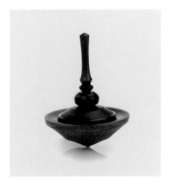

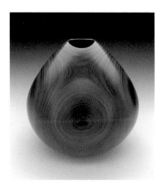

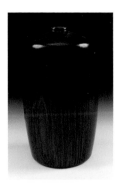

Bonnie Klein
born Los Angeles, CA 1942.
Top Secrets II, 1994. Pink ivory and ebony,
2½ x 1⅞ in. diam. Gift of Fleur and
Charles Bresler in honor of Kenneth R. Trapp,
curator-in-charge of the Renwick Gallery
(1995–2003), 2003.60.30A–C

Dan Kvitka
born Los Angeles, CA 1958
Node Form, 1987. Vera, 10 x 10¾ in. diam.
Gift of Jane and Arthur K. Mason on the
occasion of the 25th anniversary of the
Renwick Gallery, 1996.98.9

Dan Kvitka
Bottle Form, about 1988. Cocobolo, 11½ x
6½ in. diam. Gift of Eleanor T. and Samuel J.
Rosenfeld, 2002.8.7

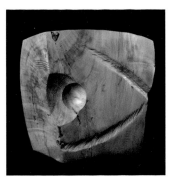

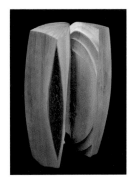

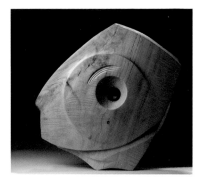

Stoney Lamar
born Alexandria, LA 1951.
Red, 1990. Box elder, 13⅜ x 14⅜ x 4⅞ in.
Gift of George Peter Lamb and Lucy Scardino in
memory of Natalie Rust Lamb, 1995.100.16

Stoney Lamar
Silent Perch, 1992. Dogwood, 14⅝ x 9 x
8 in. Gift of Jane and Arthur K. Mason on the
occasion of the 25th anniversary of the Renwick
Gallery, 1996.98.5

Stoney Lamar
Self-Portrait, 1992. Box elder, 17⅞ x 18¼ x
6½ in. Gift of Fleur and Charles Bresler in
honor of Kenneth R. Trapp, curator-in-charge of
the Renwick Gallery (1995–2003), 2003.60.31

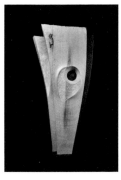

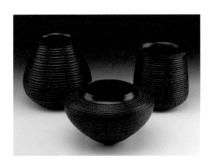

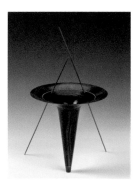

Stoney Lamar
Trio, 1999. Dogwood and steel, 28 x 12 x 7 in.
Gift of John and Robyn Horn, 1999.55

Bud Latven
born Philadelphia, PA 1949
Textured Anasazis, 1987. Honduras mahogany
(and with shoe polish for C), A: 4¾ x 7½ in.
diam. B: 7 x 7 in. diam. C: 6 x 5½ in. diam.
Gift of George Peter Lamb and Lucy Scardino in
memory of Natalie Rust Lamb, 1995.100.17A–C

Bud Latven
Tightwire, 1989. Macassar ebony, pink ivory,
holly and birch veneers, dye, sterling silver, and
steel, 13 x 7½ x 6½ in. Gift of George Peter
Lamb and Lucy Scardino in memory of Natalie
Rust Lamb, 1995.100.20

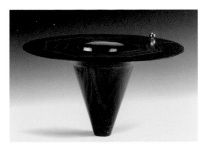

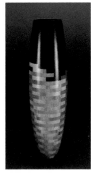

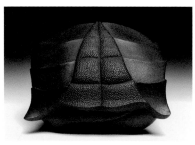

Bud Latven
Spheres, 1989. Macassar ebony, birch veneers,
sterling silver, and dye, 5½ x 8¾ in. diam. Gift
of George Peter Lamb and Lucy Scardino in
memory of Natalie Rust Lamb, 1995.100.21

Bud Latven
Integration, 1992. Maple and African black-
wood, 13⅝ x 3⅝ in. diam. Gift of Fleur and
Charles Bresler in honor of Kenneth R. Trapp,
curator-in-charge of the Renwick Gallery
(1995–2003), 2003.60.32

Michael Lee
born Honolulu, HI 1960
Armored Crab, 1998. Kingwood, 2⅝ x 5⅞
x 5⅛ in. Gift of Fleur and Charles Bresler in
honor of Kenneth R. Trapp, curator-in-charge of
the Renwick Gallery (1995–2003), 2003.60.33

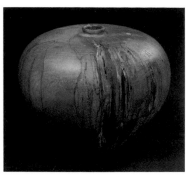

Mark Lindquist
born Oakland, CA 1949
Untitled, 1972. Maple, 7 x 8 in. diam. Gift of
Judith and Jonathan Knight, 2003.67.2

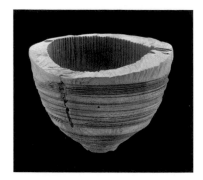

Mark Lindquist
Ascending Bowl #3, 1981.
Black walnut, 8 ¼ x 11 ⅜ in. diam. Gift of an
anonymous donor, 1981.131

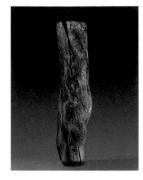

Mark Lindquist
Akikonomu, from the "Ichiboku Series," 1989.
Cherry, acrylic paint, and stain, 73 ¼ x 17 ½ x
17 in. Gift of Jane and Arthur Mason in honor
of Michael Monroe, 2005.31.2

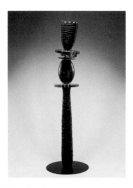

Mark Lindquist
Silent Witness #6~Dh0:\Taciturn, from the "Post
Totemic Series," 1991–95. Black walnut, mixed
media, mixed metals, and found objects, 86 x
24 in. diam. Gift of the James Renwick Alliance
in memory of our nation's loss on September 11,
2001, 2002.29

Mark Lindquist
Ascending Bowl #1, 1992. Walnut, 16 ¼ x
11¼ in. diam. Gift of Fleur and Charles Bresler
in honor of Kenneth R. Trapp, curator-in-charge
of the Renwick Gallery (1995–2003),
2003.60.34

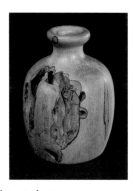

Melvin Lindquist
born Kingsburg, CA 1911—died Quincy, FL 2000
Untitled, 1972. Maple, 7 x 5 ½ in. diam. Gift of
Judith and Jonathan Knight, 2003.67.1

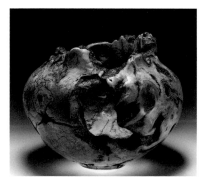

Melvin Lindquist
Hopi Bowl, 1989. Spalted maple burl, 11 ⅝ x
14 in. diam. Gift of Jane and Arthur K. Mason
on the occasion of the 25th anniversary of the
Renwick Gallery, 1996.98.6

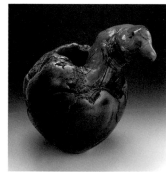

Melvin Lindquist
Vase with Duckbill Handle, 1991. Manzanita
burl, 9 ½ x 8 ¼ x 7 ¼ in. Gift of Fleur and
Charles Bresler in honor of Kenneth R. Trapp,
curator-in-charge of the Renwick Gallery
(1995–2003), 2003.60.35

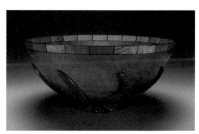

Barry T. Macdonald
born Detroit, MI 1945
Large Bowl, 1991. Black walnut, lacewood,
and padauk, 9 ⅛ x 19 in. diam. Gift of Fleur
and Charles Bresler in honor of Kenneth R.
Trapp, curator-in-charge of the Renwick Gallery
(1995–2003), 2003.60.38

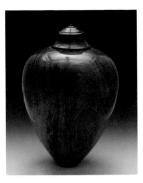

Barry T. Macdonald
Carob Jar #192, about 1993. Carob, ebony, and bloodwood, 12 x 7⅞ in. diam. Gift of Fleur and Charles Bresler in honor of Kenneth R. Trapp, curator-in-charge of the Renwick Gallery (1995–2003), 2003.60.37A–B

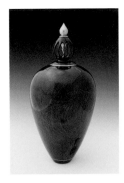

Barry T. Macdonald
Bottiglia Barrocco, 1994. Rosewood burl, ebony, and brass, 9¾ x 4½ in. diam. Gift of Fleur and Charles Bresler in honor of Kenneth R. Trapp, curator-in-charge of the Renwick Gallery (1995–2003), 2003.60.36A–B

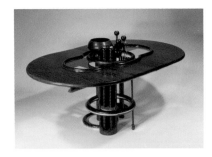

Rory McCarthy
born New York City 1948
Dining Table, 1976. Padauk, wenge, imbuia, bubinga, shedua, glass, Plexiglas, and aluminum, 40¾ x 77¾ in. diam. Gift of Walter Rich, 1991.167A–M

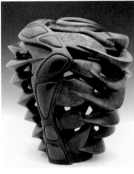

Hugh E. McKay
born Long Beach, CA 1951
Morata, 1997. Madrone burl and pipestone, 10¼ x 9⅜ in. diam. Gift of Fleur and Charles Bresler in honor of Kenneth R. Trapp, curator-in-charge of the Renwick Gallery (1995–2003), 2003.60.39

Rene Megroz
born Zurich, Switzerland 1942
Trench Coat, 1997. Sugar pine, brass, and ink, 49¾ x 15 x 6 in. Gift of the artist, 1997.65A–B

Johannes Michelsen
born Copenhagen, Denmark 1945
Untitled, 1990. Spalted maple burl with lacquer, 24½ x 15½ in. diam. Gift of George Peter Lamb and Lucy Scardino in memory of Natalie Rust Lamb, 1995.100.22

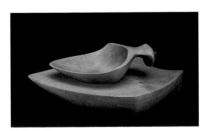

Emil Milan
born Roselle, NJ 1922—died Thompson, PA 1985
Cutting Board and Scoop, 1975. Maple, 2⅞ x 19⅛ x 10¾ in. Museum purchase, 1975.172A–B

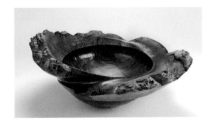

Bruce Mitchell
born San Rafael, CA 1949
Star Chamber, 1987. Walnut burl, 12¼ x 26¾ x 24 in. Gift of Jane and Arthur K. Mason, 1991.169.3

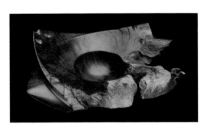

Bruce Mitchell
Canyon Oasis #4, 1995. Redwood root burl, 6⅝ x 13¾ x 15⅛ in. Gift of Fleur and Charles Bresler in honor of Kenneth R. Trapp, curator-in-charge of the Renwick Gallery (1995–2003), 2003.60.40

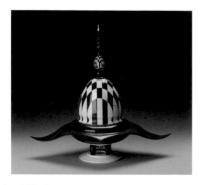

Michael Mode
born Quakertown, PA 1946
Akbar's Accession, 1997. Purpleheart, holly, rosewoods, ebony, and pink ivory, 19 x 19 x 12 in. Gift of an anonymous donor, 1997.12A–B

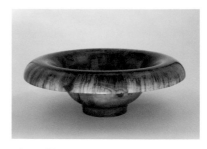

Edward Moulthrop
born Rochester, NY 1916 —
died Atlanta, GA 2003
Rolled-Edge Bowl, 1988–89. Tulipwood, 9¼ x 29½ in. diam. Gift of the James Renwick Alliance and museum purchase through the Smithsonian Institution Collections Acquisition Program, 1990.9

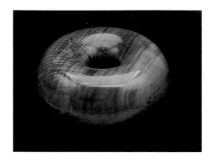

Edward Moulthrop
Donut Bowl, about 1990. Maple, 5¼ x 8½ in. diam. Gift of Fleur and Charles Bresler in honor of Kenneth R. Trapp, curator-in-charge of the Renwick Gallery (1995–2003), 2003.60.41

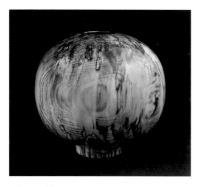

Edward Moulthrop
Hackberry Spheroid, 1995. Hackberry, 17⅝ x 17⅞ in. diam. Gift of the James Renwick Alliance on the occasion of the 25th anniversary of the Renwick Gallery, 1997.63

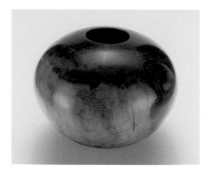

Philip Moulthrop
born Atlanta, GA 1947
Figured Tulip Poplar Bowl, 1987. Tulip poplar, 13¾ x 17 in. diam. Gift of David S. Purvis and members of the American Art Forum, 1988.9

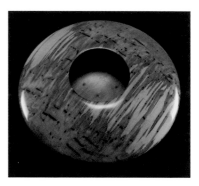

Philip Moulthrop
Ash Leaf Maple, 2003. Ash leaf maple, 4½ x 13¼ in. diam. Gift of Jane and Arthur Mason, 2005.31.3

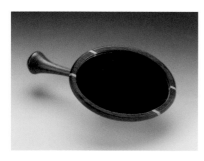

Kenneth Nelsen
born Northfield, Minnesota 1941
Hand Mirror, n.d., original design 1974. Walnut and bird's-eye maple, 11 x 5⅜ x 4½ in. Museum purchase, 1975.174

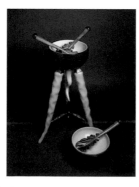

Craig Nutt
born Belmond, IA 1950
Radish Salad Bowl, 1998. Bleached maple, birch, and tupelo with lacquer and dye, 55⅝ x 21 x 21 in. Gift of the James Renwick Alliance, 1999.5A–L

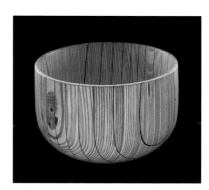

Rude Osolnik
born Dawson, NM 1915—died Berea, KY 2001
Laminated Birchwood Bowl, about 1975. Birch plywood and walnut, 7 x 11 in. diam. Museum purchase, 1975.175

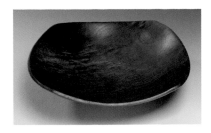

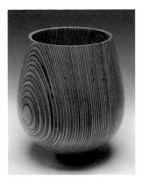

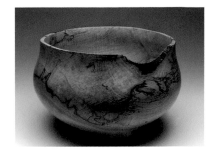

Rude Osolnik
Bowl, 1983. Walnut, 5⅛ x 16⅞ x 16¼ in.
Gift of Fleur and Charles Bresler in honor of
Kenneth R. Trapp, curator-in-charge of the
Renwick Gallery (1995–2003), 2003.60.42

Rude Osolnik
Vase, 1984. Birch plywood and walnut, 7⅜
x 6 in. diam. Gift of George Peter Lamb and
Lucy Scardino in memory of Natalie Rust Lamb,
1995.100.23

Rude Osolnik
Bowl, 1984. Spalted maple, 8⅞ x 13 in. diam.
Gift of Fleur and Charles Bresler in honor of
Kenneth R. Trapp, curator-in-charge of the
Renwick Gallery (1995–2003), 2003.60.43

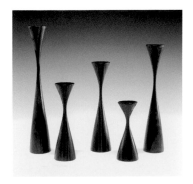

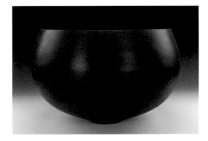

Rude Osolnik
Five Candlesticks, 1988. Macassar ebony,
height: 6¼–14¼ in.; diam.: 2⅜ in. Gift of
Fleur and Charles Bresler in honor of Kenneth R.
Trapp, curator-in-charge of the Renwick Gallery
(1995–2003), 2003.60.44A–E

Rude Osolnik
Stack Laminated Mahogany Bowl, 1990.
Mahogany, 11¾ x 18⅝ in. diam. Gift of the
artist and Connell Gallery in loving memory of
Daphne Francis Osolnik, 1999.105

Stephen Paulsen born Palo Alto, CA 1947
*The Recently Exposed Chamber of Esperanza
and Descanso,* 1988. Wenge, rosewood,
mahogany, buckeye burl, wild lilac, desert
ironwood, ebony, snakewood, olive wood, pink
ivory, kingwood, antique ivory, partridgewood,
arariba, manzanita, 22k gold, tagua, stones,
and Plexiglass, 9 x 12 x 6 in. Gift of George
Peter Lamb and Lucy Scardino in memory of
Natalie Rust Lamb, 1995.100.24

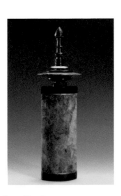

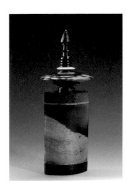

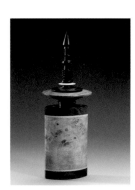

Stephen Paulsen
Scent Bottle, 1995. Camphor burl, ebony,
arariba, ironwood, tagua, and maple, 6½ x
2 in. diam. Museum purchase through the
Renwick Acquisitions Fund, 1995.53.1A–D

Stephen Paulsen
Scent Bottle, 1995. Rosewood, arariba,
ebony, tagua, and maple, 5⅛ x 2⅛ in.
diam. Museum purchase through the Renwick
Acquisitions Fund, 1995.53.2A–D

Stephen Paulsen
Scent Bottle, 1995. Maple, macassar ebony,
ebony, poinciana, tagua, and maple, 5½ x
1⅞ in. diam. Museum purchase through the
Renwick Acquisitions Fund, 1995.53.3A–D

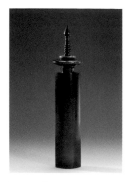

Stephen Paulsen
Scent Bottle, 1995. Ebony, poinciana, and tagua, 7 x 1 ½ in. diam. Museum purchase through the Renwick Acquisitions Fund, 1995.53.4A–D

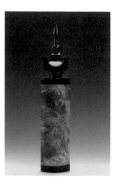

Stephen Paulsen
Scent Bottle, 1995. Myrtle burl, cocobolo, tagua, and maple, 8 ¼ x 1 ½ x 1 in. Museum purchase through the Renwick Acquisitions Fund, 1995.53.5A–D

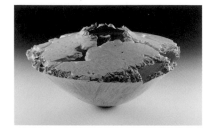

Michael Peterson
born Wichita Falls, TX 1952. *White Stone Desert #2,* 1988. Bleached maple burl, 7 x 13 ¾ in. diam. Gift of George Peter Lamb and Lucy Scardino in memory of Natalie Rust Lamb, 1995.100.25

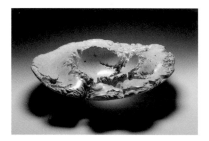

Michael Peterson
Desert Cloud, 1988. Bleached maple burl, 4 ¼ x 16 x 14 ½ in. Gift of Jane and Arthur K. Mason on the occasion of the 25th anniversary of the Renwick Gallery, 1996.98.8

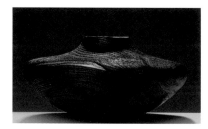

Michael Peterson
Mesa, from the "Landscape Series," 1993. Locust and india ink, 5 x 9 ⅞ in. diam. Gift of Fleur and Charles Bresler in honor of Kenneth R. Trapp, curator-in-charge of the Renwick Gallery (1995–2003), 2003.60.45

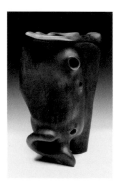

Michael Peterson
Bird House, 1994. Madrone, 9 ¾ x 6 x 4 ¾ in. Gift of Fleur and Charles Bresler in honor of Kenneth R. Trapp, curator-in-charge of the Renwick Gallery (1995–2003), 2003.60.46

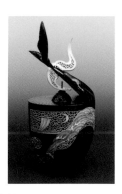

Binh Pho
born Saigon, Vietnam 1955 *Journey to Destiny,* 2003. Oak, maple, gold leaf, acrylic paint, and dye, 12 ¾ x 7 ½ in. diam. Gift of Jane and Arthur Mason, 2005.31.5A–C

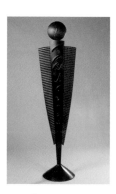

Peter Pierobon
born Vancouver, British Columbia, Canada 1957 *Time Totem,* 1993. Ebonized mahogany, mahogany, and steel, 95 x 25 x 20 in. Gift of MCI, 2001.89.2

Peter Pierobon
A long life may not be good enough, but a good life is long enough, 1997. Ebonized mahogany, 2 ½ x 29 ⅝ in. diam. Gift of Diane and Marc Grainer, 2000.52

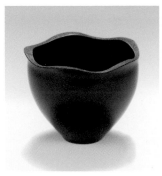

Gene Pozzesi
born San Francisco, CA 1936—
died Concord, CA 2002
Untitled, about 1996. Gabon ebony, 4⅛ x
4⅞ in. diam. Gift of Fleur and Charles Bresler in
honor of Kenneth R. Trapp, curator-in-charge of
the Renwick Gallery (1995–2003), 2003.60.47

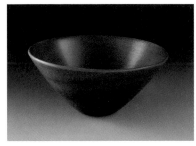

James Prestini
born Waterford, CT 1908—
died Berkeley, CA 1993
Bowl, 1933–53. Birch, 1¾ x 4⅜ in. diam.
Gift of the artist, 1970.46.1

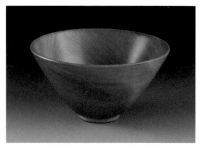

James Prestini
Bowl, 1933–53. Birch, 2⅝ x 4¾ in. diam.
Gift of the artist, 1970.46.2

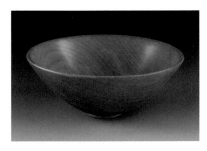

James Prestini
Bowl, 1933–53. Mexican mahogany, 2¾ x
6⅛ in. diam. Gift of the artist, 1970.46.3

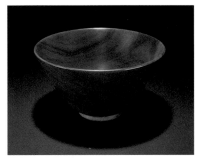

James Prestini
Bowl, 1933–53. Black walnut, 3¾ x 6¾ in.
diam. Gift of the artist, 1970.46.4

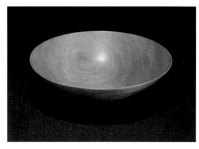

James Prestini
Bowl, 1933–53. Birch, 1¾ x 7 in. diam.
Gift of the artist, 1970.46.5

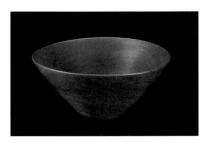

James Prestini
Bowl, 1933–53. Mexican mahogany, 3⅝ x
7⅝ in. diam. Gift of the artist, 1970.46.6

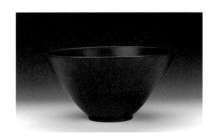

James Prestini
Bowl, 1933–53. Mexican mahogany,
4¾ x 9 in. diam. Gift of the artist, 1970.46.7

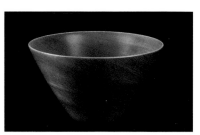

James Prestini
Bowl, 1933–53. Mexican mahogany, 5⅝ x
9¾ in. diam. Gift of the artist, 1970.46.8

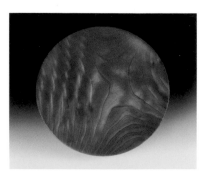

James Prestini
Bowl, 1933–53. Cherry, 1 7/8 x 10 1/2 in. diam.
Gift of the artist, 1970.46.9

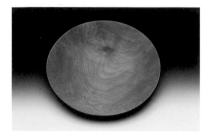

James Prestini
Bowl, 1933–53. Birch, 2 x 11 1/8 in. diam.
Gift of the artist, 1970.46.10

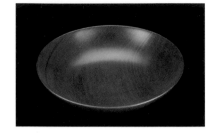

James Prestini
Bowl, 1933–53. Mexican mahogany, 3 x
11 5/8 in. diam. Gift of the artist, 1970.46.11

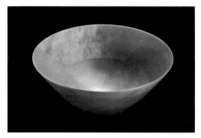

James Prestini
Yellow birch, 1933–1953, 5 1/2 x 12 in. diam.
Gift of the artist, 1970.46.12

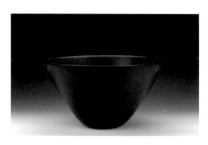

James Prestini
Bowl, 1933–53. Mexican mahogany, 7 3/8 x
13 1/2 in. diam. Gift of the artist, 1970.46.13

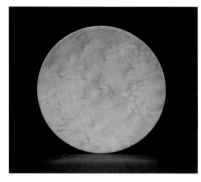

James Prestini
Platter, 1933–53. Bird's-eye maple, 3/4 x 7 1/4 in.
diam. Gift of the artist, 1970.46.14

James Prestini
Platter, 1933–53. Cherry, 7/8 x 8 in. diam.
Gift of the artist, 1970.46.15

James Prestini
Platter, 1933–53. Yellow birch, 7/8 x 10 1/4 in.
diam. Gift of the artist, 1970.46.16

James Prestini
Platter, 1933–53. Honduras mahogany, 3/4 x
11 1/2 in. diam. Gift of the artist, 1970.46.17

James Prestini
Platter, 1933–53. Sycamore, ½ x 12⅛ in. diam. Gift of the artist, 1970.46.18

James Prestini
Platter, 1933–53. Ebonized ash, 1⅛ x 13⅜ in. diam. Gift of the artist, 1970.46.19

James Prestini
Cigarette Cup, 1933–53. Teak, 2¼ x 2⅜ in. diam. Gift of the artist, 1970.46.20

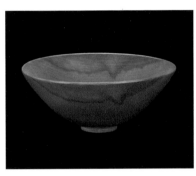

James Prestini
Bowl, 1933–53. Birch, 1⅞ x 4⅜ in. diam. Gift of George Peter Lamb and Lucy Scardino in memory of Natalie Rust Lamb, 1995.100.26

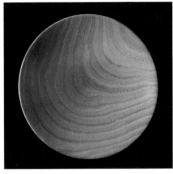

James Prestini
Saucer, 1933–53. Chestnut, 1 x 5⅜ in. diam. Gift of George Peter Lamb and Lucy Scardino in memory of Natalie Rust Lamb, 1995.100.27

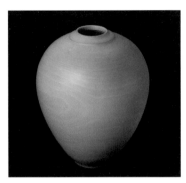

Allen Ritzman
born Ottumwa, IA 1952
Buckeye Vessel, about 1987. Buckeye, 7⅞ x 6 in. diam. Gift of George Peter Lamb and Lucy Scardino in memory of Natalie Rust Lamb, 1995.100.28

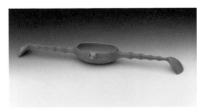

Norm Sartorius
born Salisbury, MD 1947
Spoon from a Forgotten Ceremony, 1994. Dogwood, 1½ x 18 x 3 in. Gift of John and Robyn Horn, 1994.75

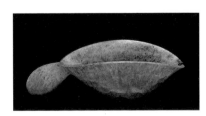

Norm Sartorius
Pita Bread Spoon, 1994. Amboyna burl, 2⅜ x 8⅞ x 3¼ in. Gift of Fleur and Charles Bresler in honor of Kenneth R. Trapp, curator-in-charge of the Renwick Gallery (1995–2003), 2003.60.50

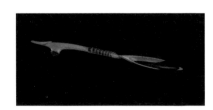

Norm Sartorius
Spear Spoon, 1997. African blackwood, ⅞ x 20⅞ x 2½ in. Gift of Fleur and Charles Bresler in honor of Kenneth R. Trapp, curator-in-charge of the Renwick Gallery (1995–2003), 2003.60.51

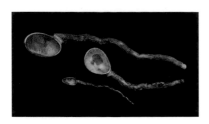

Norm Sartorius
Algerita Family, 1998. Algerita burl, a: 3⅛ x 16¾ x 3⅞ in.; b: 1¾ x 9⅝ x 2¾ in.; c: 1¼ x 7¼ x 1 in. Gift of Fleur and Charles Bresler in honor of Kenneth R. Trapp, curator-in-charge of the Renwick Gallery (1995–2003), 2003.60.48A–C

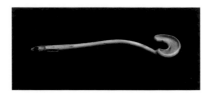

Norm Sartorius
Obsession, 1998. Maple, 2⅛ x 20¾ x 5⅞ in. Gift of Fleur and Charles Bresler in honor of Kenneth R. Trapp, curator-in-charge of the Renwick Gallery (1995–2003), 2003.60.49

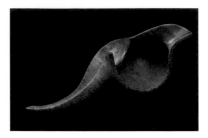

Norm Sartorius
Mutation, 1999. Mexican blue oak burl, 2½ x 9 x 4 in. Gift of John and Robyn Horn, Fleur Bresler, and Kenneth R. Trapp, 2000.15

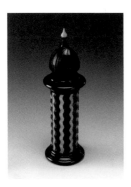

Jon Sauer
born San Francisco, CA 1949
Zig Zag Bottle, 1993. African blackwood and boxwood, 6¼ x 1⅞ in. diam. Gift of Fleur and Charles Bresler in honor of Kenneth R. Trapp, curator-in-charge of the Renwick Gallery (1995–2003), 2003.60.52A–D

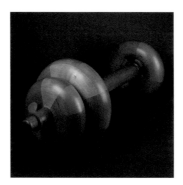

Merryll Saylan
born New York City 1936
Barbells for Arnold, 1978. Jelutong, overall: 49 x 15 in. diam. Gift of the artist, 1998.38A–I

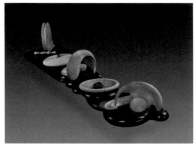

Betty Scarpino
born Wenatchee, WA 1949
From Within Our Own Bodies, 1999. Bleached curly maple and mahogany, 11⅝ x 80⅞ x 14¾ in. Gift of John and Robyn Horn, 2000.25A–N

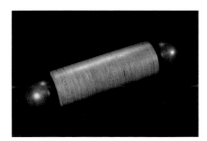

Lee A. Schuette
born Berlin, NH 1951
Rolling Pin, 1975. Birch plywood and walnut, 20⅛ x 4½ in. diam. Museum purchase, 1975.177

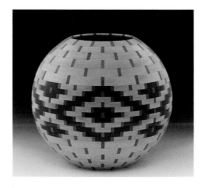

Lincoln Seitzman
born New York City 1923
Petrified Hopi Basket–Second Mesa, 1993. Guatambu, wenge, bloodwood, and lacewood, 13⅛ x 14⅝ in. diam. Gift of Fleur and Charles Bresler in honor of Kenneth R. Trapp, curator-in-charge of the Renwick Gallery (1995–2003), 2003.60.53

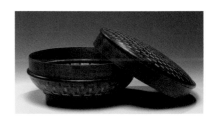

Lincoln Seitzman
Petrified Sewing Basket, 1995. Cherry, wenge, and imbuia, 6⅞ x 12⅞ in. diam. Gift of Fleur and Charles Bresler in honor of Kenneth R. Trapp, curator-in-charge of the Renwick Gallery (1995–2003), 2003.60.54A–B

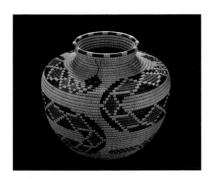

Lincoln Seitzman
#193 Yokut Snake Basket Illusion, 1996. Oak, ink, and acrylic paint, 10 x 12 in. diam. Gift of the artist and Connell Gallery, Atlanta, Georgia, 2002.7

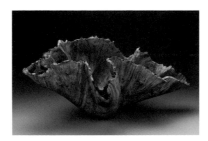

Brad Sells
born Cookeville, TN 1969
Spirit, 2000. Maple burl, 12⅛ x 25½ x 16 in. Gift of Dr. Donald and Mrs. Sue M. Spicer, 2001.54

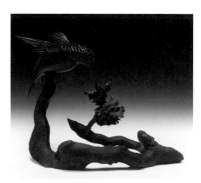

David Sengel
born Radford, VA 1951
Hummingbird Box, 1996. Box elder, rose thorns, locust, trifoliate orange thorns, laurel root, hazelnut husks, india ink, and lacquer, 5¾ x 7½ x 5⅛ in. Gift of Fleur and Charles Bresler in honor of Kenneth R. Trapp, curator-in-charge of the Renwick Gallery (1995–2003), 2003.60.55A–B

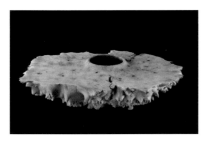

David Sengel
Vessel #19, 2000. Bleached big-leaf maple burl, 3⅞ x 13⅞ x 10⅝ in. Museum purchase through the Renwick Acquisitions Fund, 2002.44

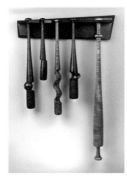

Mark Sfirri born Chester, PA 1952
Rejects from the Bat Factory, 1996. Mahogany, curly maple, cherry, zebrawood, cocobolo, and lacewood, overall: 37⅞ x 25⅜ x 5⅝ in.; bats: height: 15⅝–37⅛ in.; width: 2⅛–2¾ in. Gift of Fleur and Charles Bresler in honor of Kenneth R. Trapp, curator-in-charge of the Renwick Gallery (1995–2003), 2003.60.56A–F

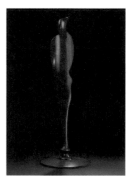

Mark Sfirri
Glancing Figure, 1997. Walnut, 46 x 15¾ in. diam. Gift of Fleur and Charles Bresler, 1998.137

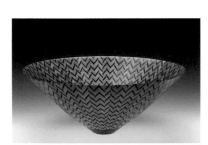

Mike Shuler
born Trenton, NJ 1950
Satinwood Bowl #458, 1989. Satinwood, bloodwood, and amaranth, with French polish, 4¾ x 11⅝ in. diam. Gift of Fleur and Charles Bresler in honor of Kenneth R. Trapp, curator-in-charge of the Renwick Gallery (1995–2003), 2003.60.57

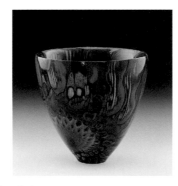

Mike Shuler
Monterey Pinecone Vase #602, 1991. Monterey pine with epoxy resin, 2¼ x 2⅜ in. diam. Gift of Fleur and Charles Bresler in honor of Kenneth R. Trapp, curator-in-charge of the Renwick Gallery (1995–2003), 2003.60.59

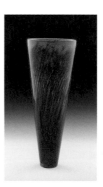

Mike Shuler
Protea Blossom Vase #705, 1994. Queen Protea blossom with epoxy resin, 4⅜ x 1⅝ in. diam. Gift of Fleur and Charles Bresler in honor of Kenneth R. Trapp, curator-in-charge of the Renwick Gallery (1995–2003), 2003.60.58

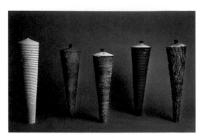

Jack R. Slentz
born Oklahoma City, OK 1963
A Group of Individuals, 1998–99. Ash and cherry, part A: 34½ x 9 in.; part B: 32½ x 8 in.; part C: 32½ x 9 in.; part D: 31 x 9 in.; part E: 29¼ in. x 8½ in. Gift of John and Robyn Horn, 1999.60A–E

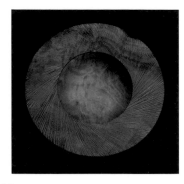

Al Stirt
born New York City 1946
Floating Rim Bowl, 1988. Myrtle burl, 3⅛ x 11½ in. diam. Gift of George Peter Lamb and Lucy Scardino in memory of Natalie Rust Lamb, 1995.100.29

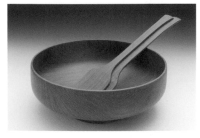

Bob Stocksdale
born Warren, IN 1913—died Oakland, CA 2003
Salad Bowl with Servers, about 1975. Teak, bowl: 3⅞ x 9¾ in. diam.; servers: ⅜ x 10½ x 2⅜ in. Museum purchase, 1975.178A–C

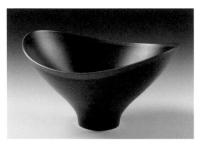

Bob Stocksdale
Bowl, 1978. African yokewood, 4 x 7 x 6¼ in. Gift of David C. Lund in memory of his father, Oscar, 1991.134

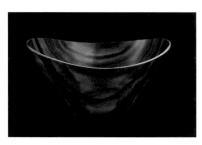

Bob Stocksdale
Bowl, 1986. Philippine ebony, 3⅝ x 6⅛ x 5¼ in. Gift of Jane and Arthur K. Mason, 1991.169.7

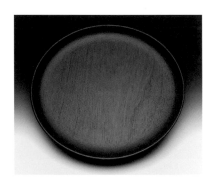

Bob Stocksdale
Plate, 1986. Wenge, 1⅝ x 12 in. diam. Gift of George Peter Lamb and Lucy Scardino in memory of Natalie Rust Lamb, 1995.100.30

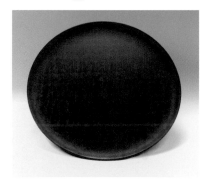

Bob Stocksdale
Tray, 1986. Honduras mahogany, 1 x 20⅜ in. diam. Gift of Jane and Arthur Mason, 2005.31.6

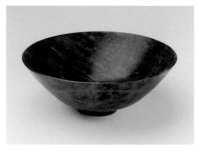

Bob Stocksdale
Bowl, 1987. Moroccan Thuja burl, 4⅜ x 11¼ in. diam. Gift of Jane and Arthur K. Mason, 1991.169.6

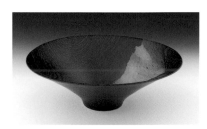

Bob Stocksdale
Bowl, 1988. Brazilian rosewood, 2¾ x 8¼ in. diam. Gift of Jane and Arthur K. Mason, 1991.169.8

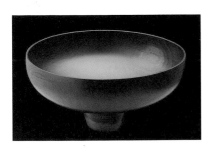

Bob Stocksdale
Bowl, 1988. Pink ivorywood, 4 x 7 ½ in. diam.
Gift of Jane and Arthur K. Mason, 1991.169.9

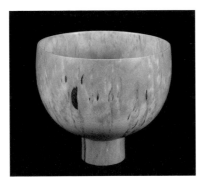

Bob Stocksdale
Bowl, 1990. Masur birch, 4 ⅛ x 4 ½ in. diam.
Gift of Jane and Arthur K. Mason, 1991.169.5

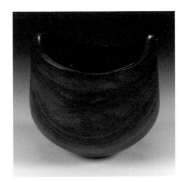

Bob Stocksdale
Bowl, 1992. Brazilian rosewood, 5 x 5 in. diam.
Gift of Colleen and John Kotelly in honor of
Jane and Arthur Mason, 2003.63

Jack Straka
born Mahanoy City, PA 1934
Square Rim Bowl, 1991. Koa, 3 ¼ x 13 ⅝ x
13 in. Gift of Jane and Arthur K. Mason on the
occasion of the 25th anniversary of the Renwick
Gallery, 1996.98.10

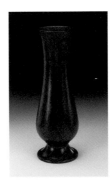

Del Stubbs
born Red Bluff, CA 1952
Turned Wood Vase, 1979. Claro walnut, 9 ⅞ x
3 ¼ in. diam. Gift of Del Stubbs in honor of his
teacher Paul English, 2003.2

Del Stubbs
Nesting Eggs and Goblet, 1979. Tulipwood,
rosewood, desert ironwood, lignum vitae,
ebony, boxwood and bone, height: ⅛–1 in.;
diam.: ⅛–½ in. Gift of Kay Sekimachi in
memory of Bob Stocksdale, 2008.27A–F

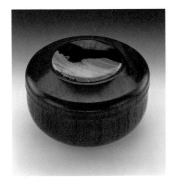

Del Stubbs
Claro Walnut Box with Desert Ironwood Inlay,
1982. Claro walnut and desert ironwood,
2 x 3 ¼ in. diam. Gift of the James Renwick
Alliance, 2003.22.2A–B

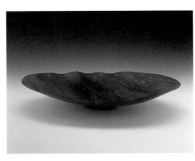

Del Stubbs
Almond Bowl, 1984. Almond, 2 ¼ x 12 ¾ in.
diam. Gift of the James Renwick Alliance,
2003.22.1

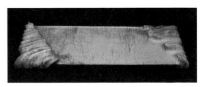

Holly Tornheim
born Ann Arbor, MI 1948
Topographic Tray, 1999. Curly maple, 1 ¾ x
24 ¼ x 9 in. Gift of Keith and Susan Tornheim,
2000.46

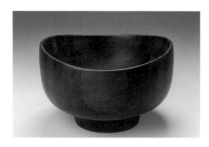

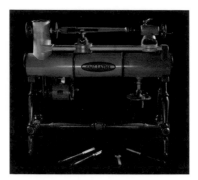

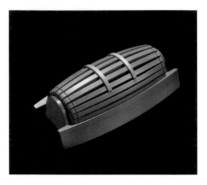

Daniel Valenza
born Rochester, NY 1934
Salad Bowl, about 1970. Black walnut, 7½ x
11¾ in. diam. Gift of Daniel Valenza, 1978.48

Various Artists
Glendale Woodturners Guild Lathe, 1999.
Various woods including black walnut, cherry,
maple, ebony, purpleheart, teak, and white
ash, 28 x 36 x 17 in. Gift of the Glendale
Woodturners Guild, California, 2000.38A–Q

Philip Weber
born New York City 1952
Space Probe, 1998. Pacific yew and suede,
1¾ x 5 x 2¼ in. Gift of the artist in honor of
his parents, Bernice and Gerald Weber; gift
of Beverly Heilman Wise and Alan Wise in
memory of their parents, Alice C. Heilman,
Louis Heilman and Lawrence Wise; and in
honor of Annetta Wise, 1998.78.1A–B

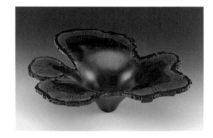

Philip Weber
Oval, 1998. Pacific yew, Honduras rosewood,
picture jasper, and suede, 4⅜ x 2¼ x 1⅜ in.
Gift of the artist in honor of his parents, Bernice
and Gerald Weber; gift of Beverly Heilman
Wise and Alan Wise in memory of their
parents, Alice C. Heilman, Louis Heilman and
Lawrence Wise; and in honor of Annetta Wise,
1998.78.2A–B

Philip Weber
Inner Wisdom 67–87, 1998. Ebony, brass,
and suede, 3¼ x 11¾ x 7 in. Gift of the artist
in honor of his parents, Bernice and Gerald
Weber; gift of Beverly Heilman Wise and Alan
Wise in memory of their parents, Alice C.
Heilman, Louis Heilman and Lawrence Wise;
and in honor of Annetta Wise, 1998.78.3

Helga Winter
born Niederrossbach, Germany 1948
Open Vessel, 1990. Plum, 4⅛ x 11 x 11¼ in.
Gift of George Peter Lamb and Lucy Scardino
in memory of Natalie Rust Lamb, 1995.100.31

Image Credits and Copyrights

Front cover: Derek A. Bencomo, *Hana Valley*, photo by Bruce Miller, see page 116

Mark and Melvin Lindquist, photo by Kathy Lindquist, courtesy of Lindquist Studios, page 24

Derek A. Bencomo, *Gift from the Sea*, photo by Bruce Miller, page 116

Phil Brown, *Maple Vessel*, photo by Bruce Miller, page 117

Frank E. Cummings III, *On the Edge Naturally*, photo by Bruce Miller, pages 51, 118

Virginia Dotson, *Dunes Series #3*, ©1990 Virginia Dotson; *Shadow Play #1*, ©1994 Virginia Dotson. All images, page 118

Addie Draper, *Escher #2*, photo by Bruce Miller, page 119

Dennis Elliott, *Untitled*, ©1992 Dennis Elliott and Tona Elliott, page 119

Giles Gilson, *Sunset*, ©1985 Giles Gilson, photo by Bruce Miller, page 120

Michelle Holzapfel, *Bound Vase*, photo by Bruce Miller, page 121; *Table Bracelet: Promenade Suite*, ©1997 Michelle Holzapfel, pages 6, 9, 66–67, 121

William Hunter, *Visions*, ©1987 William Hunter; *Cuzco Moon*, photo by Bruce Miller. All images, page 122

Dan Kvitka, *Node Form*, photo by Bruce Miller, page 124

Bud Latven, *Textured Anasazis*, ©1987 Bud Latven, photo by Mildred Baldwin; *Tightwire*, ©1989 Bud Latven; *Spheres*, ©1989 Bud Latven. All images, page 125

Mark Lindquist, *Ascending Bowl #3*, photo by Bruce Miller, pages 26, 126; *Silent Witness #6~Dh0:\Taciturn* from the "Post Totemic Series," photo by Bruce Miller, page 126

Melvin Lindquist, *Hopi Bowl*, ©1989 Melvin Linquist and Mark Lindquist, pages 28, 126

Philip Moulthrop, *Rolled-Edge Bowl*, photo by Bruce Miller; *Figured Tulip Poplar Bowl*, ©1987 Philip C. Moulthrop, photo by Bruce Miller. All images, page 128

Craig Nutt, *Radish Salad Bowl*, ©1998 Craig Nutt, page 128

Rude Osolnik, *Laminated Birchwood Bowl*, photo by Bruce Miller, page 128

Norm Sartorius, *Spoon from a Forgotten Ceremony*, ©1994 Norm Sartorius, photo by Bruce Miller, page 133

Del Stubbs, *Claro Walnut Box with Desert Ironwood Inlay* and *Almond Bowl*, photos by Bruce Miller. All images, page 137

Philip Weber, *Space Probe* ©1998 Philip Weber; *Oval* ©1998 Philip Weber; *Inner Wisdom* ©1998 Philip Weber. All images, page 138

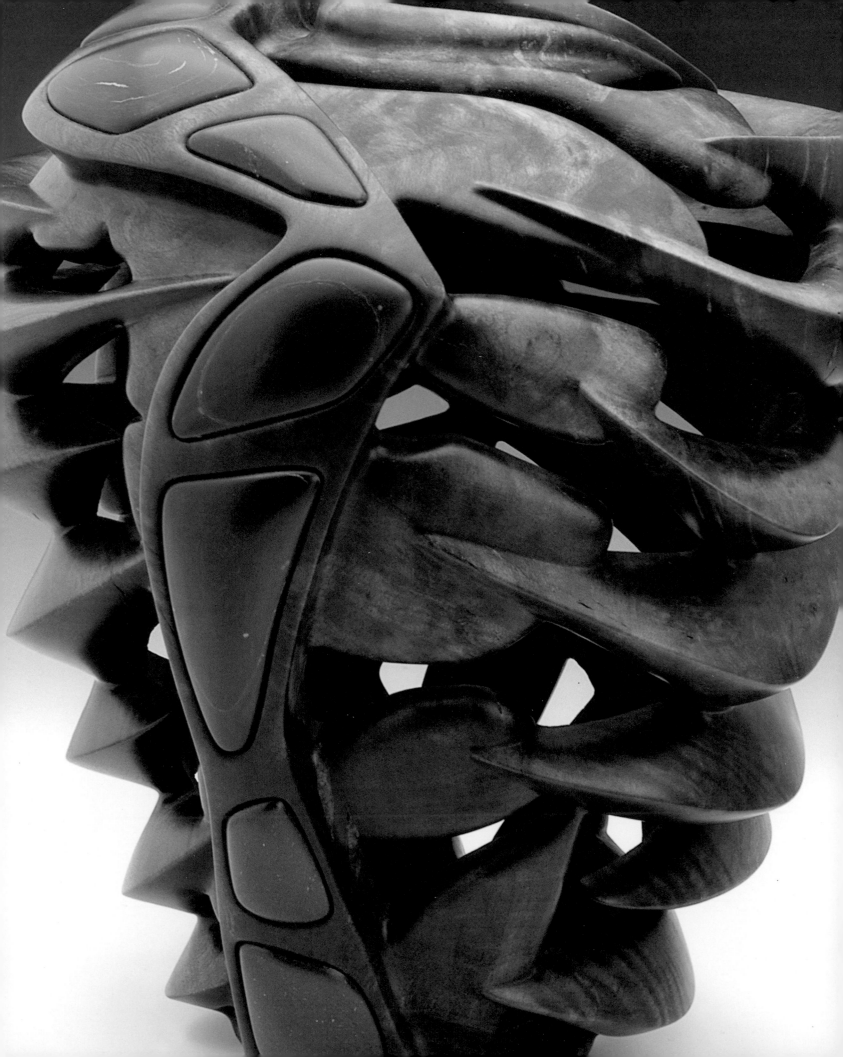

Bibliography

Adamson, Glenn. "California Spirit: Rediscovering the Furniture of J. B. Blunk." *Woodwork* 59 (Oct. 1999): 22–31.

——. "Michelle Holzapfel's 'Bespoke Vessels' at Barry Friedman." *Turning Points* 12, no. 3 (winter 1999–2000): 16–18.

Adamson, Glenn, and Gary Michael Dault. *Gord Peteran: Furniture Meets Its Maker*. Milwaukee: Milwaukee Art Museum, 2006.

Alexander, Tom. "Decorative Turning: Plunging Right into a Bowl's Personality." *Fine Woodworking,* no. 50 (January–February 1985): 44–45.

American Woodturner. "It's a Small World." (spring 2007): 40–45.

Arizona State University Art Museum. *Turning Plus: Redefining the Lathe-Turned Object III.* Tempe, Ariz.: Arizona State University Art Museum, 1994.

Augustine, Ellen. "A Family Feeling for Trees: The Work of Ed and Philip Moulthrop." *American Woodturner* 10, no. 3 (September 1995): 19–21.

Benesh, Carolyn L. E. "Janel Jacobson: Stirring the Dawn." *Ornament* 20, no. 3 (spring 1997): 42–46.

Brown, Phil B. "On Any Sunday: Elegant Vessels by Hilliard Booth." Unpublished manuscript, Renwick Gallery artist files, 1996.

Burchard, Christian. "Learning to Speak." *American Woodturner* 9, no. 1 (March 1994): 26–27.

——. "Ways to Have a Ball: Turning, Decorating, and Hollowing Spheres." *American Woodturner* (June 1995): 26–28.

Burgard, Timothy Anglin. *The Art of Craft: Contemporary Works from the Saxe Collection.* San Francisco: Fine Arts Museums of San Francisco and Bulfinch Press / Little, Brown, 1999.

Burrows, Dick. "Akron Sparkles with Talent and Fellowship." *American Woodturner* (fall 1998): 12–15.

Carlsen, Spike. *A Splintered History of Wood: Belt Sander Races, Blind Woodworkers & Baseball Bats.* New York, N.Y.: Collins, 2008.

Carter, Tom. *A Way with Wood: Southern Style.* Exhibition catalogue. Huntsville, Ala.: Huntsville Museum of Art, 1990.

Connell, Martha. *Out of the Woods: Turned Wood by American Craftsman.* Mobile, Ala.: Fine Arts Museum of the South at Mobile, 1992.

——. "Rude Osolnik: Grandmaster of Wood Turning." *Turning Points* 10, no. 3 (fall 1997): 15–18.

Conover, Ernie. "Turning Balls." *Fine Woodworking,* no. 60 (September–October 1986): 76.

Cooke, Edward S., Jr., Glenn Adamson, Patricia E. Kane, and Albert LeCoff. *Wood Turning in North America Since 1930.* New Haven, Conn.: Yale University Art Gallery / Wood Turning Center, 2001.

Cooke, Edward S., Jr., Wendell Castle, and Gerald Ward. *The Maker's Hand: American Studio Furniture, 1940–1990.* Boston: MFA Publications, 2003.

Cope, Kenneth L. *American Lathe Builders: 1810–1910.* Mendham, N.J.: Astragal Press, 2001.

Courter, Elodie. "Wood Shapes by James Prestini." *Arts & Architecture* 65 (August 1948): 27–29.

Csaszar, Tom. "Review: Lincoln Seitzman." *American Craft* (October–November 2004): 92.
——. "Review: Ron and Patti Fleming." *American Craft* (August–September 2005): 64–65.

Cummings, Frank E., III. "Design: A Practical Approach." *Woodturning Magazine* (July–August 1992): 27–31.
——. "Journey into Art." *International Review of American Art* 11, no. 2 (1994): 54–57.

Dickey, Gary C. "Ed Moulthrop: Masters Video Celebrates a Woodturning Pioneer." *American Woodturner* 15, no. 1 (spring 2000): 32–33.

Douglas, Diane, et al. *Cabinets of Curiosities.* Edited by Judson Randall. Philadelphia: Wood Turning Center / Furniture Society, 2003.

Douglas, Mary for Nanette L. Laitman. "Documentation Project for Craft and Decorative Arts in America." Interview with Edward Moulthrop at the artist's home in Atlanta, April 2, 2001. Smithsonian Archives of American Art.

Draper, Addie, and Bud Latven. "Segmented Turning: Redefining an Old Technique." *Fine Woodworking* 54 (September–October 1985): 64–67.

Dubois, Alan. *Moving Beyond Tradition: A Turned-Wood Invitational.* Exhibition catalogue. Little Rock: Arkansas Arts Center, Decorative Arts Museum, 1997.

Duncan, Robert Bruce. "Bob Stockdale: Still on a Roll at 75." *Woodwork,* no. 1 (spring 1989): 16–21.

Ellsworth, David. "Hollow Turnings." *Fine Woodworking* 16 (May–June 1979): 62–66.
——. "Woodturning: The Modern Movement." *Washington Home & Garden,* September 1991, 4–5, 19.
——. "5 Giants in Woodturning." *American Woodturner* 19, no. 1 (spring 2004): 20–25.
——. *Ellsworth on Wood Turning: How a Master Creates Bowls, Pots and Vessels.* East Petersburg, Pa.: Fox Chapel, 2008.

Fine Arts Museum of the South at Mobile. *Out of the Woods: Turned Wood by American Craftsmen.* Exhibition catalogue. Mobile, Ala.: Fine Arts Museum of the South, 1992.

Fitzgerald, Oscar P. *Studio Furniture of the Renwick Gallery, Smithsonian American Art Museum.* Washington, D.C.: Smithsonian American Art Museum. East Petersburg, Pa.: Fox Chapel, 2008.
——. *New Masters of the Wooden Box: Expanding the Boundaries of Box Making.* East Petersburg, Pa.: Fox Chapel, 2009.

Fleming, Ron, and Patti Fleming. "Looking for Inspiration: Seeing Nature as Images on Vessels." *American Woodturner* 16, no. 2 (summer 2001): 34–36.

Gear, Josephine. *Eight Contemporary Sculptors: Beyond Nature, Wood into Art.* Exhibition catalogue. University of Miami, Fla.: Lowe Art Museum, 1994.

Goff, G. A. "Turning Mostly Air: Finding the Hidden Shapes in Rotted Logs." *Fine Woodworking,* no. 52 (May–June 1985): 54–57.

Green, Harvey. *Wood: Craft, Culture, History.* New York, N.Y.: Viking, 2006.

Herman, Lloyd E. *Art That Works: Decorative Arts in the 80s, Crafted in America.* Seattle: University of Washington Press, 1990.

Herman, Lloyd E., and Mirian Davidson Plotnicov. *Craft Multiples.* Washington, D.C.: Renwick Gallery of the National Collection of Fine Arts, 1975.

Herrmann, Joseph M. "Backyard Timber, Tabletop Treasure: Turning Natural-Edge Wooden Bowls." *Fine Woodworking,* no. 78 (September–October 1989): 58–60.

Hobbs, Robert. *Mark Lindquist: Stratographs and De-Compositions.* Exhibition catalogue. New York, N.Y.: Franklin Parrasch Gallery, 1990.
——. *Mark Lindquist: Revolutions in Wood.* Exhibition catalogue. Richmond, Va.: Hand Workshop Art Center / University of Washington Press, Seattle. 1995.

Hogbin, Stephen, and Tony Boyd. *Wood Turning: The Purpose of the Object.* Edited by John Ferguson. New York, N.Y.: Australia & Van Nostrand Reinhold, North America, 1980.

Holzapfel, Michelle, "Reflections of a Perpetual Student." *Turning Points* 10, no. 1 (spring 1997): 16–18.
——. "An Exploration of the Vessel Form." *Turning Points* 10, no. 3 (fall 1997): 9.
——. "The Art of Michelle Holzapfel." *Turning Points* 15, no. 2 (summer 2002):18–29.

Holzapfel, Michelle, Robin Rice, Christopher D. Tyler, and Philip and Muriel Berman Museum of Art at Ursinus College. *Challenge VI—Roots: Insights and Inspirations in Contemporary Turned Objects.* Exhibition catalogue. Philadelphia: Wood Turning Center, 2001.

Holzapfel, Michelle, Peter D. Slatin, and Peter T. Joseph. *Michelle Holzapfel.* Exhibition catalogue. New York, N.Y.: Becotte and Gershwin / Peter Joseph Gallery, 1991.

Hoyer, Todd. "My Work, My Life: A Portrait of the Artist as a Woodturner." *American Woodturner* 12, no 1 (March 1997): 10–13.

Hummel, Charles F. *With Hammer in Hand: The Dominy Craftsmen of East Hampton, New York*. Charlottesville, Va.: University of Virginia Press, 1968.

Isaacson, Philip. "Wonders in Wood." *Maine Sunday Telegram,* June 19, 1983.

Jacobson, Edward, Lloyd E. Herman, Dale L. Nish, and Ruby H. Turk. *The Art of Turned-Wood Bowls: A Gallery of Contemporary Masters—and More*. New York, N.Y.: E. P. Dutton, 1985.
——. *Nature Turning into Art: The Ruth and David Waterbury Collection of Turned-Wood Bowls*. Northfield, Minn.: Carleton Art Gallery, Carleton College, 1995.

Jepson, Barbara. "As the Wood Turns: From Logs into Art." *Wall Street Journal,* December 27, 1983.

Juszak, Craig J. "Special Spoon: Area Man's Carving Chosen for Museum in D.C." *Parkersburg News,* February 26, 1995.

Kane, Patricia E. "Yale Collects Wood: Gifts from the Collection of John and Robyn Horn." *Turning Points* 15, no. 2 (summer 2002): 8–15.

Kangas, Matthew, Edward S. Cooke Jr., John Perreault, and Tran Turner. *Expressions in Wood: Masterworks from the Wornick Collection*. Exhibition catalogue. Oakland, Calif.: Oakland Museum of California, 1996.

Kangas, Matthew, and Kevin Wallace. *Michael Peterson: Evolution | Revolution*. Exhibition catalogue. Bellevue, Wa.: Bellevue Arts Museum, 2009.

Kelsey, John. "Ornamental Turning." *Fine Woodworking* 1, no. 4 (fall 1976): 46.
——. "The Turned Bowl: The End of Infancy for a Craft Reborn." *Fine Woodworking* 32 (January–February 1982): 54–60.

Kent, Ron, Glenn Adamson, and Jonathan L. Fairbanks. *Ron Kent: Extremes*. N.p.: Ron Kent, 2003.

Keoughan, Ken. "Michael Peterson: The Lathe Is Just a Starting Point." *American Woodturner* 14, no. 3 (fall 1999): 28–31.

Kessler, Jane. *Lathe-Turned Objects*. Exhibition catalogue. Philadelphia: Wood Turning Center, 1988.
——. "Rude Osolnik: By Nature Defined." *American Craft* 50, no. 1 (February–March 1990): 54–57.

Kessler, Jane, and Dick Burrows. *Rude Osolnik: A Life Turning Wood*. Louisville, Ky.: Crescent Hill Books, 1997.

Koplos, Janet. "Franklin Parrasch Gallery, New York: Exhibit." *Art in America* (April 1990): 263.

Krasner, Deborah. "Michelle Holzapfel: Sacred Elements of Domestic Ritual." *American Craft* 53 (June–July 1993): 48–51.

Lacer, Alan. "Bill Hunter: A Turner's Turner." *American Woodturner* 16, no. 4 (winter 2001): 12–15.

Lauria, Jo. "William Hunter: Coming Full Circle." *American Craft* 64, no. 2 (April–May 2004): 46–49.

LeCoff, Albert. *A Gallery of Turned Objects*. Exhibition catalogue. Provo, Utah: Brigham Young Press, 1981.
——. *International Lathe-Turned Objects: Challenge IV*. Exhibition catalogue. Philadelphia: Wood Turning Center, 1991.
——. *Challenge V: International Lathe-Turned Objects*. Exhibition catalogue. Philadelphia: Wood Turning Center, 1993.
——. *Curators' Focus: Turning in Context*. Exhibition catalogue. Philadelphia: Wood Turning Center, 1997.
——. *Challenge VII: dysFUNctional*. Philadelphia: Wood Turning Center, 2008.

LeCoff, Albert B., Tina C. LeCoff, Linda McGillin, Bruce Katsiff, and Eileen J. Silver. *Revolving Techniques: Clay, Glass, Metal, Wood*. Doylestown, Pa.: James A. Michener Art Museum / Wood Turning Center, 1992.

LeCoff, Albert B., and Eric E. Mitchell. *Lathe-Turned Objects: An International Exhibition*. Exhibition catalogue. Philadelphia: Wood Turning Center, 1988.

Leier, Ray, Jan Peters, and Kevin Wallace. *Contemporary Turned Wood: New Perspectives in a Rich Tradition*. Madison, Wis.: Hand Books Press, 1999.

Lieberman, Laura C. "The Southern Artists: Ed Moulthrop." *Southern Accents* (July–August 1986): 101–105.

Lindquist, Mark. "Spalted Wood: Rare Jewels from Death and Decay." *Fine Woodworking* 2, no. 1 (summer 1977): 50–53.
——. "Turning Spalted Wood: Sanders and Grinders Tame Ghastly Pecking." *Fine Woodworking,* no. 11 (summer 1978): 54–59.
——. "Ascending Bowl." *The Studio Potter* 10, no. 2 (June 1982): 40–41.
——. "Harvesting Burls: Strange Formations Are Turners' Delight." *Fine Woodworking* (July–August 1984): 67–71.
——. *Sculpting Wood: Contemporary Tools and Techniques*. Worcester, Mass.: Davis Publications, 1986.

Lovelace, Joyce. "Contemporary Netsuke." *American Craft* 60, no. 3 (June–July 2000): 46–51, 68–69.

Lydgate, Tony. *The Art of the Elegant Wood Box*. New York, N.Y.: Sterling Press, 1997.

MacAlpine, Daniel. "Lamar's Wood Sculpture Takes Turning a Step Beyond." *Woodshop News* (January 1993).

Mackey, Jack. "Mark Lindquist." *American Way* (June 1996): 67–75.

Magill, Jon. "Rose-Engine Turning." *American Woodturner* 22, no. 1 (spring 2007): 46–53.

Martin, Terry. "Materials & Contemporary Illusions: Innovations in Lathe Turning." *Turning Points* 15, no. 4 (winter 2003): 20–25.
——. "The Spoonish Sculptures of Norm Sartorius." *Woodwork* (June 2006): 22–28.
——. *Icons: A Tribute to Mel Lindquist*. Exhibition catalogue. Dania Beach, Fla.: rakovaBRECKERgallery, 2008.

Martin, Terry, and Kevin Wallace. *New Masters of Woodturning: Expanding the Boundaries of Wood Art*. East Petersburg, Pa.: Fox Chapel, 2008.

Matthews, Martin. *Engine Turning 1680–1980: The Tools and Technique*. N. p.: Seven Oaks, 1984.

Mayer, Barbara. *Contemporary American Craft Art: A Collectors Guide*. Salt Lake City: Gibbs Smith, 1988.

Meilach, Dona Z. *Creating Small Wood Objects as Functional Sculpture*. New York, N.Y.: Crown Publishers, 1976.

Mitchell, Bruce. "Sculptural Bowls: Working on Making Them Work." *American Woodturner* 10, no. 2 (June 1995): 29–31.

Monroe, Michael W. *The White House Collection of American Crafts*. New York, N.Y: Abrams, 1995.

Neff, Jack. "W. Va. Spoon Carver Stirs Up an Art Form All His Own." *Woodshop News* (June 1995): 8–9.

Nish, Dale L. *Creative Woodturning*. Provo, Utah: Brigham Young University Press, 1975.
——. *Artistic Woodturning*. Provo, Utah: Brigham Young University Press, 1980.
——. "Turning Giant Bowls: Ed Moulthrop's Tools and Techniques." *Fine Woodworking*, no. 41 (July–August 1983): 48–53.
——. *Master Woodturners*. Provo, Utah: Artisan Press, 1985.

Nordness, Lee. *Objects: USA—Works by Artist-Craftsmen in Ceramic, Enamel, Glass, Metal, Plastic, Mosaic, Wood, and Fiber*. New York, N.Y.: Viking Press, 1970.

Nuckols, Carol. "Artist's 'Wrong' Methods Produce Unique Bowls." *Star Telegram*, September 1, 1982.

Nutt, Craig. "Woodturners Gather at Arrowmont." *American Craft* 46:1 (February–March 1986): 95.

Osolnik, Rude. *Rude Osolnik: A Retrospective*. Exhibition catalogue. Asheville, N.C.: Southern Highland Handicraft Guild, 1990.

——. "Tips for Turning Irregular Pieces." *Fine Woodworking*, no. 47 (July–August 1984): 70–71.
——. "Spindle Turning: Fine Points for the Beginner." *Fine Woodworking*, no. 63 (March–April): 36–38.

Palladino-Craig, Allys. "Mark Lindquist: Making Split Decisions." *Art Today* (spring 1989): 24–28, 48.

Perreault, John, "Out of the Woods." *American Craft* 66, no. 5 (October–November 2006): 58–61.

Perrault, John, and Heather Sealy Lineberry. *Turned Wood Now: Redefining the Lathe-Turned Object IV*. Exhibition catalogue. Tempe, Ariz.: Arizona State University Art Museum, 1997.

Podmaniczky, Michael. "The International Turned Objects Show: New Signs of the Turning Tide." *Fine Woodworking*, no. 74 (January–February 1980): 84–85.

Prestini, James. *James Prestini, 1938–1988*. Petaluma, Calif.: Creators Equity Foundation, 1990.

Prestini, James, and Edgar Kaufmann Jr. *Prestini's Art in Wood*. New York, N.Y.: Pocahontas Press, 1950.

Raffan, Richard. "Current Work in Turning: Do High Gallery Prices Make It Art?" *Fine Woodworking*, no. 67 (November–December 1987): 92–95.

Ramljak, Suzanne, and Michael W. Monroe. *Turning Wood into Art: The Jane and Arthur Mason Collection*. New York, N.Y.: Abrams, 2000.

Randall, Judson, Philip and Muriel Berman Museum of Art at Ursinus College, and the Wood Turning Center. *Connections: International Turning Exchange 1995–2005*. Philadelphia: Wood Turning Center, 2005.

Randall, Judson, and the Wood Turning Center (Philadelphia). *Enter the World of Lathe-Turned Objects*. York, Pa.: York Graphic Services for the Wood Turning Center, 1997.

Roszkiewicz, Ron. *To Turn the Perfect Wooden Bowl: The Lifelong Quest of Bob Stocksdale*. East Petersburg, Pa.: Fox Chapel, 2008.

Saylan, Merryll. "Women's Role in Woodworking." *Woodwork* (June 1998): 65–69.

Scarpino, Betty J. "Turning Bottoms." *Fine Woodworking*, no. 78 (September–October 1989): 61.

Schilling, Carol. "The Work of Art." *Turning Points* 17, no. 3 (spring 2005): 6–11.

Shuler, Michael. "Segmented Turning." *Fine Woodworking* 76 (May–June 1989): 72–75.

Sloan, David. "Arrowmont Turning Conference: New Work, New Guild." *Fine Woodworking* 56 (January–February 1986): 64–66.

Smith, Haley. "Hayley Smith / Todd Hoyer Collaboration." *Turning Points* 12, no. 1 (winter–spring 1999): 30–32.

Smith, Helen C. "Turning: Ed Moulthrop." *American Craft* 39, no. 6 (December 1979–January 1980): 18–23.

Spielman, Patrick E. *The Art of the Lathe*. New York, N.Y.: Sterling, 1996.

Starr, Richard. "The Woodcraft Scene: Woodturning on a Metal Lathe." *Fine Woodworking*, no. 34 (May–June 1982): 98–99.

Stirt, Alan. "Carved Bowls: Texture Enriches the Basic Shape." *Fine Woodworking*, no. 66 (September–October): 44–47.

Taragin, Davira S., Jane Fassett Brite, and Terry Ann R. Neff. *Contemporary Crafts and the Saxe Collection*. New York, N.Y.: Hudson Hills Press / Toledo Museum of Art, 1993.

Time-Life Books. *Woodturning: The Art of Woodworking*. New York, N.Y.: Time-Life Books, 1994.

Todd, Sharon. "The Wood Is Rotten, but the Art Exquisite." *Greenville News and Piedmont,* February 11, 1979.

Trapp, Kenneth R., and Howard Risatti. *Skilled Work: American Craft in the Renwick Gallery.* Washington, D.C.: National Museum of American Art, Smithsonian Institution Press, 1998.

Turner, Tran. "Frank E. Cummings III." *American Craft* 57, no. 4 (August–September 1997): 67.

Ulmer, Sean M., Janice Blackburn, Terry Martin, and David Revere McFadden. *Nature Transformed: Wood Art from the Bohlen Collection.* Manchester, Vt.: Hudson Hills Press, 2005.

Wallace, Kevin. "Turning away from the Lathe." *Turning Points* 15, no. 1 (spring 2002): 16–20.
——. "Ocean Harmony: Derek Bencomo at the Contemporary Museum." *Turning Points* 15, no. 2 (summer 2002): 30–33.
——. ed. *Transforming Vision: The Wood Sculpture of William Hunter, 1970–2005.* Exhibition catalogue. Long Beach, Calif.: Long Beach Museum of Art, 2006.
——. *River of Destiny: The Life and Work of Binh Pho.* Long Beach, Calif.: Long Beach Museum of Art, 2006.
——. *Moulthrop: A Legacy in Wood.* Louisville, Ky.: Crescent Hill Books, 2007.

Wallace, Kevin, Arthur Mason, and David Ellsworth, "An Appreciation of Criticism." *American Woodturner* 22, no. 1 (spring 2007): 54–57.

Wilke, Christopher, and Paul J. Smith, *Art of Woodturning.* New York, N.Y.: American Craft Museum, 1983.

Winters, Melanie. "An Evolutionary Path from Function to Pure Art." *Woodshop News* (April 1998): 8–9.

Wood, D. "What's in a Name? *ReTurnings* at the Wood Turning Center." *Turning Points* 14, no. 4 (winter 2002): 6–13.

Wood, Robin. *The Wooden Bowl.* Ammanford, Carmarthenshire, UK: Stobart Davies, 2005.

Woodbury, Robert S. *History of the Lathe to 1850: A Study in the Growth of a Technical Implement of an Industrial Economy.* Cleveland: Society for the History of Technology, 1961.

Wood Turning Center. *Papers from the 1997 Conference.* Philadelphia: Wood Turning Center, 1997.

World Turning Center and Hagley Museum and Library. *A Sampling of Papers from the 1993 World Turning Conference.* Philadelphia: Wood Turning Center, 1997.

Wright, Nancy Means. "Mark Lindquist: The Bowl Is a Performance." *American Craft* 40, no. 5 (October–November 1980): 23–25.

Zurcher, Suzette. "Prestini, a Contemporary Craftsman." *Craft Horizons* 8, no. 23 (November 1948): 25–26.

Index

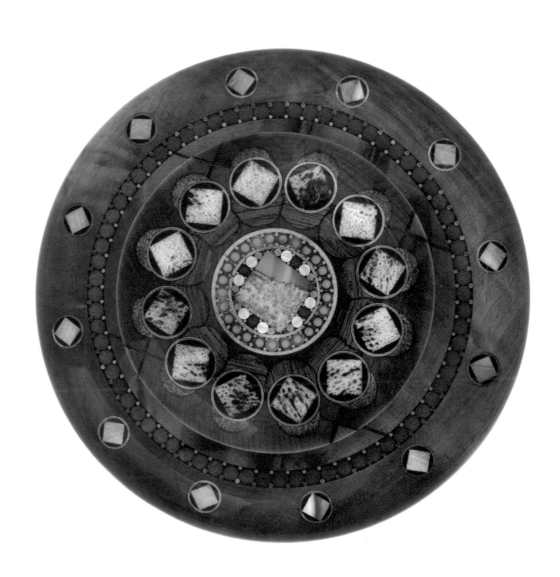